Minimalism DesignSource

Minimalism DesignSource

HDi

**HARPER
DESIGN**
international

An Imprint of HarperCollins*Publishers*

Publisher: Paco Asensio

Editor and Text: Encarna Castillo

Editor in Chief: Haike Falkenberg

Copy Editing: Rafael Lozano, Matthew Clarke

Art Direction: Mireia Casanovas Soley

Graphic Design: Emma Termes Parera

Layout: Pilar Cano

Translation: William Bain

First published in 2004 by:
Harper Design International, an imprint of HarperCollins Publishers
10 East 53rd Street
New York, NY 10022

Distributed throughout the world by:
HarperCollins International
10 East 53rd Street
New York, NY 10022
Tel.: (212) 207-7000
Fax: (212) 207-7654
www.harpercollins.com

Library of Congress Cataloging-in-Publication Data

Minimalism designsource / edited by Encarna Castillo.

p. cm.

ISBN 0-06-074798-6 (softcover)

1. Minimal architecture--Catalogs. 2. Architecture, Modern--20th century--Catalogs. 3. Architecture, Modern--21st century--Catalogs.

I. Title: Minimalism design source. II. Castillo, Encarna.

NA682.M55M55 2004

724'.6--dc22

2004008136

D.L.: B-24.994-2004

Editorial project

LOFT Publications
Via Laietana, 32, 4.°, of. 92
08003 Barcelona. Spain
Tel.: 0034 932 688 088
Fax: 0034 932 687 073
E-mail: loft@loftpublications.com
www.loftpublications.com

Printed by: Ferré Olsina Indústria Gràfica,
Barcelona, Spain

First Printing, 2004

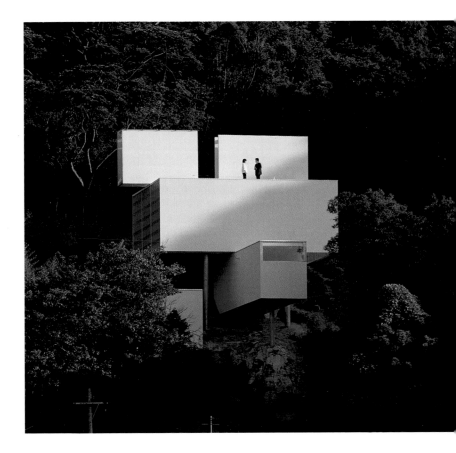

The term *minimalism* has not always been used in a favorable sense, especially in architecture, and even today it may be the cause of some confusion and ambiguity. The problem comes from the word's use in defining a creative current, school, or trend, when in fact it refers to an aesthetic. At the same time, this aesthetic is not chronologically well defined either and, moreover, interacts with different disciplines. This explains why we find minimalist buildings in periods very far apart from each other and in architects as different as Tadao Ando, Eduardo Souto de Moura, Jacques Herzog, Pierre de Meuron, or Luis Barragán, among others.

The introduction that opens this selection of minimalist buildings, which covers the decade of the 1990s and the first years of the 21st century, inquires into the origins of the term minimalism and into how a phenomenon like minimal art—which originated in the United States in the 1960s in the fields of painting and sculpture—has filtered into other sectors of society. Minimalism is now used in such endeavors as fashion, music, decoration, and architecture, and it has come to define the result of the use of pure and simple lines, the reduction of language elements, and, as far as architecture is concerned, the investigation of the treatment of space and of building possibilities.

MINIMALISM: ORIGINS OF A UNIVERSAL STYLE

The term minimalism is currently used to refer to a style marked by a certain asceticism in the arts, architecture, and design. The meaning is also extended, as an aesthetic idea or trend, to other aspects of our life and embraces the premises of simplicity, formal reduction, pureness of line, and the absence of the manual in favor of the use of industrial processes and materials. However, when applied to the visual arts, this term can only be spoken of in a precise way from two basic perspectives: from a historical context, referring to a style or movement in the arts (mainly sculpture, and defined also as three-dimensional pieces begun in the 1960s); or as still another side of abstraction, where geometry is accentuated, eliminating expressive resources.

From this last perspective, minimalism is rather firmly anchored in the exercises of the first avant-garde movements. It is to be found in the suprematism of Kazimir Malevich, in the De Stijl group, and in El Lissitzky. It is also in the abstract constructivist painting of Alexander Rodchenko, Naum Gabo, Antoine Pevsner, Vladimir Tatlin, or Georges Vantongerloo, and then passing through Piet Mondrian and Josef Albers until we come to the Dada of Marcel Duchamp. But outside this historical perspective we find a notable reaction on the part of artists such as Donald Judd or Tony Smith. Made using North American industrial production, their works of art were deemed "useless objects."

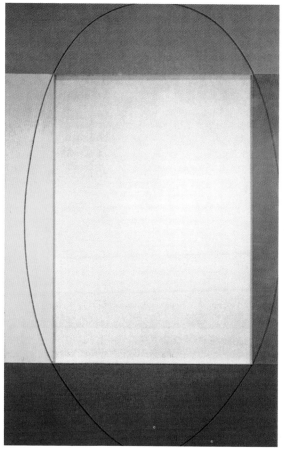

ROBERT MANGOLD. *Four Color Frame Painting No. 3* (rose, yellow-green, red, and green), 1983
Acrylic and pencil on canvas, 53 x 84 inches

Another origin of the term is found in the tendency of Carl André, Dan Flavin, or Robert Morris to empower a controversy of identification of the work of art with the object. The aesthetic reference of this ideology is the legacy of Duchamp, who introduced the *objet trouvé* (the readymade), and the influence of Constantin Brancusi in his development of sculpture on the limits of its consideration as artwork from the traditional point of view. The tension in the minimalist movement between these two currents—one in the context of an industrial aesthetic, the other caught between appreciation of the object as artistic or not artistic—took the North American art of the 1960s to a point of unprecedented theoretical and philosophical discussion. In this context we find artists who would later work with dedication to clarify the question of art's relation to society—and the work would take place in different countries. In continental Europe we find Joseph Beuys, Yves Klein, and Piero Manzoni; in England, Anthony Caro and William Turnbull; in the United States, Ellsworth Kelly, Frank Stella, and André. For art critic Kenneth Baker the most significant differences between the Europeans and the North Americans reside in the fact that the former subvert the conventions that sustain art from the rest of reality by choosing these materials to represent a metaphorical subjectivity. This is the case of Beuys, who creates sculptures made of grease, felt, and rubber. Somewhat differently, Americans like André, Judd, or Robert Morris will reject any type of metaphor or subjectivity to achieve a greater lucidity and precision with their artworks.

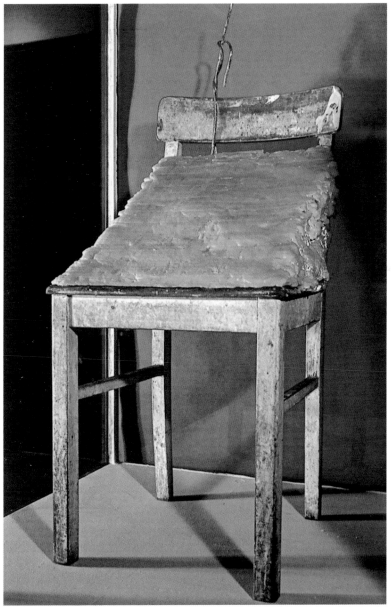

JOSEPH BEUYS. *Fat Chair*, 1964
Wood, fat, metal; 36 $^3/_8$ x 11 $^3/_4$ x 11 $^3/_4$ inches

From the North American perspective, minimalism is seen as a reaction period in the face of the vulgarity of the prosperous welfare state. It is a question of what the poet and philosopher Ralph Waldo Emerson describes as a collision between the state as political democracy and the ambitions of the capitalism being generated in that same period. This movement contains the frustrated idea of North American simplicity, considered as a national ideal to achieve and a model of behavior to follow, as a counterbalance to the excesses of a materialism whose major axis is individualism. The quest for an aesthetic clarification via the minimalism of art's function and of the art object as just one more object in the chain of production should be understood as a way of facing the contradictions and ideological aspects rooted in North American society from its foundation by communities like the Shakers and other utopian-minded groups like the Oneida or Brook Farm communities.

Minimalism, mainly developed in New York, also took root quickly due to the valuation of pragmatism in American culture—patent in the philosophies of Charles Sanders Peirce and William James—in defending the functional and simplistic aspects manifested in the designs of Shaker furniture, the precision painting of Charles Sheeler, the scientific realism of Thomas Eakins, the photography of Paul Strand and Walker Evans, and the poetry of William Carlos Williams and Marianne Moore.

MINIMAL ART

Minimal art essentially describes the abstract and geometric painting and sculpture created mainly in the United States in the 1960s. It is an art done in basic forms such as the right angle, the square, or the cube. In its concise compositions, this art is interpreted as a reaction to abstract expressionism, a trend led mainly by Jackson Pollock and Barnett Newman. In spite of sharing certain characteristics with pop art—such as the use of ordinary house paint, anonymous designs, and a preference for the flat painting— minimal art was defined as "imageless pop" in 1966 because it rejected all forms of commentary, representation, or reference. Initially, the work done by those engaged in minimal art was variously called "ABC art" (on the authority of Barbara Rose), "rejective art," "cool art," or "primary structures."

Frank Stella's black paintings, shown in the exhibition *Sixteen Americans* at New York's Museum of Modern Art in 1959, inaugurated this phase at the same time it appeared in the oeuvres of other artists—who similarly valued the creative process—and the earthworks of Michael Heizer. The show by Anne Truitt in 1963 at the André Emmerich Gallery in New York is, in the words of critic Frances Colpitt, the first recognizably minimal art exhibit. It was described by Judd and the influential art critic Michael Fried. But the first show that awoke critical interest was that by Morris at the Green Gallery, directed by Richard Bellamy in the fall of 1963.

As the 1960s closed, exhibits like *Black, White, and Gray* and *Primary*

Structures established minimal art, in the eyes of art historian James Meyer, as an important movement. Each of the artists associated with it developed a style marked by great austerity, with one-off or mass-produced geometrical forms. Judd began using industrial techniques to produce his pieces, creating piles of iron, aluminum, and Plexiglas crates; Morris made his structures in wooden planks and mirror cubes; Flavin mounted fluorescent lights on the floor and walls of the gallery beside fragments of brick and metal surfaces; André resorted to open cubes; Sol LeWitt, asymmetric metal forms; Truitt, like Larry Bell, used glass; and in the case of John McCracken, the glass was lacquered. Young artists of the time—people like Robert Smithson, Mel Bochner, and Eva Hesse—adopted geometric forms and mass production in their distinct language. Robert Ryman, Jo Baer, David Novros, Robert Mangold, Ralph Humphrey, Agnes Martin, Paul Mogensen, and Brice Marden created large-format one-off series after the style of Stella.

The essay "Specific Objects" (1965) by Judd has been considered and later read as if it were a minimalist manifesto. At the same time, as critic David Batchelor points out, such was never the intention of the essay. Judd begins the essay with the familiar sentence: "Half or more of the best new work in the last few years has been neither painting nor sculpture." This shows his predilection for the denomination of three-dimensional works or objects. That same year, LeWitt created the first of the pieces that became a kind of personal trademark: the open modular cubes. As in the case of Judd, LeWitt wanted to differentiate these creations from the sculptural tradition by

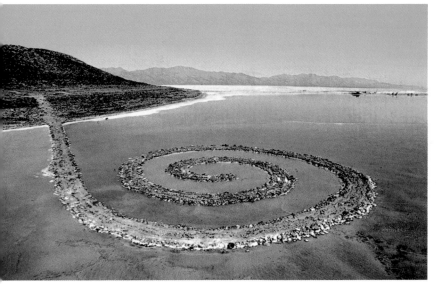

ROBERT SMITHSON. *Spiral Jetty*, 1970
Rock, earth, and salt crystals, coil 1500 x 15 feet
Utah, Great Salt Lake (destroyed)

referring to them as structures. Flavin referred to his fluorescent lights as proposals and objected to calling them sculptures in the tradition of painting. Parallel to this, we find Morris publishing in the magazine *Artforum*, between 1966 and 1969, a series of essays titled "Notes on Sculpture." In this series, he decides that "sculpture stopped dead and objects began." Only André continues to refer to his pieces as sculptures.

For Meyer, the history of minimalism, from the end of the 1950s to the present, is not defined as the configuration of a movement that would later clearly define itself, but as a debate on the new form of abstraction that came out of the 1960s. The series of geometric creations by André, Flavin, Judd, Morris, and LeWitt and their contemporaries Truitt, Bell, McCracken, Ronald Bladen, and Smithson—usually done via industrial processes and on a scale close to that of the viewer—established a new paradigm in sculpture. The series of monochromatic paintings by Baer, Humphrey, Marden, Mangold, Martin, Mogensen, Novros, Ryman, and Stella himself invite comparisons with the minimalist object, and they were spoken of in terms of that denomination as something inferior.

Following the lead of Meyer's studies, at the end of the 1970s minimalism became an international project: the different sculptors had one-person shows in the most important institutions, such as the Whitney Museum of American Art, the Solomon R. Guggenheim Museum, the Gemeentemuseum, and the Tate Gallery. Baer, Ryman, Marden, and Mangold did important retrospectives and a large number of shows in

international museums in the middle years of their careers. Gregory Battcock noted that the assimilation of minimalism by the museums and art galleries marked the end of the avant-garde phase, as his anthology on minimalism was coming off the presses in 1968, and he lamented that the museums had absorbed minimalism, "transforming it into a historical movement." Rosalind Krauss would make statements to the same effect in "The Cultural Logic of the Late Capitalist Museum," where she criticizes the grandiloquence of museum spaces for the exhibition of minimal art objects.

Questions such as centrality, humanization, and narration in the artwork were not important to the critics and artists of that period. Artists such as Ad Reinhardt had an enormous influence on Judd and Martin. On the other hand, André, Judd, Morris, Flavin, LeWitt, and their contemporaries Truitt and McCracken situated their sculptures directly on the walls of the gallery or on the floor, without a pedestal—the cubical base from which the sculptured piece itself or its essence comes. For the musician John Cage, art would not only appropriate the facts, but also encourage fresh perspectives—something like a bird's-eye view of a town (an allusion to the relief work on the surfaces of the artworks). Clement Greenberg—who was (according to Batcheleor) ignored by the artists ascribing to postwar minimalism—would state that "the picture has now become an entity belonging to the same order of space as our bodies; it is no longer the vehicle of an imagined equivalent of that order. Pictorial space has lost its 'inside' and become all 'outside.' The spectator can no longer escape into it from the space in which he himself stands."

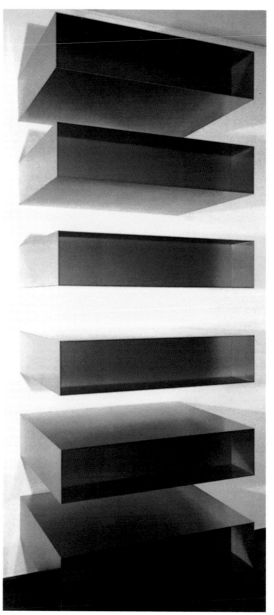

DONALD JUDD. Untitled, 1968
Stainless steel and anodized aluminum; 9 x 40 x 31 inches

Minimalism's field of influence has affected numerous contemporary artists, such as Dan Graham and Mel Bochner, who have employed the tools and techniques of minimalism in their most conceptual creations. In addition to the artists who came out of the 1960s and 1970s, young artists in the 1980s also began to work in so-called neo-geo or cute commodity, demonstrating interest in such figures of minimalism as André, Flavin, or Judd. And artists closer to hand, like Félix González-Torres, Charles Ray, and Janine Antoni, absorbed—and were not alone in doing so—the proposals and accomplishments of minimalism, using them in the later development of their own work.

DONALD JUDD

This artist's paintings go back to the 1950s. However, from the 1970s on, Judd's irregular forms—floating, abstract, in spaces with landscape contexts—are replaced by dense swathes of oil paint, frequently cadmium red. Often we distinguish in his pieces a central element that tends to be an *objet trouvé*: it is incised or superimposed on a picture's surface with notable texture. The object is there for the purpose of breaking the monochromatic field and bestowing it with an anecdotal or narrative action. With time, this disappears in favor of the introduction of lineal construction in the later pieces. Without distinguishing between support and pictorial surface, and in the fusion of different materials, his unitary conception confers on these works a quality of objective art, an essential characteristic of minimalism and its theoretical postulates. Around 1962 Judd began to

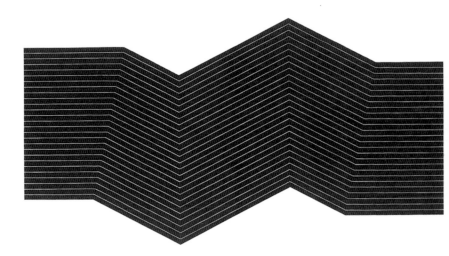

FRANK STELLA. *Nothing Ever Happens*, 1964
metallic polymer on canvas, 110 x 220 inches

create his paintings/objects with their base on the floor, many of them sustained frontally. He himself years later attributed the influence of that period to the works of Pollock, Clyfford Still, Newman, and Mark Rothko.

FRANK STELLA

In a 1964 interview by Bruce Glaser with Judd and Stella, the latter said, "My painting is based in the fact that only what can be seen there is there. It is really an object." This statement foreshadows Leo Steinberg's appreciations of the new painting as a surface free of subjective or narrative components. Stella's painting during this period, based on simple linear forms in large format, was designed to scale on the canvas through the use of an artist's brush; the canvas was later painted over with a standard house painter's brush and commercial paint such as enamel or aluminum paint. Sometime in the 1960s, Stella started to section the canvas space so that its overall appearance would correspond to the internal design. The resulting pieces were characterized by their use of repetitive and symmetrical designs on large monochromatic surfaces, where the satin finish or glossy paint acted as an opaque medium, without the possibility of spatial suggestion or narration. According to Batchelor, this absence of narrative, of literature, situates Stella and Judd in opposition to the European painting of the time, which maintains metaphorical values and the presence of something beyond mere pictorial qualities.

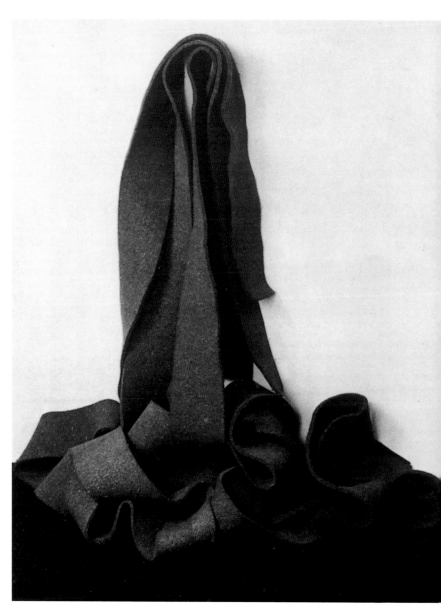

ROBERT MORRIS. Untitled (Tan Felt), 1968
Nine strips 120 x 8 inches each; installation 68 x 72 x 26 inches

ROBERT MORRIS

Morris's oeuvre has something like what we find in that of Judd, but without the link to historical predecessors. In "Notes on Sculpture," he rejects the influence of painting on the sculpture of that time and postulates its separation. For Judd, the interests of sculpture are both different from and hostile to painting. His conception of the autonomy of the modern tradition in sculpture begin with Vladimir Tatlin and Russian constructivism, and can only develop if it abandons any characteristic shared with painting. For Morris, such things as the use of color and formal arbitrariness are elements that originate in painting and that corrupt sculpture. His writings recommend the example of simple forms, with the end of empowering a gestalt perception of sculpture, which shows his concern about and interest in the relations between sculpture, the space it occupies, and the viewer. From 1963, he was the exponent of repetitive and modular work that corresponds to the arguments of his later theoretical texts. The pieces he created in wood and painted in a uniform light gray tone were based on simple polyhedral forms. Some of them are floor mounted; others are suspended from the gallery ceiling or immobilized on their walls. In an interview in 1985, he recognizes the influence of Duchamp and Jasper Johns in the work he did in the 1960s; he also acknowledges the influence of theater and dance more than of constructivism and the readymade. His love of experimental dance makes it possible to understand, from the 1950s onward, his interest in and link with the international movement Fluxus, with whom he worked and in whose events he actively participated. Therefore, the performance, the idea of temporality, and also the reference to a human presence are constants in his work.

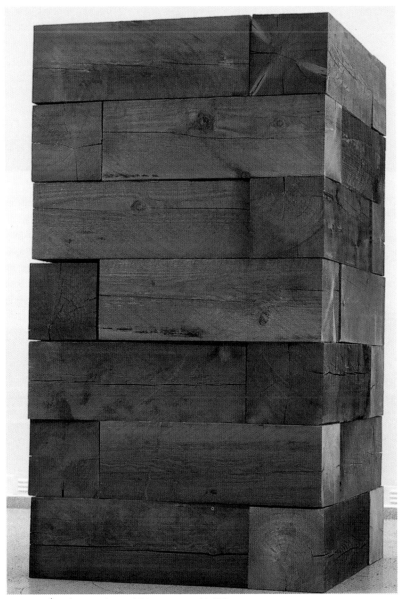

CARL ANDRÉ. *Timber Piece*, destroyed 1964, reconstructed in 1970
Wood, 28 pieces; 84 x 48 x 48 inches

CARL ANDRÉ

André is considered as the only artist in his group who bases his work on tradition in sculpture. In the final period of the 1960s, he created a series of small- and large-format works—intensely influenced by Brancusi—that are in fact sectioned rectangular pieces and that rise up vertically from their base. These blocks of unpolished wood, as in the work of Brancusi, appear with regular, repetitive incisions sculpted in by electric saw. André greatly admired the linear aspects of the Romanian sculptor and the way he used his assembly and repetition process of the same paradigmatic unit. Andrè admired Brancusi's combination of materials and their unaltered sections. And yet, unlike Brancusi, André's early experimental sculptures were created from single pieces of wood. As the 1950s closed, he began a process of assembling different prefab units. This is what we see in his most complex and ambitious creation, titled *Cedar Piece*. André demonstrated constantly that he took seriously the questions related to sculpture. In recorded conversations with filmmaker Hollis Frampton, André constantly alludes to Auguste Rodin, Brancusi, Pablo Picasso, Duchamp, Smith, John Chamberlain, Claeslul Oldenbrg, and Johns. At the beginning of the 1960s, André threw himself into a series of drawings and sculptures that showed his admiration for Brancusi and Stella, as well as for their pictorial processes (for example, the combination of identical pieces repeated). André's *Cedar Piece* has its origins in a sculpture that does not shun painting. The new sculpture, according to Greenberg, owed its evolution to the rejection of the tactile qualities of the 19th century, influenced by cubist sculpture, collage, and the experimental constructions of Picasso of the opening of the 20th century.

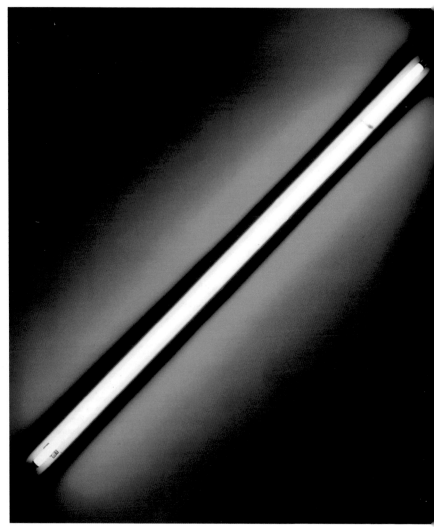

DAN FLAVIN. *Diagonal of May 25, 1963 (to Constantin Brancusi),* 1963
Green fluorescent light, 96 x 4 inches

INTRODUCTION

DAN FLAVIN

The installations of this artist, using fluorescent lighting, began in 1963. The structural elements are obvious, as is their identification with the industrially produced object of everyday life that is so in keeping with minimalism's aesthetic theory and is known as "new art." In spite of using these lights on conventional supports, Flavin achieved a result that is one of great optical intensity: the lights create different luminous ambiences in strict relation to the space they are put in. Flavin combines different lights to create new colors, and this effect caused Judd to call his work pictorial and relate it to the art of Morris Louis. Other aspects that gave it these plastic qualities were his assiduousness in occupying the spaces of the gallery walls; the very dimensions; his scale; and his relation to the first three-dimensional works that combine the fluorescent with wall-mounted, monochromatically painted, quadrilateral structures. His well-known admiration for constructivism, whose legitimate heir he felt himself to be, led him to express this as homage in the titles of some of his most emblematic productions.

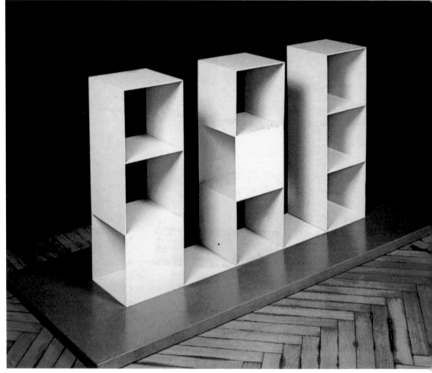

SOL LeWITT. *Three Part Variations on Three Different Kinds of Cubes*, 1967
Enamel on steel; 48 x 98 x 16 inches

SOL LeWITT

LeWitt decided to reveal the internal structure of the cube in modular compositions that date from 1965. To accentuate the structural and linear appearance, he originally painted them black to bestow them with an industrial look. Later, in a quest for greater expressive neutrality, his pieces were painted white, adopting their most characteristic appearance. Batchelor considers that the relation of this artist to sculpture and painting is ambiguous. In his first productions, he developed the search for three-dimensional projection from framed, quadrilateral, two-dimensional forms, where the three-dimensional projection was generated as the center of the two-dimensional space, as in *Wall Structure, White* (1962). The question of interior and exterior in this piece, as in previous pieces, is more or less explicitly suggested; some pieces, remarkably, include elements such as lightbulbs, works by another artist, and nude photography. His later creations, in addition to showing their structure, lack volume or mass in the traditional sense; they recall the linearity and projections of drawing, a technique that he also develops as a complement to the creation of his paintings. Hence, it is important to take into account that this obeys procedural rationales, since the drawing is the point of departure for carpenters or blacksmiths in the production of their pieces, as it was for Judd or Morris. In any event, there is clearly a development from the idea to its materialization, and this relationship is what is found between the drawing and its structures and physical objectification.

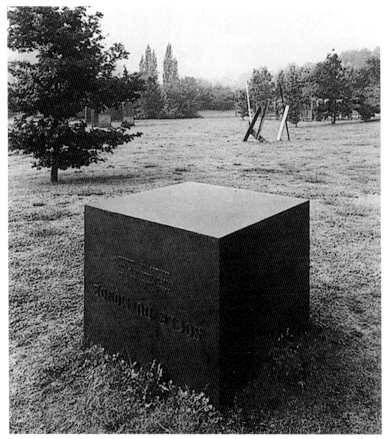

PIERO MANZONI. *Base of the World* (Dedicated to Galileo), 1961
Iron with bronze lettering; 32 x 39 x 39 inches

NEW SOUNDS: MUSIC

Minimalism in the field of sound has a clear antecedent in the figure of John Cage, as is the case with Merce Cunningham in dance. But we find vestiges and antecedents that go back to Erik Satie or even to his master Claude Debussy. Cage created a piece that is held to be paradigmatic, "4' 33"," where silence has been musically valuated for a specific time span that is also the title of the piece. In spite of the minimalist definition of this conceptual work, neither Cage nor his works were considered a part of this trend. For Tom Johnson, a musician and longtime contributor of articles to New York's *Village Voice*, minimalist music can be seen as an extended category. It is diversified and, by definition, includes all music that works from limited or minimal materials. Johnson holds that works that use lyrics or written for instruments alone, are very limited. And he is not only talking about these types. He includes pieces that sustain a prolonged electronic nudge to the knowledgeable—pieces built on recordings of rivers or other waterways that just keep going. Musical minimalism, in the words of Pablo Vázquez Gómez (author of an extensive essay on this topic), was born with the 1960s North American avant-garde, through people such as Terry Riley, Steve Reich, Philip Glass, and La Monte Young. All of these artists were born in the mid-1930s and possessed solid academic training as well as their shared experience on many projects. In the new style they show their rejection of the European serialism of the time and seek inspiration in ethnic classicism. Thus, Glass is inspired by the Indian music of Ravi Shankar; Young, inspired by Japanese theater; Reich, by the rhythms of Ghana, Ivory Coast, or Bali; Riley, by

European avant-garde composers and jazz, as well as being, along with Young, the disciple of the Indian musician Pandit Pran Nath; and, of course, Buddhism and the Zen philosophy influence Cage. Other members of this movement are Wim Mertens, Michael Nyman, John Adams, and the Penguin Café Orchestra. The musical scores considered emblematic in this context, and that still remain in the vanguard today, are those of Glass and Reich.

Minimalism in the field of music began in the United States, although it has European roots, such as the reaction to the serialism of the German school of Darmstadt. Its main proponents are Young, creator of the multiethnic sound; Glass, still today a faithful exponent of this movement—his most relevant work being "Music in Twelve Parts" (1976); Reich, considered the most puristic, who clearly represents the minimalist style—his most significant productions are "Clapping Music" (1972) and "Music for 18 Musicians" (1976), where four hands are heard clapping out a melody; Riley, initiator of the current and of the minimalist score, now related to electronic music and its variations, and whose most representative pieces are found in "In C" (1968), "A Rainbow in Curved Air" (1969), and "Song for the Ten Voices of the Two Prophets" (1982). Michael Nyman—internationally known for his sound tracks, especially in relation to film director Peter Greenaway, and whose most important works are heard in *The Draftsman's Contract* (1982) and *The Cook, The Thief, His Wife, & Her Lover* (1989)—is perhaps the artist who least ascribes to the movement. The influence of other trends intervene and perhaps alienate Nyman from things minimalist, as is the case of expressionism or romanticism; however, these influences

connect him with European authors like Gavin Bryars, whose most representative and paradigmatic work is "Jesus' Blood Never Failed Me Yet" (1974), held to be the most important piece in European minimalism. Mertens, a follower of Reich, Glass, and Nyman, is the creator of *American Minimal Music* (1980), an essential work for understanding the American vanguardist movement. His main composition is "Jeremiades" (1995), which uses his own voice with piano accompaniment. Among other composers who are present in a more tangential way in this current, Brian Eno is noteworthy. He has collaborated with Glass and applied minimalist techniques to his electronic compositions. Also important, though in another context, is Carles Santos, a unique composer and the creator of "L'Adeu de Lucrecia Borgia."

ESSENTIAL FORMS: ARCHITECTURE

"Less is more."
—Ludwig Mies van der Rohe

John Pawson, the author of *Minimum* and considered to be the guru of minimalist architecture, shows in his statements the influence of a Zen Buddhist attitude—in a broader sense, an attitude not unrelated to the detachment from objects and the rejection of accumulation. It is, in short, simplicity as both a life philosophy and a path to individual liberation. Regarding the definition of architectural minimalism and its input, this

architect today defines as elitist—as the ultimate form of luxury—those qualities that inspire the minimalist trend in architecture. Why? Because space is the most difficult and costly thing to obtain.

Minimalism in architecture is characterized by placing value on essential elements like light and the way it falls on the volume, and masses that make up buildings and shape space, design, and structure. Textures are revalued at the cost of any other form of decoration or ornamentation, without making concessions to unnecessary commodities or evocations. This architecture champions concrete forms that are thought out in relationship to their surroundings; thus, here, functionalism, linear structures, and essential geometric forms define identity.

SPACE AS PROTAGONIST: INTERIOR DECORATION

The aesthetic trend we know as minimalism is the model for contemporary interior decoration, where the value aimed at is simplicity of space; light; combinations of white with intense shades and colors like black and red; and natural materials or high-tech manufactures. In this new context, ornamental simplicity and purity of line in furniture are imposed. There is also the use of different types of wood as an element of subtle expressiveness, taking pains to bring out the natural grain. Furthermore, industrial elements are introduced—plastics, foams, steels, and chrome, among others. The context uses aesthetic proposals oriented toward the

functions of space and its relation to the objects that live in it. The London restaurants of Sir Terence Conran offer a clear example of this style, prepared to host a multitude. The walls are white. They express neutrality and the aseptic values of high tech. The metal-and-glass furniture visually delights diners, who discover an extensive menu of special international cuisine. The store known as Colette, inaugurated in Paris in 1997, provides another representative simple of this style, where white is the stage on which objects to be sold act.

PURENESS OF LINE: FASHION

"Simplicity is the soul of modern elegance."
—Bill Blass, 1992

When Japanese designers, as well as some European designers such as Christian Lacroix, coincided in their appreciation for radicalism, North American designers like Ralph Lauren and Calvin Klein were engaged in developing very different proposals. They saw fashion not only as a form of the contemporary and the avant-garde, but also as a political and social expression of the democracy, industrialization, and mass culture characteristic of the United States. Those designers saw the way we dress as another element included in the tool kit that makes up our everyday life. Without class or caste differentiation, their fashions are designed for all of society, whose guiding standard is to seek a formal comfort and simplicity

that define the new individual within an advanced and democratic collective. For the German designer Gerda Buxbaum, the so-called new classics like Giorgio Armani, Calvin Klein, and Jil Sander propose a look based on neutral colors and essential forms that is based on architecture and geometry—a look that can be called purist, and that shouldn't be confused with minimalism. This subtle distinction is important, since purism is not based on an artistic or aesthetic movement, but is linked to those aspects of each movement, trend, or style in the history of art. In any event, in the contemporary concept, purism becomes extended in relation to the essential geometric forms, which figure in minimalism as they previously did in the case of its forerunners. Buxbaum sets forth this differentiation: the designer Giorgio Armani, for example, developed a functionalism in the design of women's clothing fashions that are intrinsic to the traditional design of the modern man, but in Calvin Klein, Donna Karan, or Bill Blass, such functionalism represents a style of life out of North American tradition.

Austrian designer Helmut Lang is considered the most avant-garde of all of the minimalists. He represents the paradigm of the 1990s in the fusion of European and North American culture. He also expresses the liberation of women and the triumph of globalization, and manifests, in his clothing fashions, the influence of politics and society on the coordinated purist or minimalist stylistics of his precursors. Italian designer Giorgio Armani has always kept minimalism present in all of his work, defined by the use of simple, basic forms and lines that come from men's styles and from ethnic

sources. These are clothing fashions whose fabrics have been processed to obtain the effects described above, making the items refined and elegant in their functionalism and the requirements of contemporary city life. In the mid-1990s the renovation of Prada and Gucci brought with it the compromise to provide the luxury object—the chic object—with importance, blended with a touch of necessary simplicity and sobriety characteristic of the minimalist style.

Juan Carlos Rego

Artist and art critic

BIBLIOGRAPHY

Baker, Kenneth
Minimalism: Art of Circumstance
Abbeville Press, New York, 1988

Batchelor, David
Minimalism
Tate Gallery, London, 2001

Battcock, Gregory
Minimal Art: Critical Anthology
University of California Press, Berkeley, 1995

Berger, Maurice
Labyrinths: Robert Morris, Minimalism, and the 1960's
Harper & Row, New York, 1989

Calvo Serraller, F.; González García, Á.; Marchán Fiz, S. (eds.)
Escritos de arte de vanguardia: 1900-1945
Istmo, Madrid, 2003

Colpitt, Frances
Minimal Art: The Critical Perspective
UMI Research Press, London, 1990

Doss, Erika
Twentieth Century American Art
Oxford University Press, New York, 2002

Friese, Peter
Minimal-Maximal
Centro Galego de Arte Contemporánea (CGAC)
Santiago de Compostela, 1999

Marchán Fiz, Simón
La historia del cubo. Minimal art y fenomenología
Rekalde, Bilbao, 1993

Marchán Fiz, Simón
Del arte objetual al arte del concepto
Akal, Madrid, 2001

Meyer, James
Minimalism
Phaidon, London, 2000

DISCOGRAPHY

JOHN CAGE

"4'33""; Floating Earth, 1959.

"Cartridge Music," For the Merce Cunningham dance "Changing steps"; Mode, 1960.

"The Piano Works, Volume 1"; Stephen Drury (piano); Mode, 1990.

LA MONTE YOUNG

"31 VII 69 10:26-10:49 PM Munich from Map of 49's Dream the Two Systems of Eleven Sets of Galactic Intervals Ornamental Lightyears Tracery; 23 VIII 64 2:50:45-3:11 AM The Volga Delta from Studies in the Bowed Disc"; La Monte Young and Marian Zazeela; Edition X, 1969.

"Dream House 78'17" 13 I 73 5:35-6:14:03 PM NYC; Drift Study 14 VII 73 9:27:27-10:06:41 PM NYC from Map of 49's Dream the Two Systems of Eleven Sets of Galactic Intervals Ornamental Lightyears Tracery"; La Monte Young and Marian Zazeela; Shandar Disques, 1974.

"Just West Coast/Microtonal Music for Guitar and Harp: Sarabande"; Bridge Records BCD, 1993.

"Just Stompin'/Live at the Kitchen, Young's Dorian Blues in G"; La Monte Young and The Forever Bad Blues Band; Gramavision, 1993.

PHILIP GLASS

"Einstein on the Beach"; Pera in Four Acts; The Philip Glass Ensemble; Nonesuch, 1993.

"Music in Twelve Parts"; The Philip Glass Ensemble; Nonesuch, 1996.

"Minimal Music"; Music by Philip Glass and Michael Nyman; t.e.c.c. quartet; Beoton, 1996.

"Minimal Piano Works, Volume 1"; Jeroen Van Veen (piano); Piano Productions, 1999.

STEVE REICH

"Steve Reich: Works (1965-1995)", various artists, Nonesuch, 1995.

"Early Works: 'Clapping Music' (1972), 'Come Out' (1966), 'It's Gonna Rain' (1965), 'Piano Phase' (1967)"; Nonesuch, 1992.

"Triple Quartet: 'Electric Guitar Phase' (1967, 2001), 'Music for a Large Ensemble,' 'Tokyo/Vermont Counterpoint' (1981, 2000)"; Nonesuch, 2001.

TERRY RILEY

"In C"; Terry Riley and members of the Buffalo NY State Univ, Center of the Creative & Performing Arts; CBS, 1968.

"A Rainbow in Curved Air"; Poppy Nogood and the Phantom Band: Terry Riley, electric organ and electric harpsichord; CBS, 1969.

"The Church of Anthrax"; Terry. Riley and John Cale; CBS, 1970.

"The Ten Voices of the Two Prophets"; Terry Riley, vocals and synthesizers; Kuckuck, 1983.

HOUSES

HAKONE HOUSE

Moriko Kira | © Satoshi Asakawa | Shizuoka, Japan

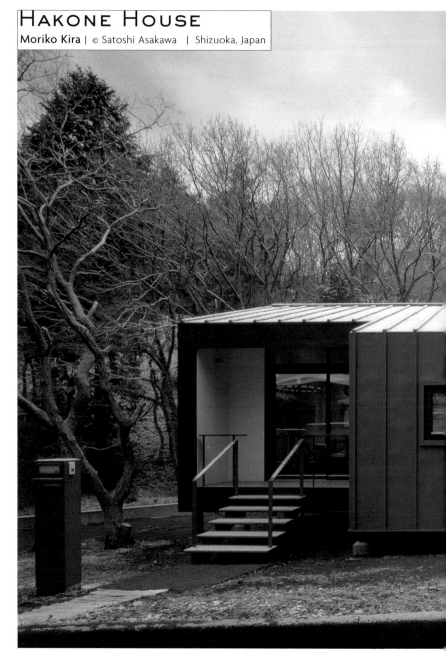

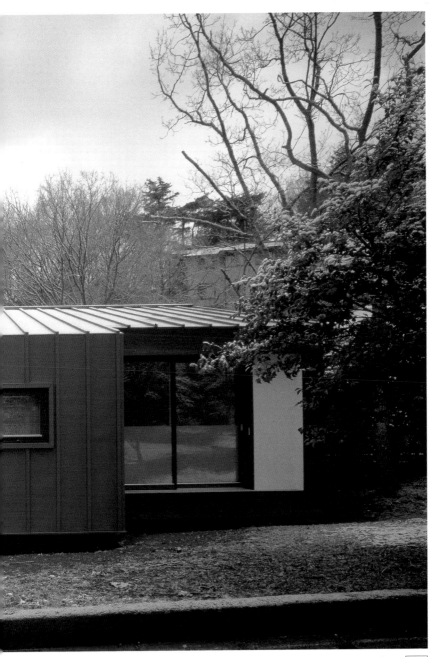

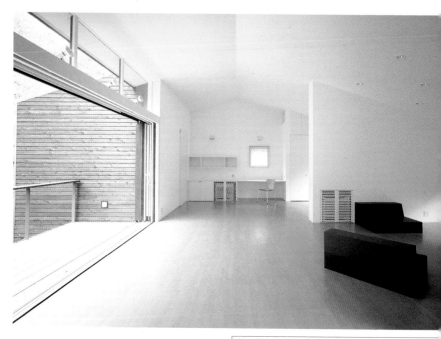

The white interior walls, illuminated by the natural light, act as a unifying element within the house.

Elevation

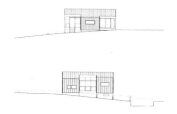

Elevation

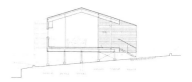

Section

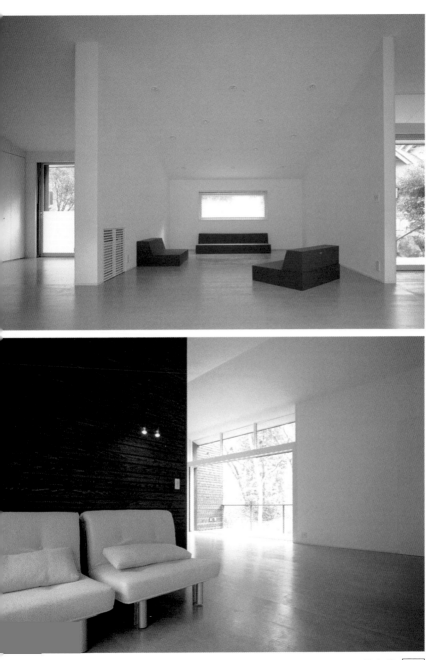

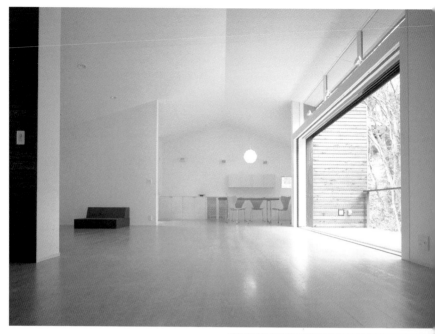

Plan

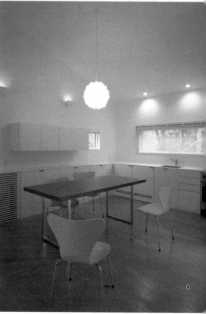

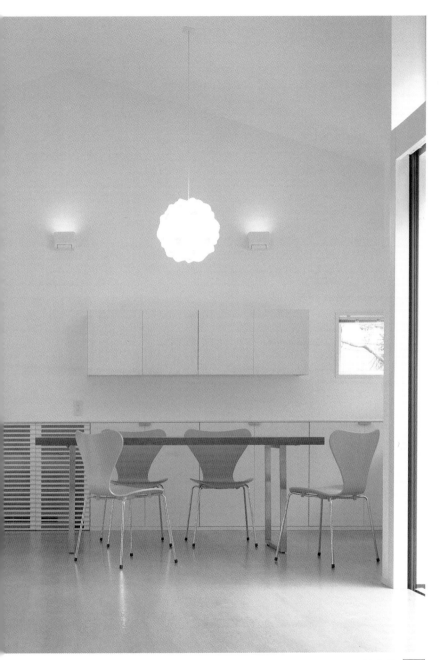

Na Xemena House

Ramon Esteve | © Ramon Esteve | Ibiza, Spain

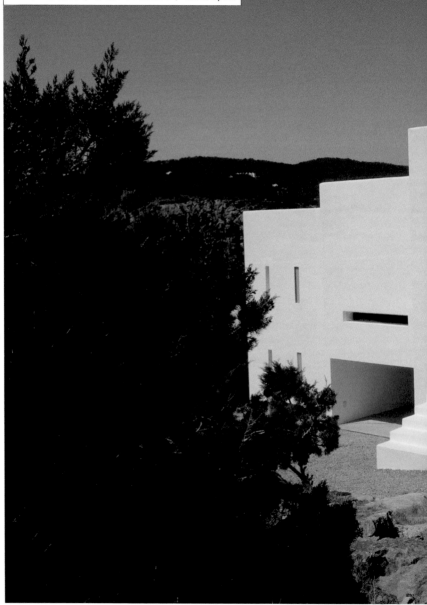

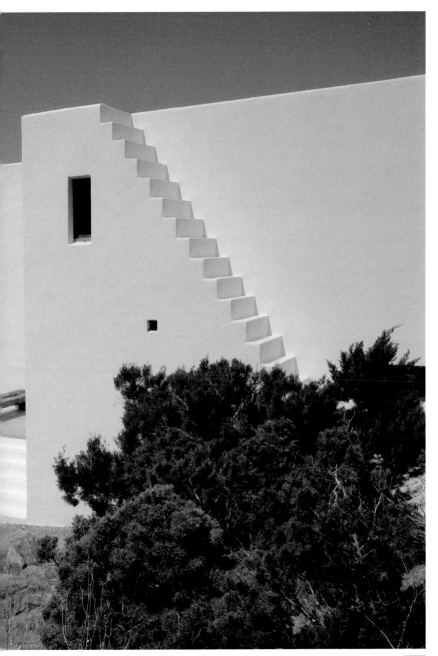

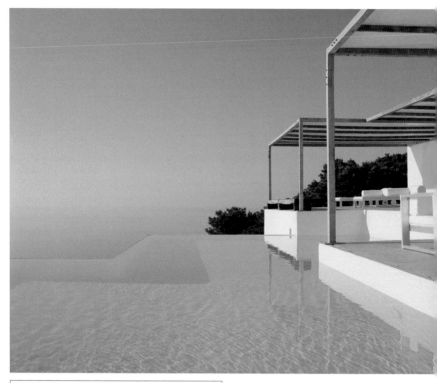

The clean exterior walls are broken to capture light,
following a natural order determined by the interior
room arrangement.

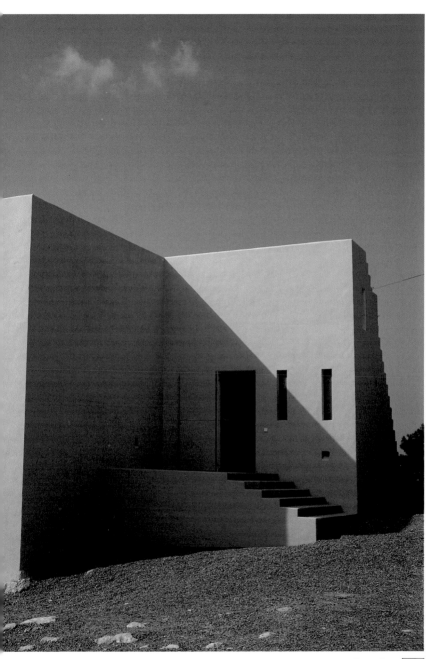

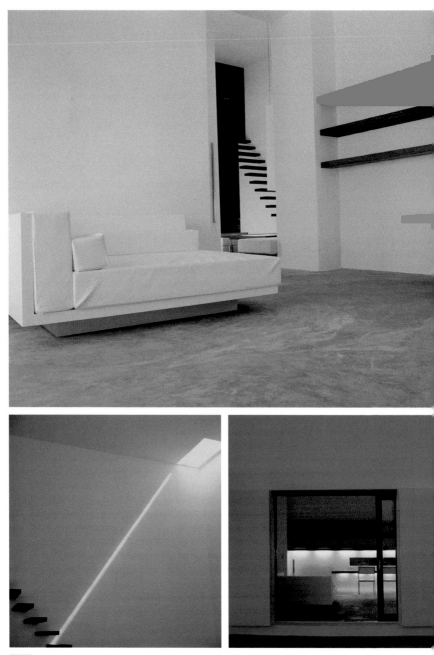

NA XEMENA HOUSE

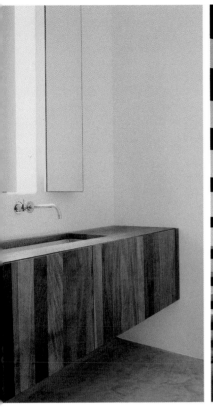

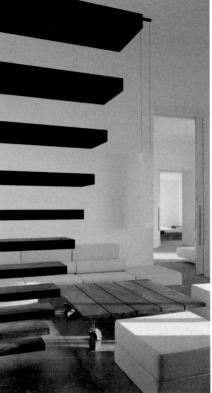

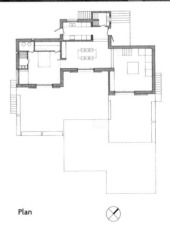

Plan

ELEKTRA HOUSE

David Adjaye | © Lyndon Douglas | London, UK

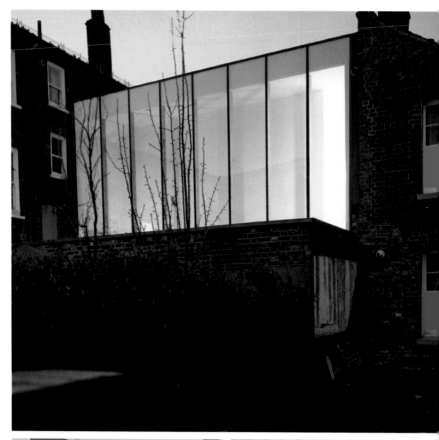

The façade's lack of ostentation is reflected in the interior, where a two-story space with a skylight runs the entire length of the house.

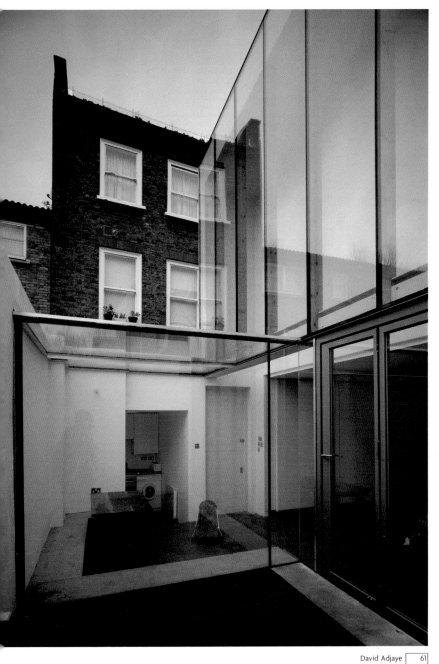

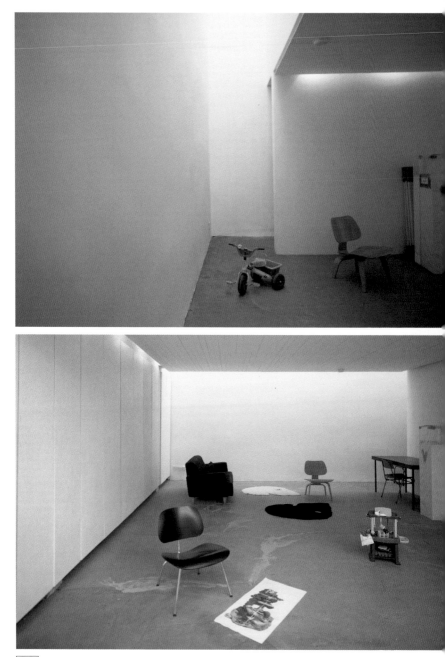

ELEKTRA HOUSE

First floor

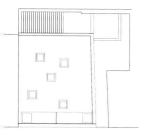

Second floor

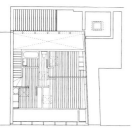

Roof plan

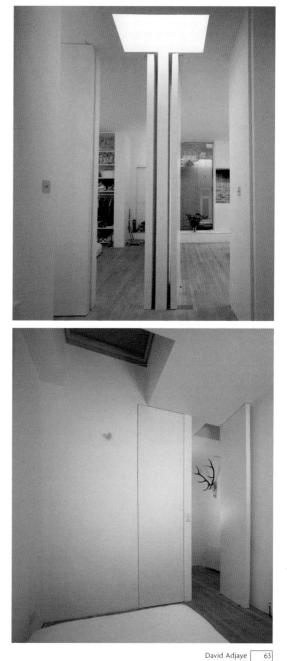

HOUSE ON MOUNT FUJI

Satoshi Okada | © Hiroyuki Hirai | Yamanashi, Japan

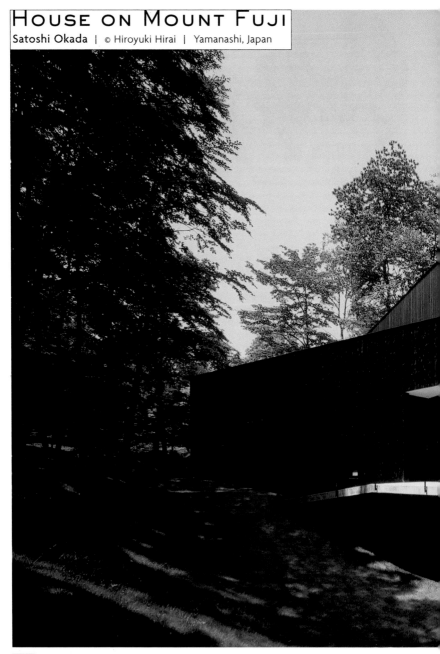

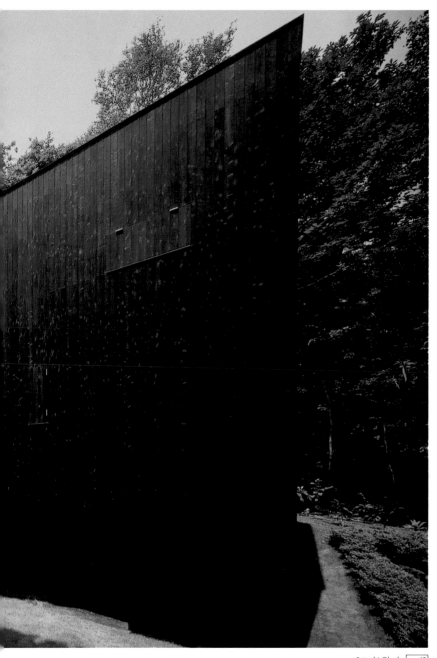

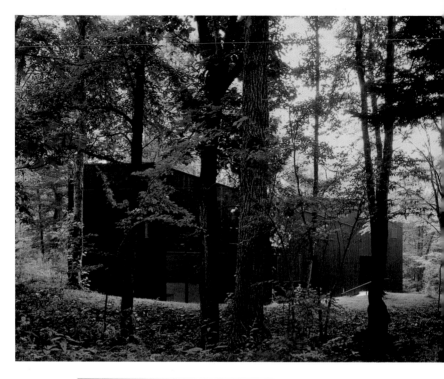

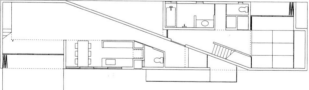

First floor

Second floor

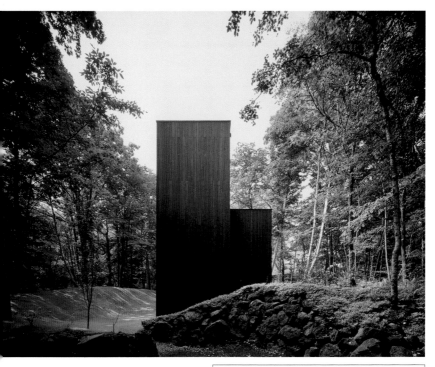

At the client's request, a 1,184-square-foot house was built in the middle of a 8,500-square-foot parcel, to emphasize and enhance enjoyment of the natural setting.

elevations

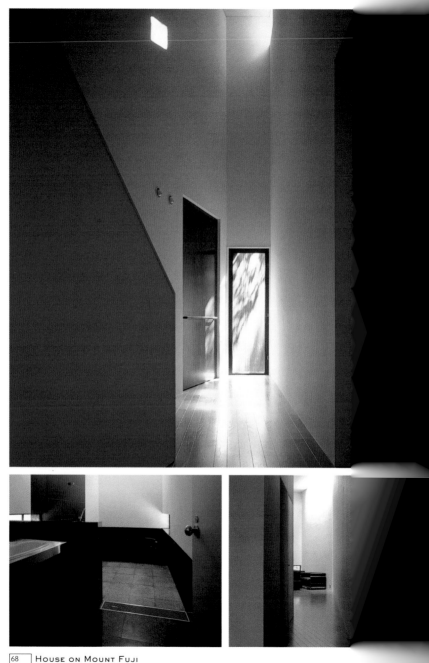

HOUSE ON MOUNT FUJI

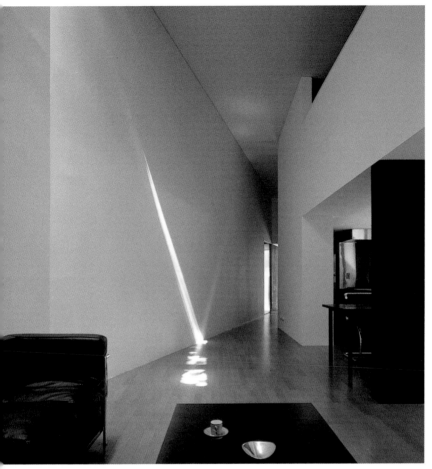

The house has a diagonal layout that divides it into two gallery-like principal spaces. One of these spaces houses the living area, and the other the bedrooms and a bathroom.

BALANCING ACT

Ángel Sánchez + Vicente Tomás | © Alejo Bagué | Majorca, Spain

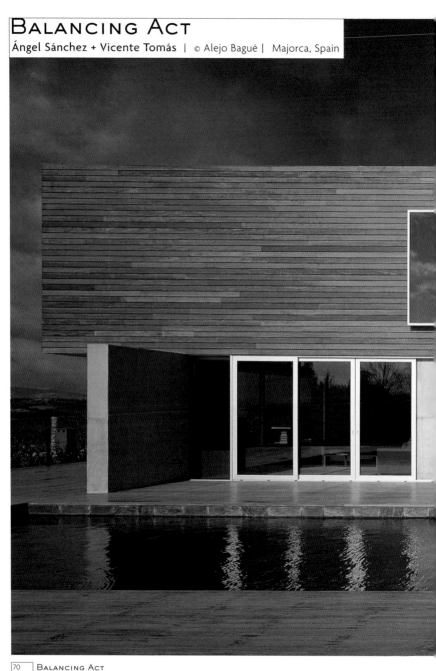

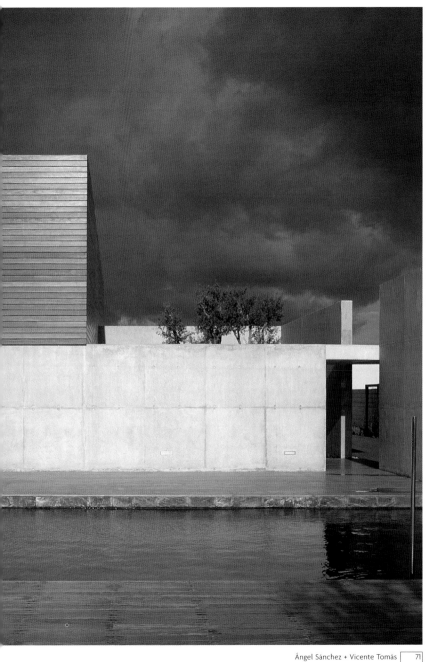

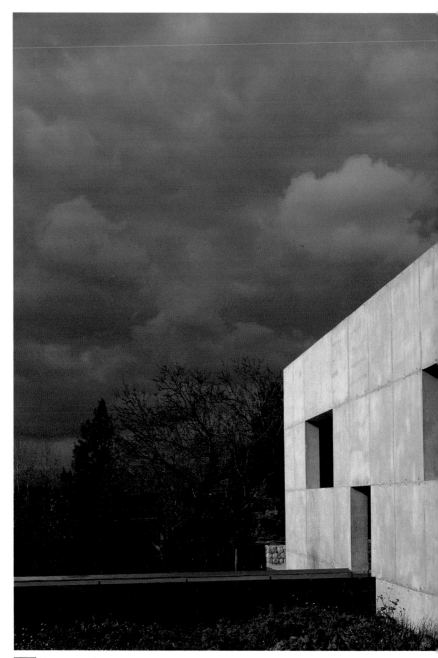

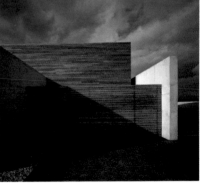

The structure is defined by a concrete base, and a concrete wall wraps around one corner of the plot, containing a large, landscaped patio.

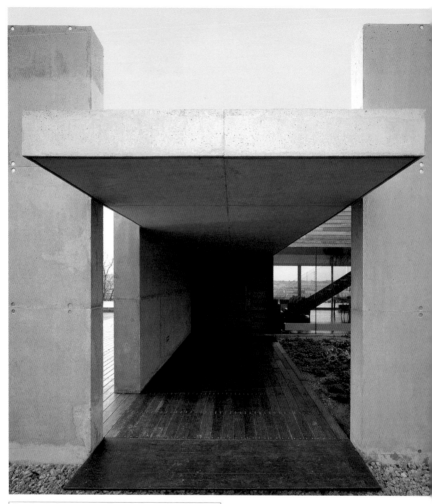

Openings in the concrete walls guide the eye through a framed view of the landscape beyond. The project intends to find a balance in architecture inspired by nature.

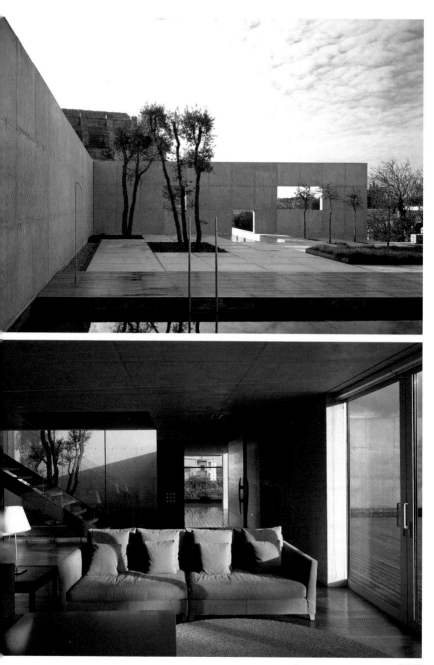

A NAKED HOUSE

Shigeru Ban Architects | © Hiroyuki Hirai | Kawagoe, Japan

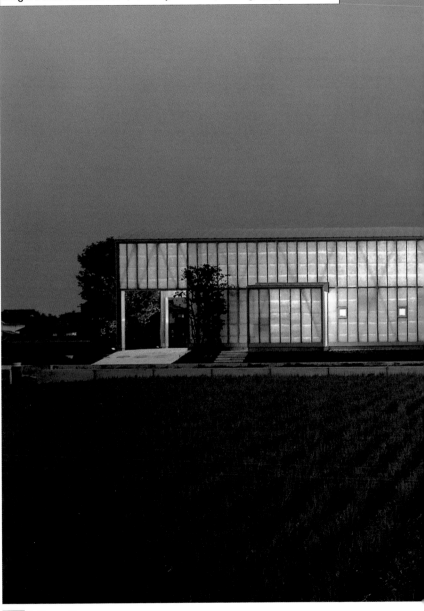

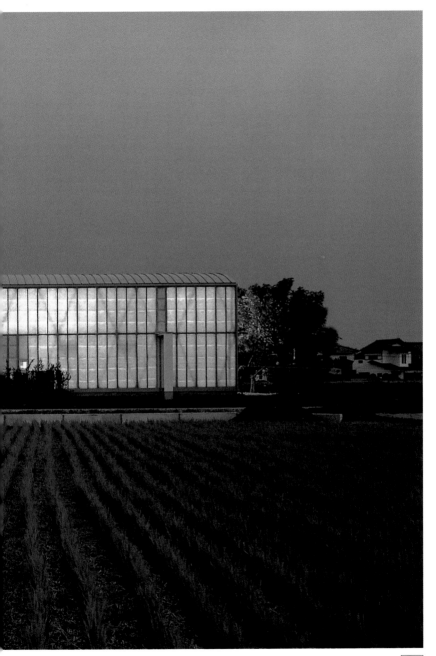

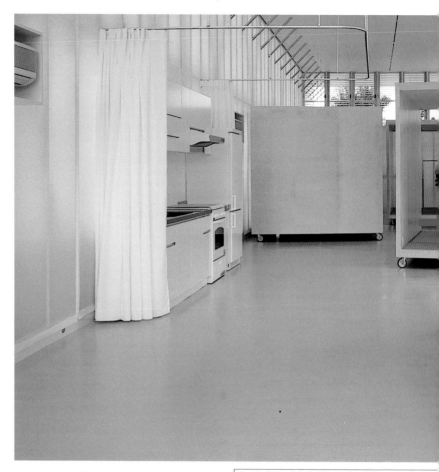

The simplicity of the building and its different distribution solutions gives the containing module a lot of flexibility in terms of living space.

Perspective

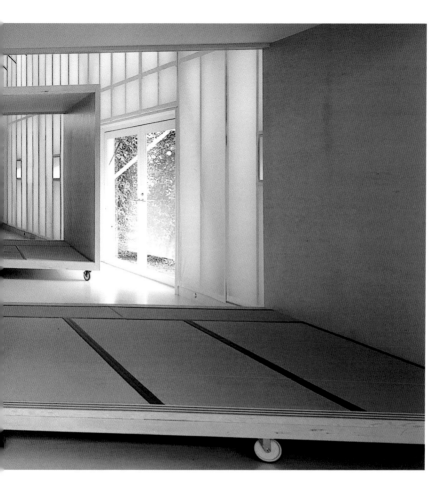

Plan, section, and elevation of the container

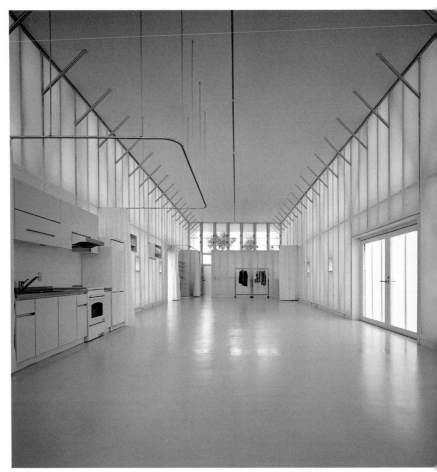

Plan

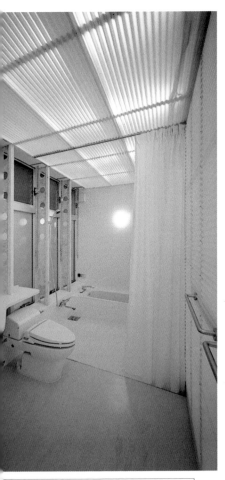

The house is governed by a large space divided into two apartments where the individual rooms are linked via wheeled modules that can be easily moved.

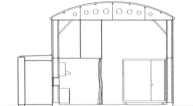

Section

Distribution plans

PANORAMIC HOUSE

Aranda, Pigem & Vilalta | © Eugeni Pons | Olot, Spain

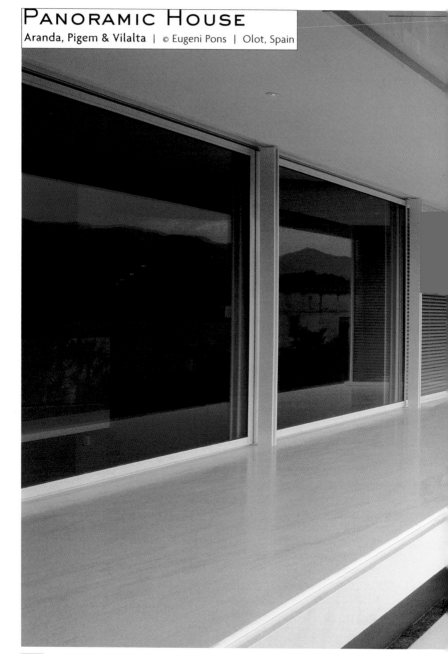

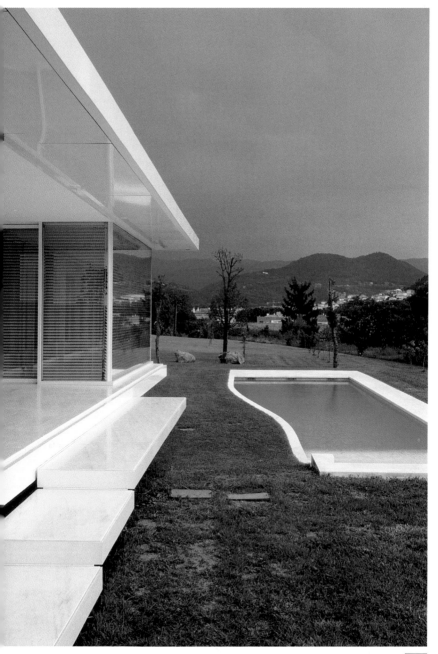

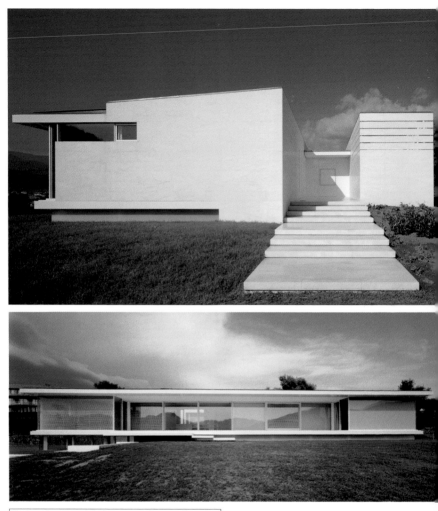

The house's entrance is in the open area between the two volumes that comprise the residence: one contains the service area, and the other the bedrooms and living areas.

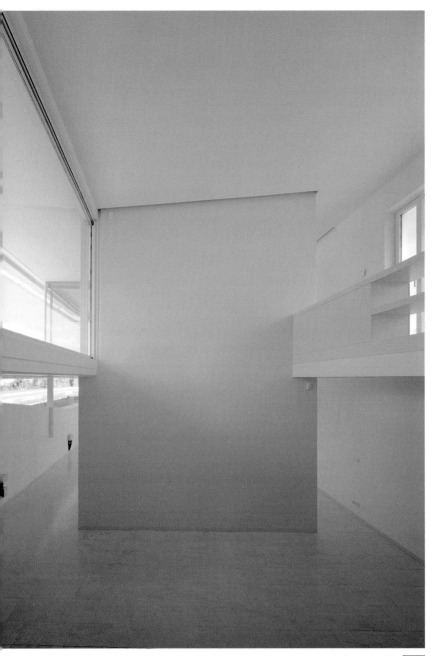

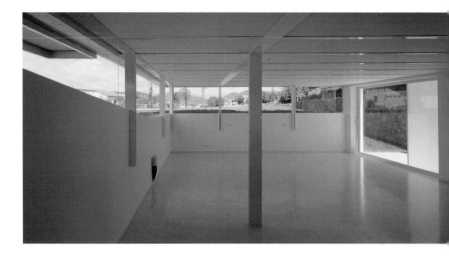

Elevations

Section

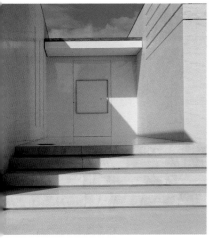

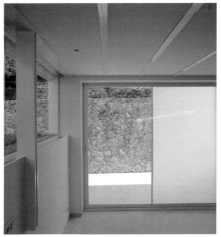

A glass base connects the house with the ground, reinforcing the floating sensation and allowing light to pass into the semibasement.

In and Out

Pool Architektur | © Hertha Hurnaus | Vienna, Austria

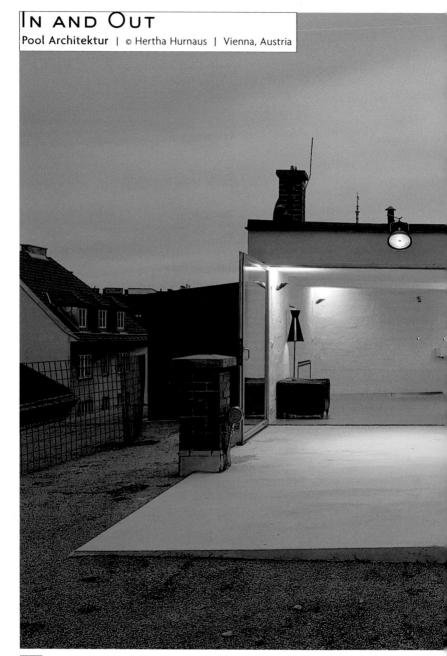

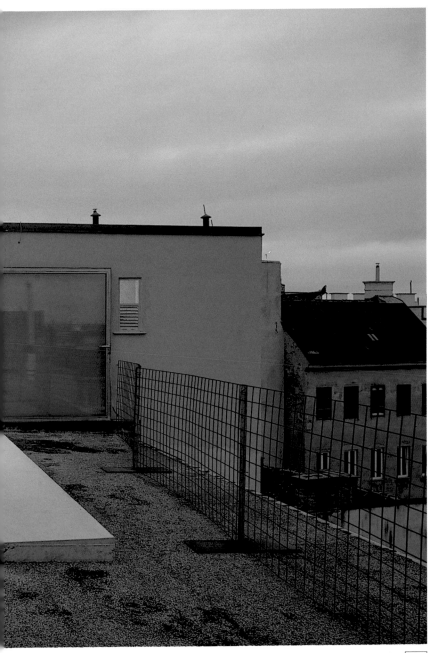

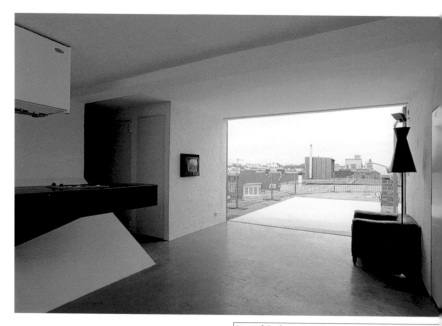

Most of the furniture, including the bed, the dining table and the closet, is mobile and slides into a small metal volume in the wall when not in use.

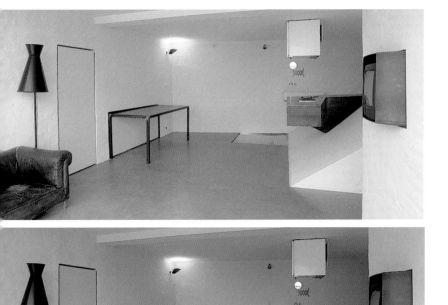

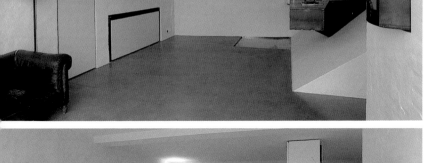

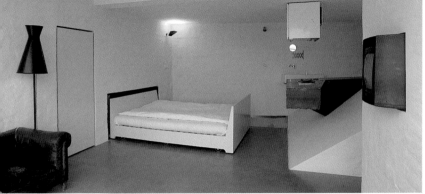

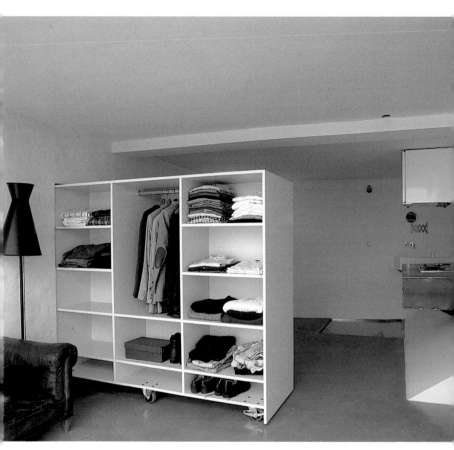

Plan

0 1 2

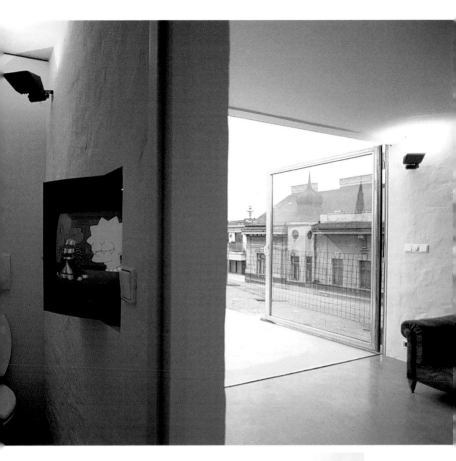

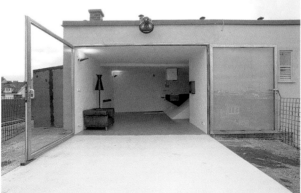

GLASS HOUSE

Dirk Jan Postel | © Jordi Miralles | Almelo, The Netherlands

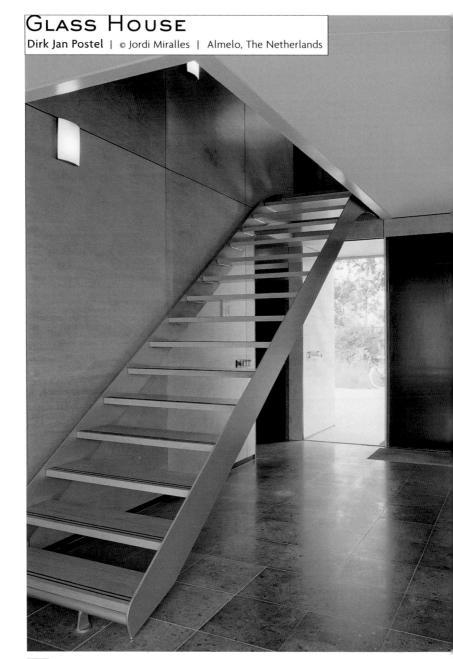

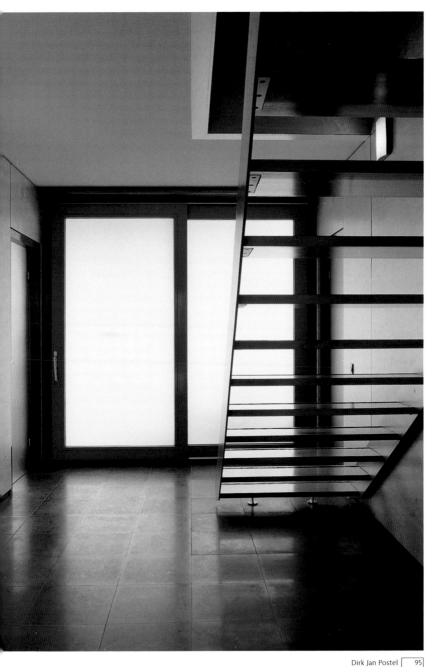

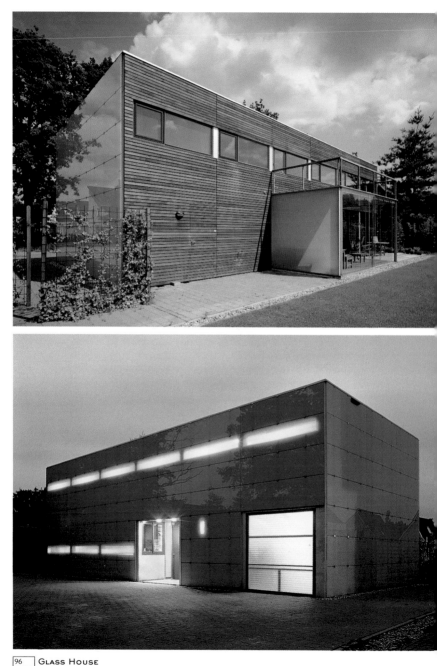

This house is an austere container whose dimensions are based on the repetition of a module the size of a single bedroom. Toward the street and on the side façades, a serigraphed glass plate clads the whole volume.

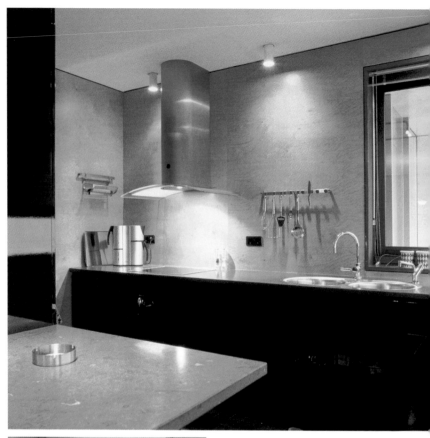

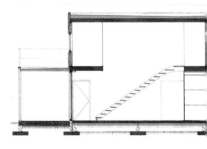

Section

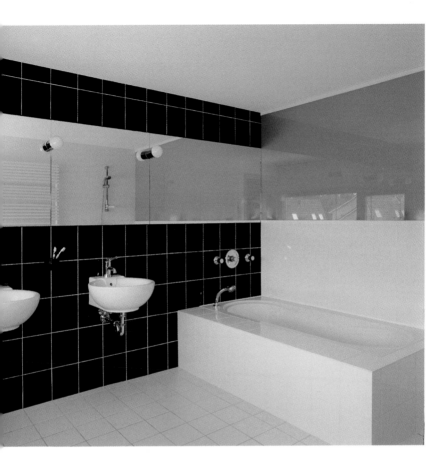

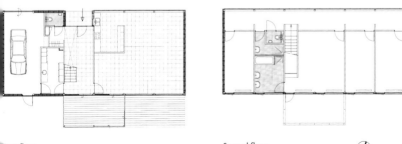

First floor

Second floor

EXTENSION OF A HOUSE

Josep Llobet | © Josep Llobet/Eugeni Pons | Girona, Spain

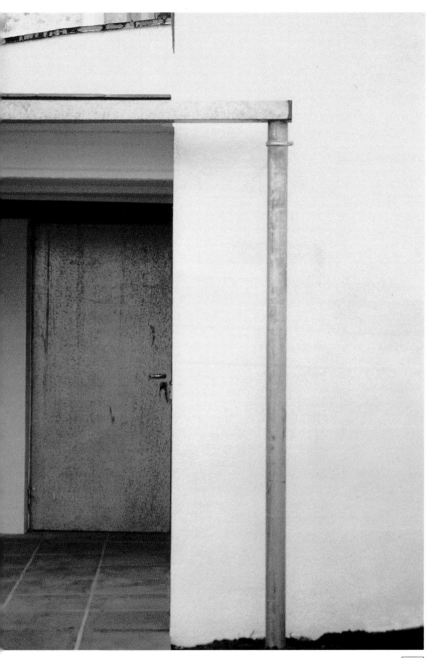

Plan

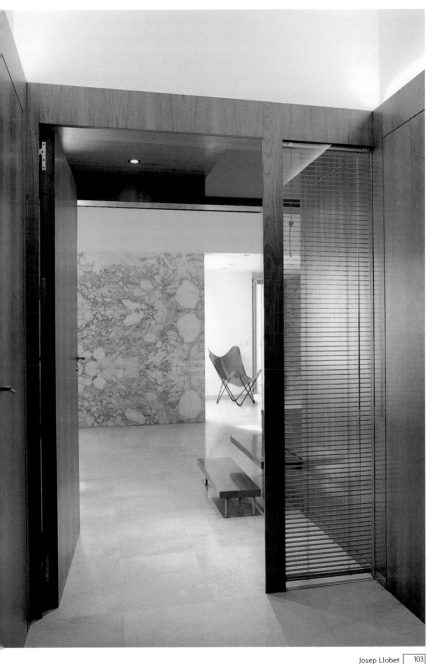

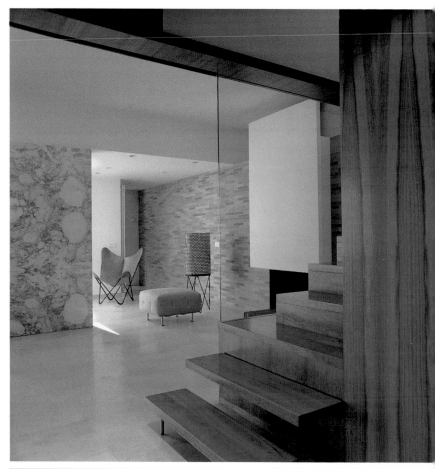

The renovation took the form of displacements of the walls, the creation of a large opening, and the addition of a skylight—to impose order on both the service areas and the living spaces.

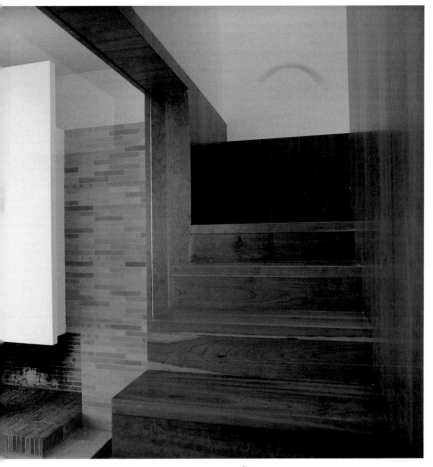

Sections

RESIDENCE IN LA AZOHÍA

José Tarragó | © Eugeni Pons | Murcia, Spain

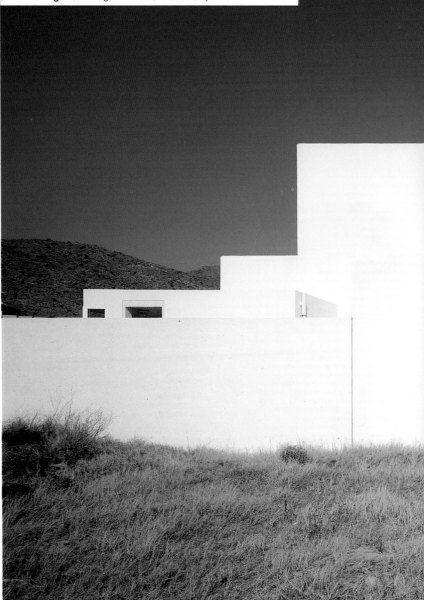

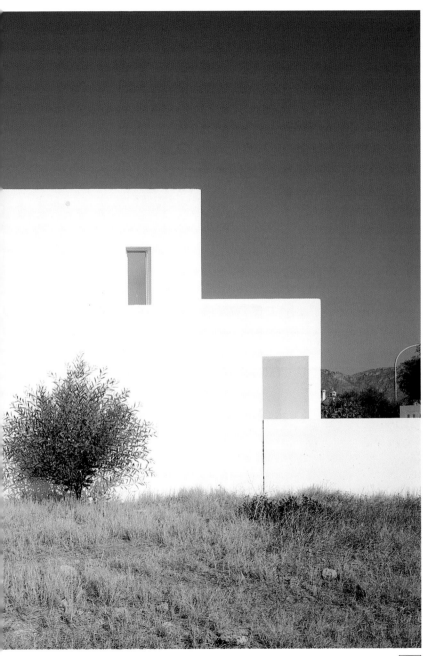

The inner rooms are interrelated and open toward the exterior, and allow no outside examination. The patios are conceived in the same way; they are enclosed by walls that isolate them from the immediate landscape.

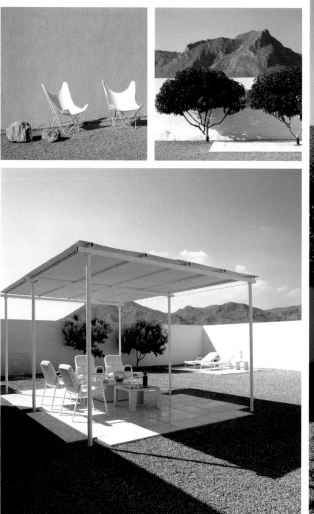

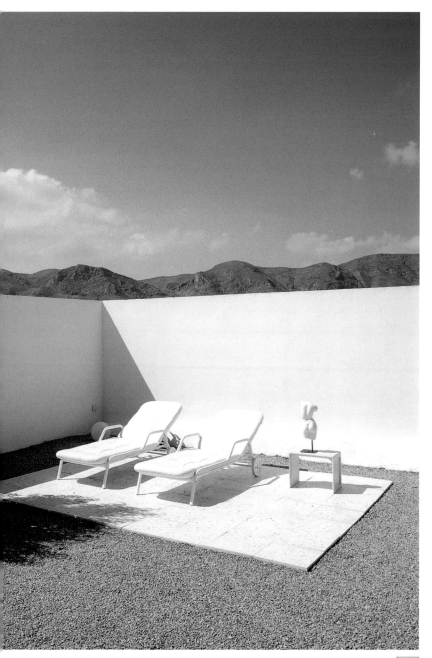

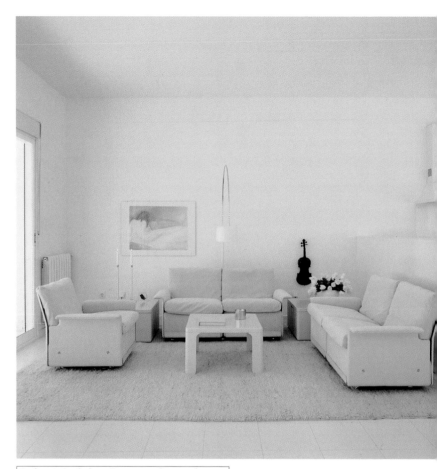

On the exterior, the house incorporates elements of traditional architecture that protect against the inclement weather: thick walls provide thermal insulation, the walls are whitewashed to reflect the sun's rays, and openings are on the north side.

AI WEI WEI'S HOUSE

Ai Wei Wei | © Satoshi Asakawa | Beijing, China

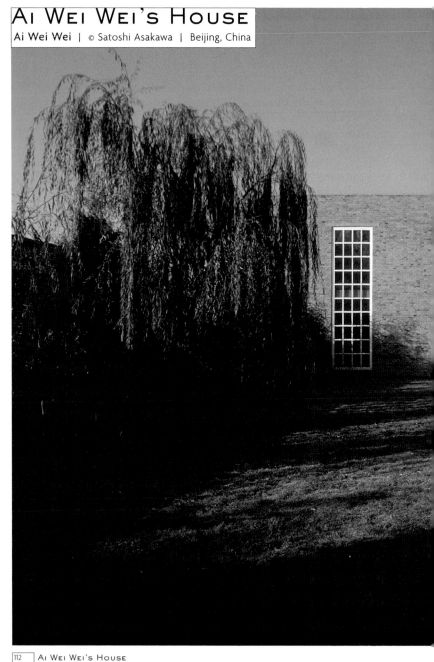

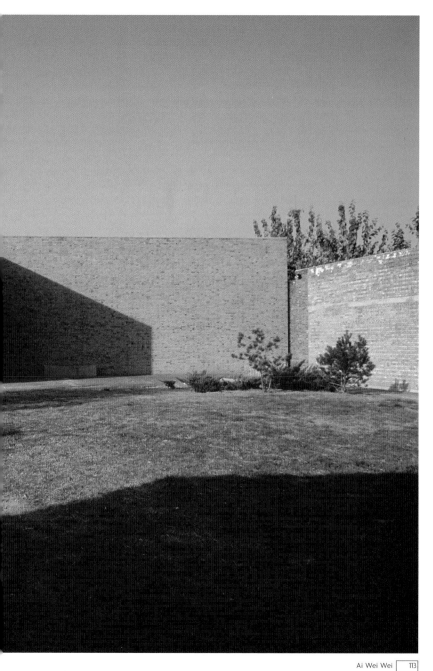

The project is dominated by the two stories that make up the artist's studio, set at right angles to the living section. This windowless studio only receives daylight from above, via two narrow skylights.

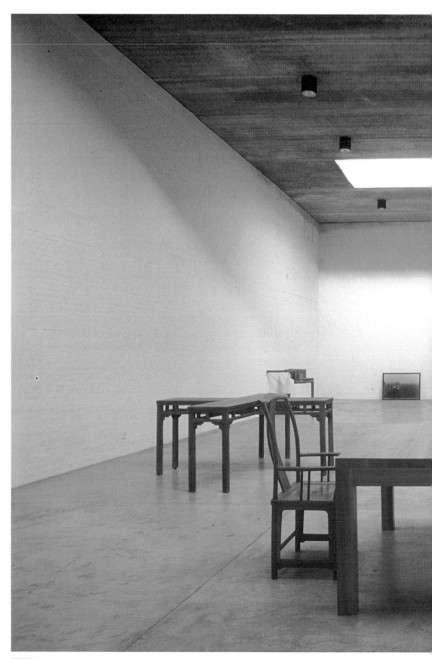

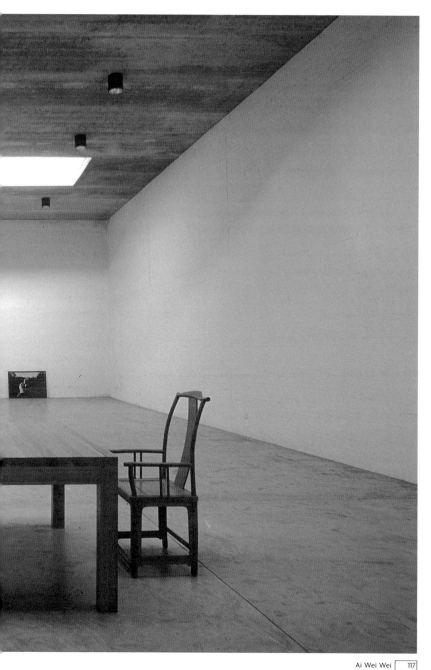

Country House

Picado-De Blas-Delgado | © Eugeni Pons | Belvís de Monroy, Spain

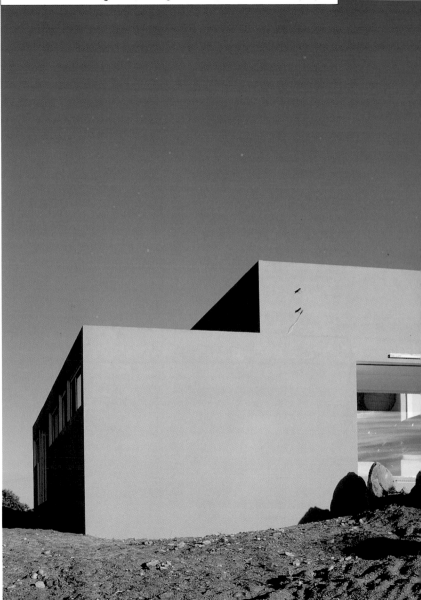

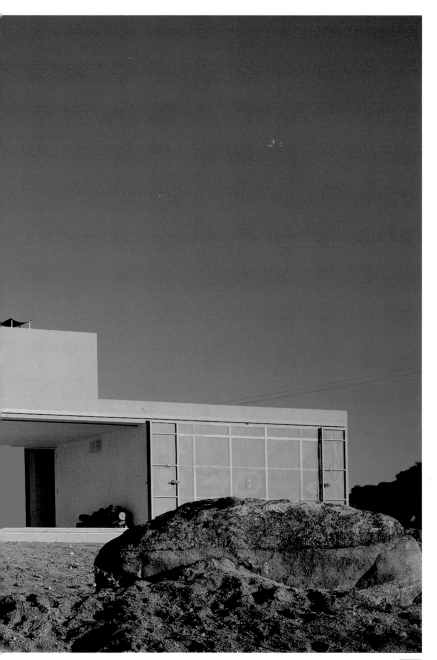

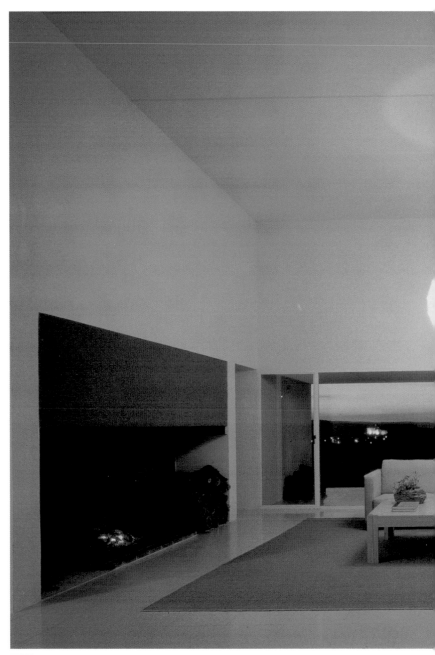

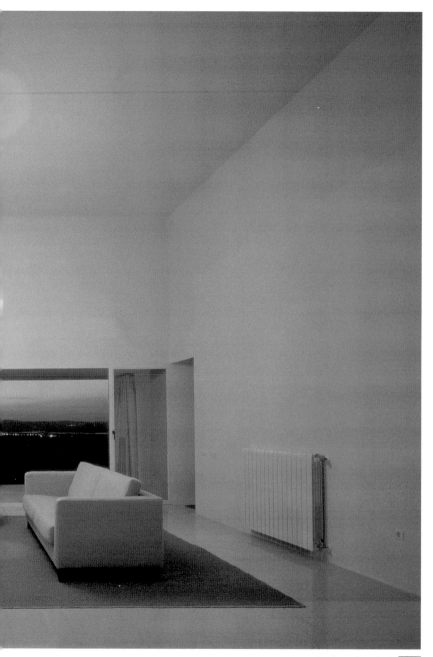

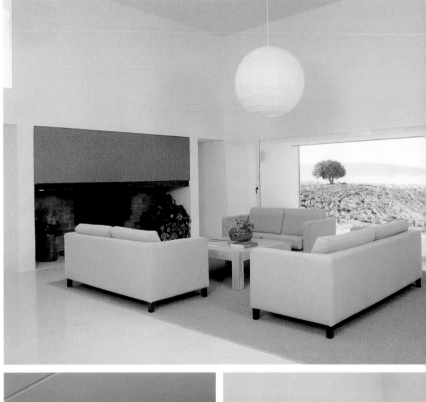

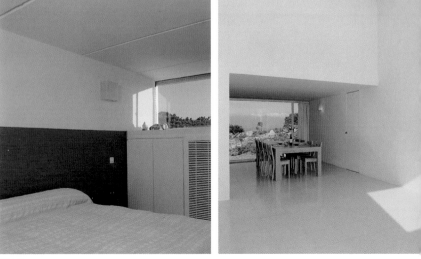

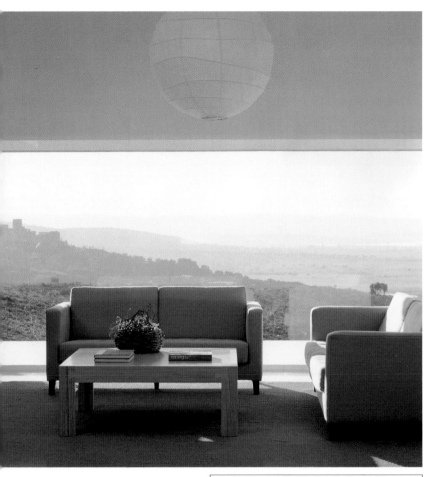

The objective was to highlight the exceptional views of La Vera valley, so it was decided that the main window should face west, where the sun sets behind the medieval castle on a hilltop less than a mile away.

THE HUETE HOUSE

Vicens/Ramos | © Eugeni Pons | Madrid, Spain

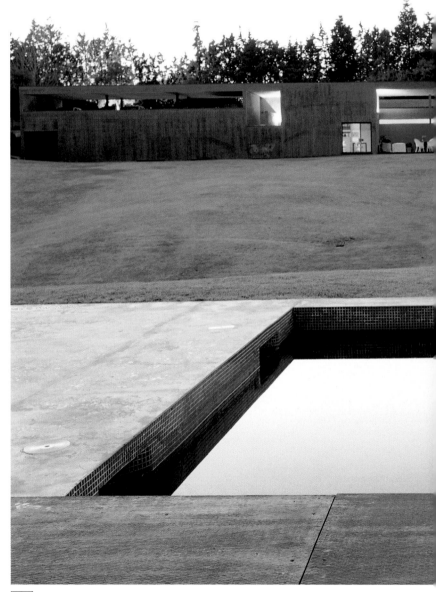

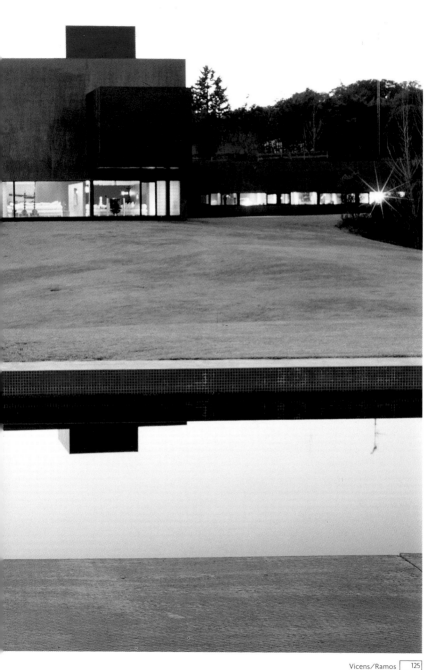

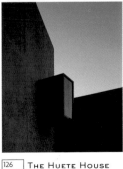

The common areas consist of large spaces divided by partial wooden walls that contain strategic openings that set up specific visual relationships.

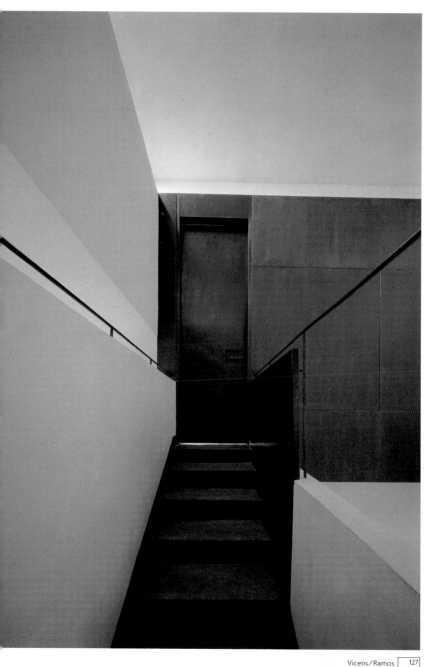

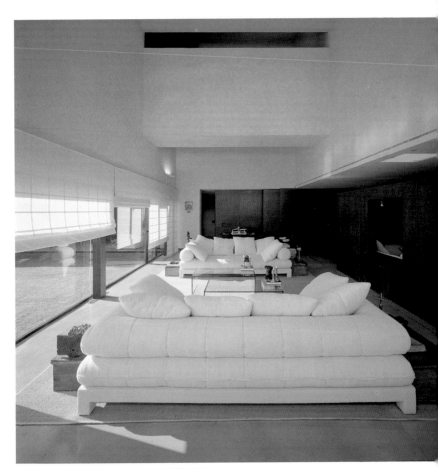

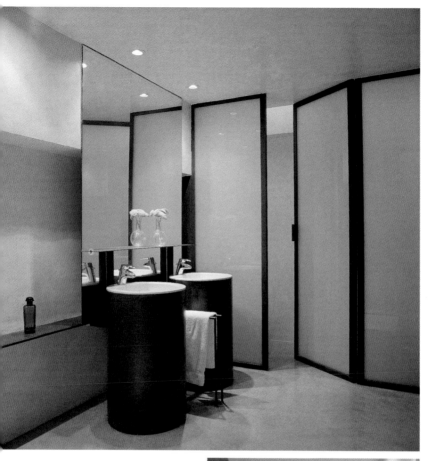

finishes differentiate the roles of the walls and partitions:
solid, stuccoed walls perform a structural function, while
timber partitions endow the ambience with warmth.

THE SHARED HOUSE

Kanika R'kul | © Satoshi Asakawa | Bangkok, Thailand

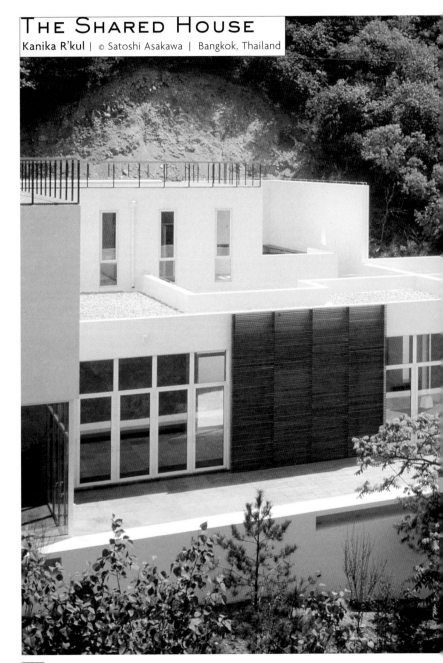

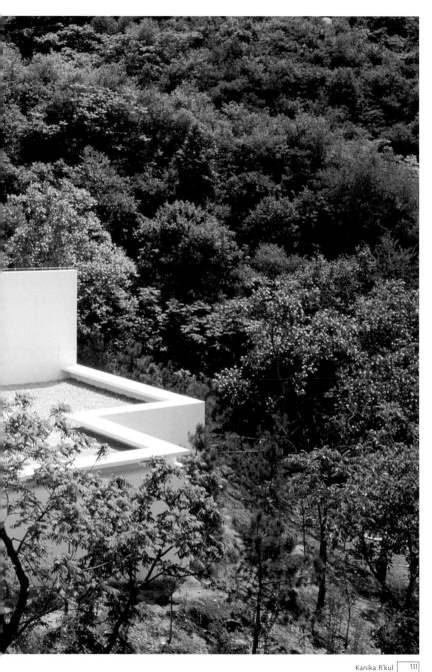

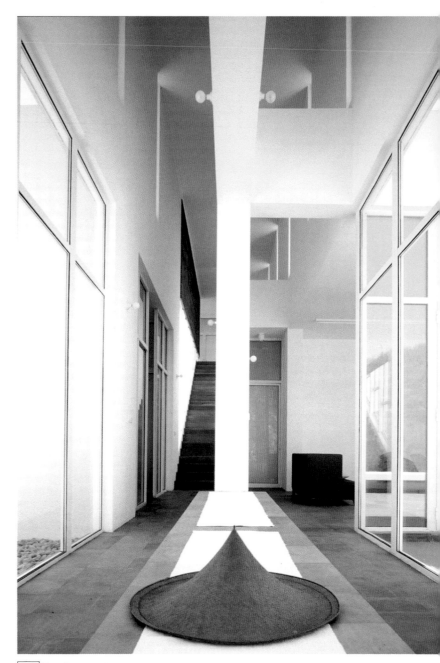

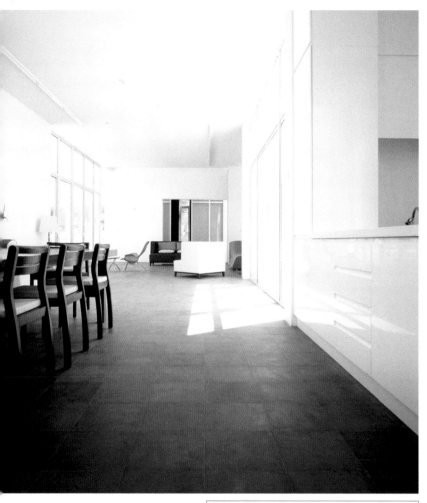

The house is approached as sequences of spaces that are not intended to be understood at first sight. Each space offers an encounter between the man-made and the natural.

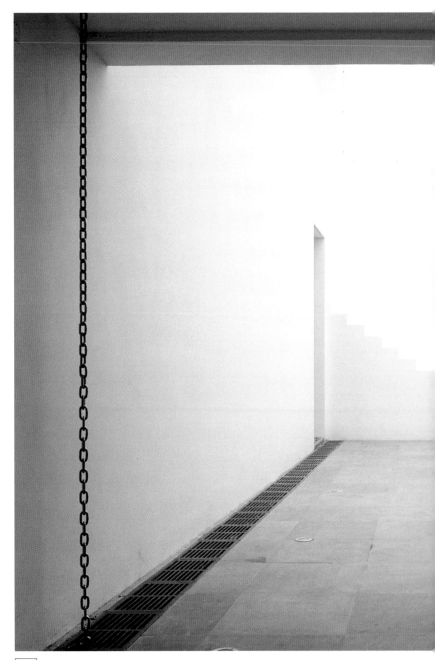

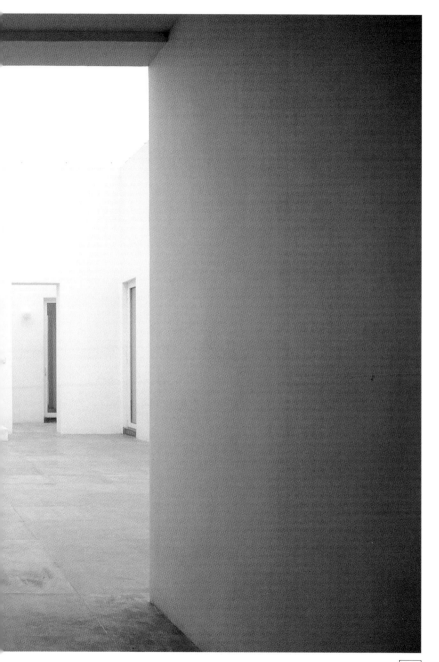

HOUSE IN ONTINYENT

Ramon Esteve | © Pere Planells | Valencia, Spain

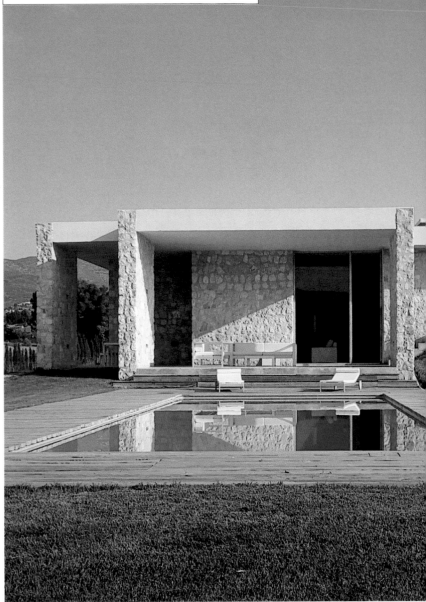

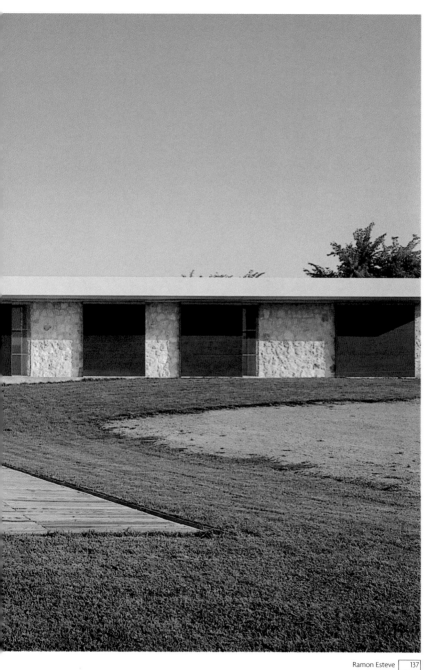

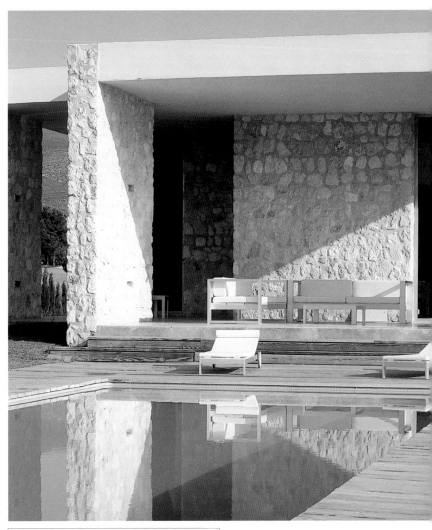

The architect used the limitations of a building with resistant rubble walls as the unifying theme on which the project is based.

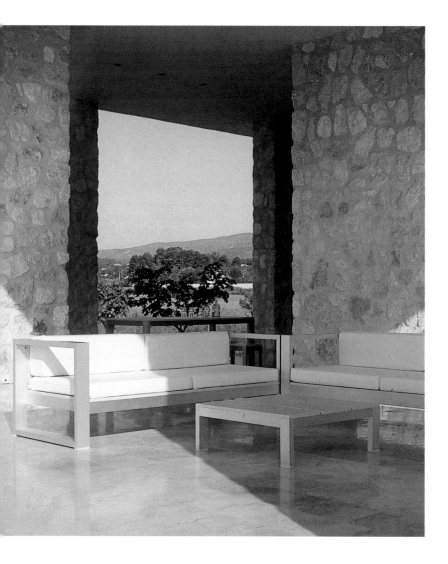

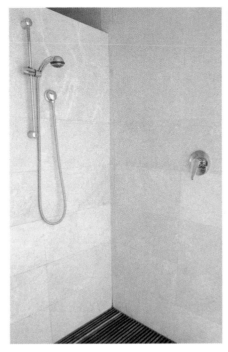

The simplicity of the exterior is also used in the interiors, where an intense chromatic contrast is generated between whitewashed walls and iroko wood finished in black.

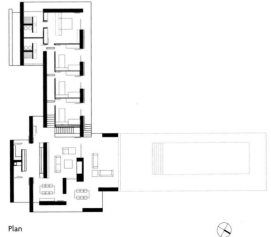

Plan

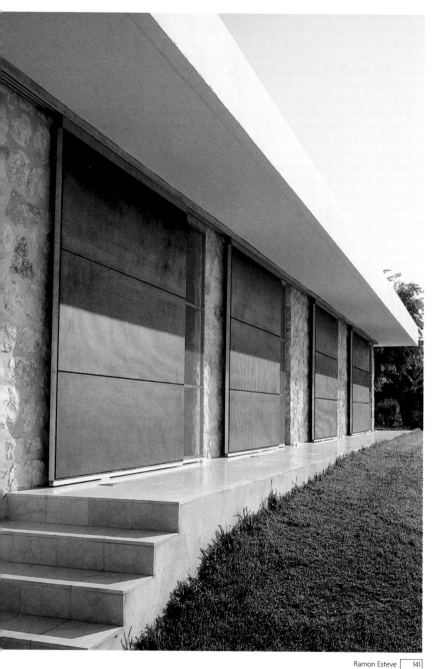

Minimalist Apartment

John Pawson | © Richard Glover | London, UK

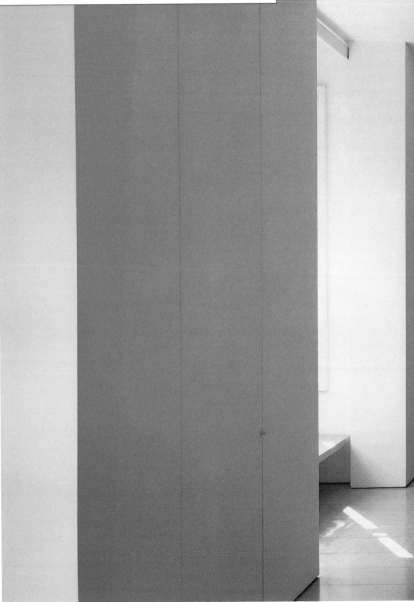

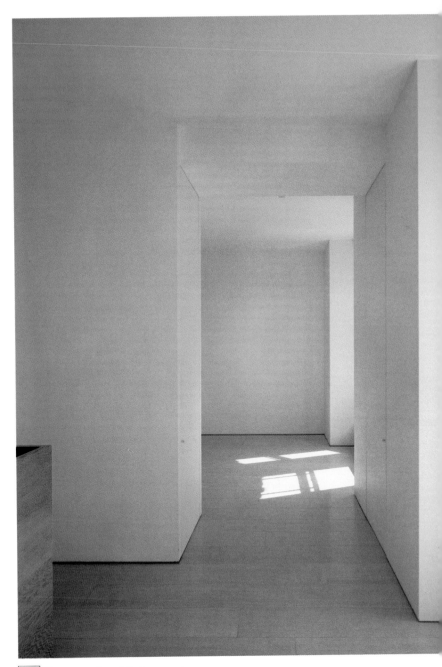

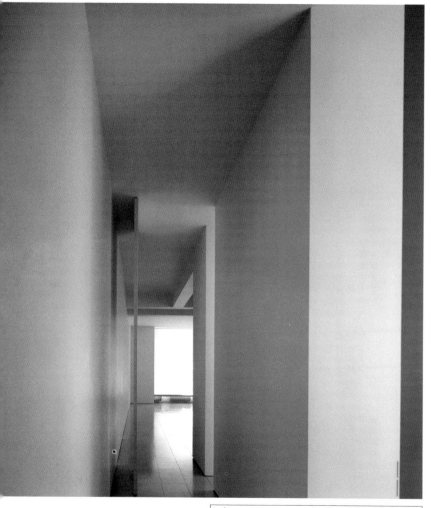

In this project, a succession of monumental walls provides a layout for the apartment that demarcates the smaller, private rooms. The sober texture of the walls and the bone-colored hues provide a solemn, yet warm, finish.

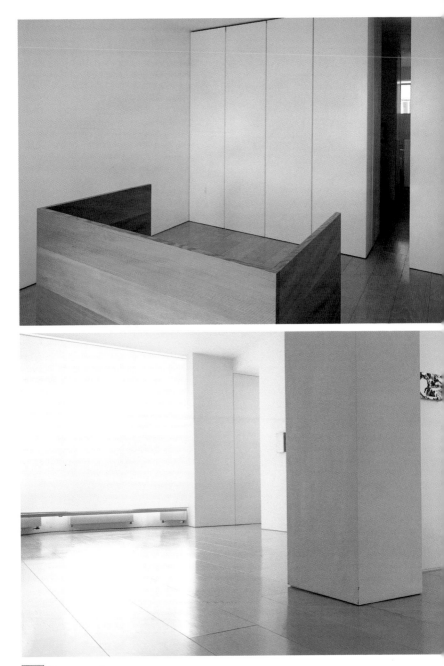

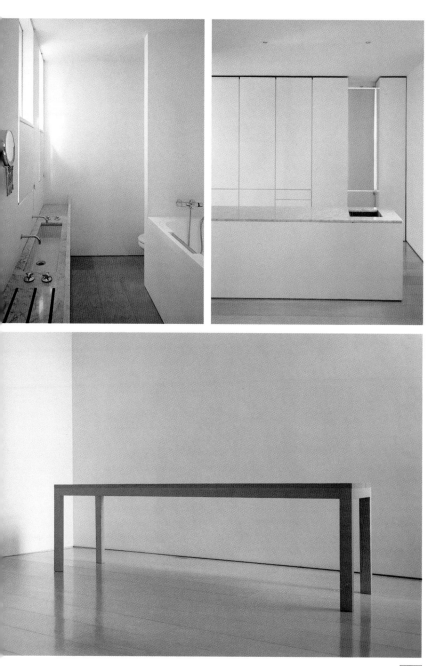

WHITE APARTMENT

Frank Lupo & Daniel Rowen | © Michael Moran | New York City, US

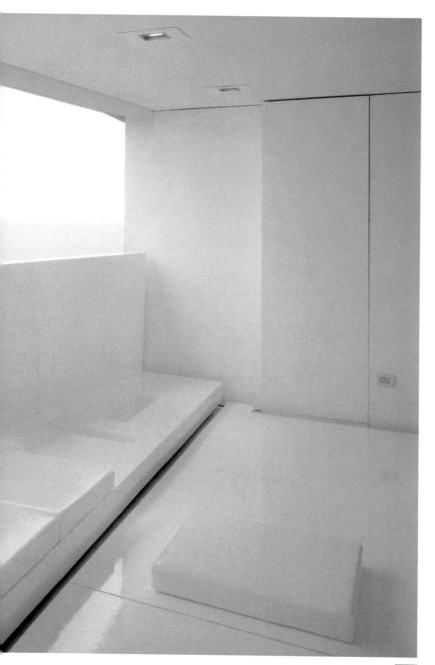

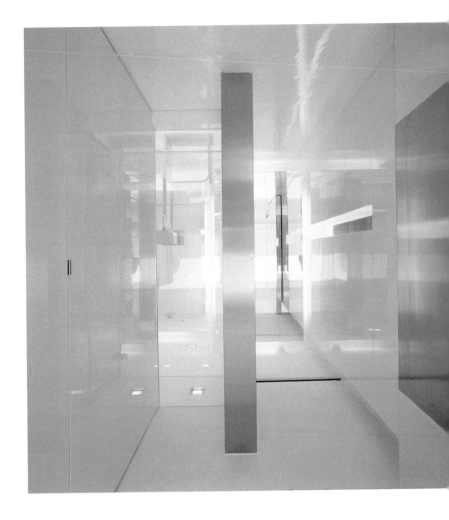

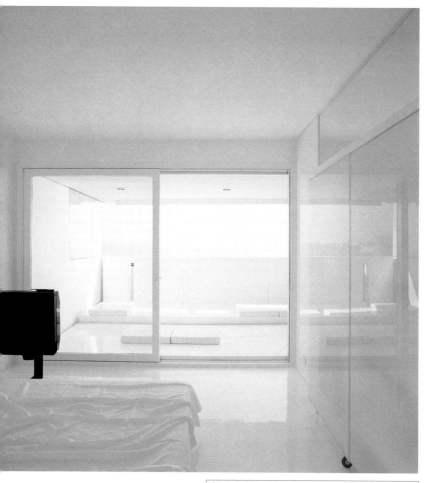

This project joined two traditional apartments located on Park Avenue. The new interior space communicates the idea of abstraction, reinforced by the elimination of several windows and the use of translucent screens.

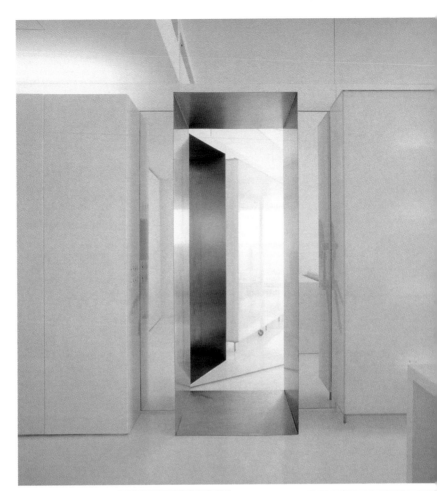

The partition walls are slightly separated from the floors, as not to touch them. This technique gives the sensation that the partition walls are not fixed and able to move.

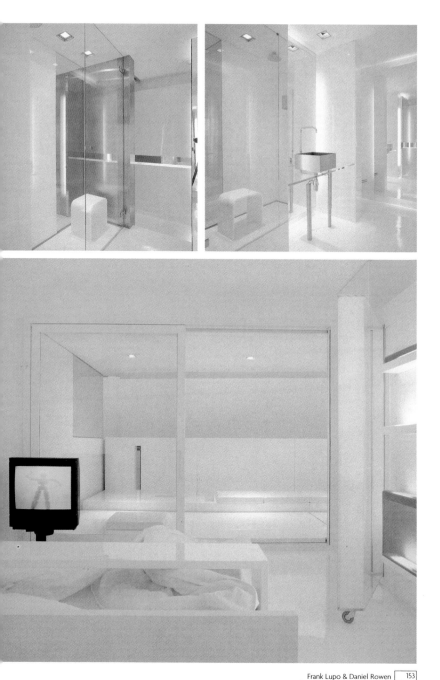

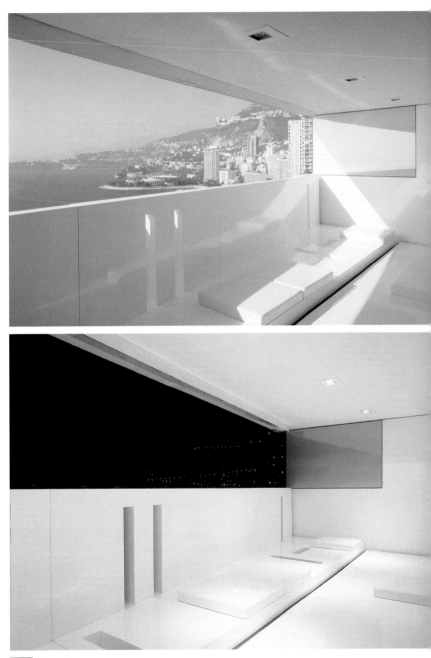

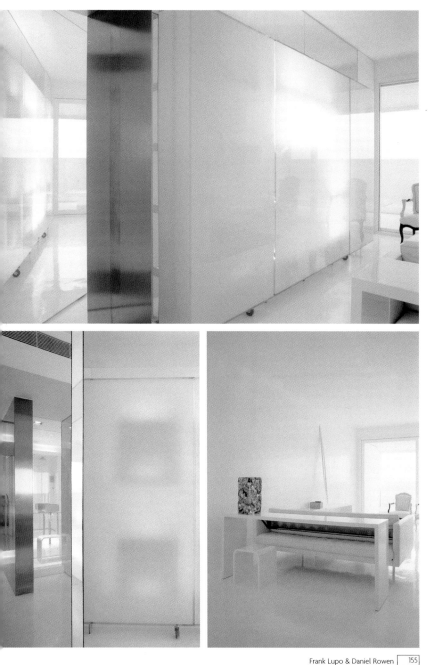

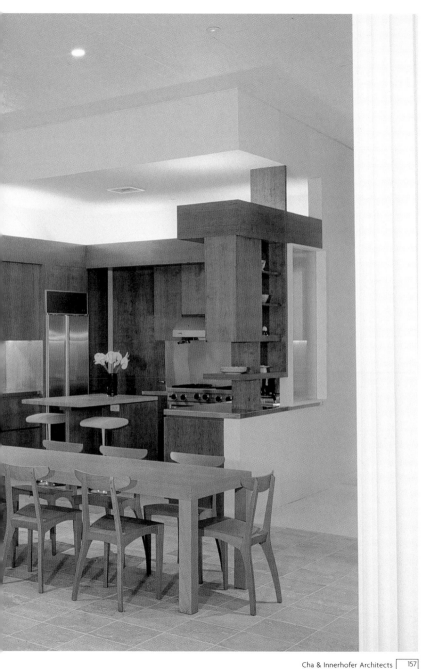

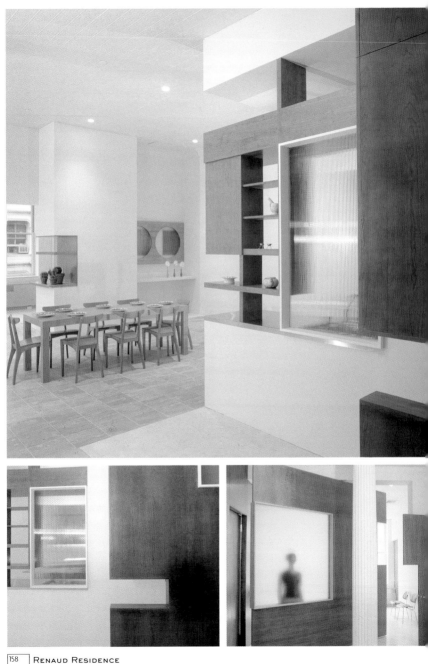

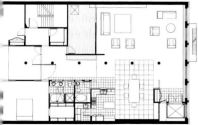

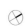

The wall separating the kitchen from the hall is made up of a shelf and an etched glass window. These elements, see-through and penetrable by light rays, play a unique role in the perception of the spaces.

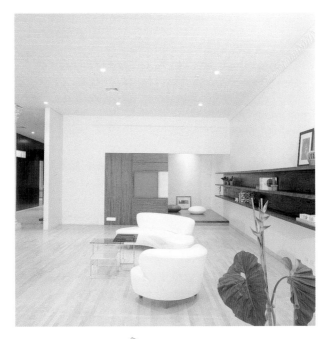

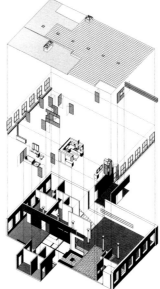

Perspective

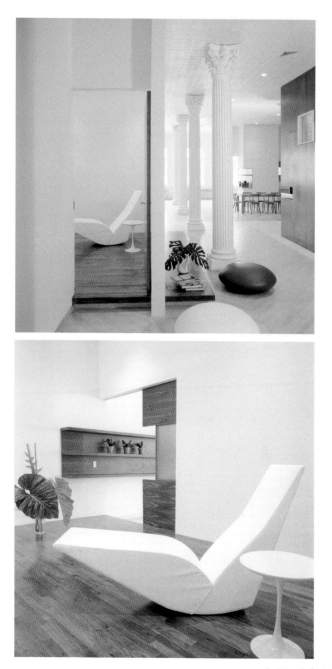

B House

Claudio Silvestrin Architects | © Claudio Silvestrin Architects | Provence, France

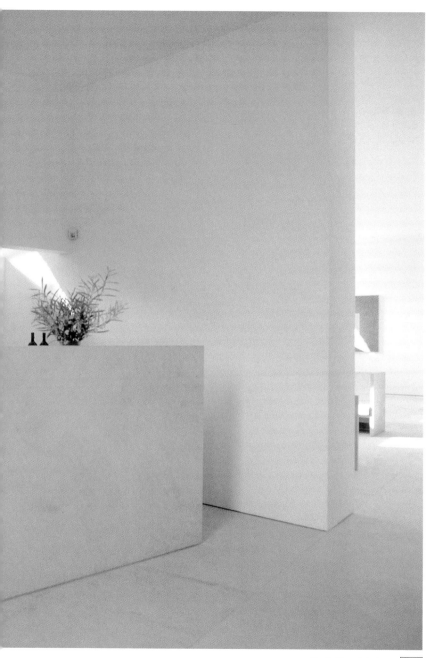

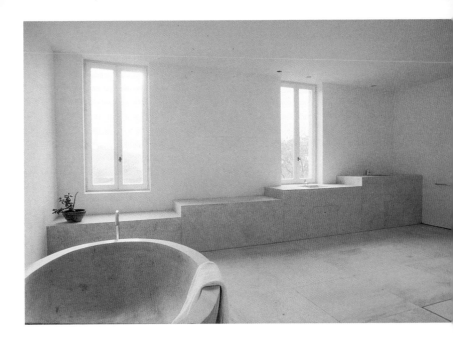

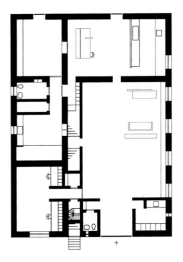

First floor

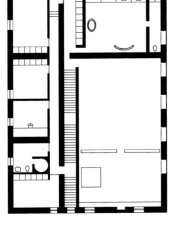

Second floor

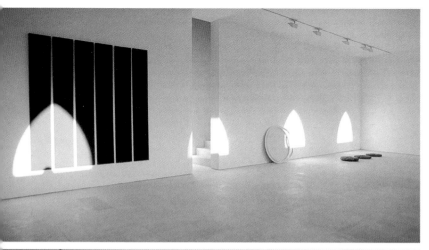

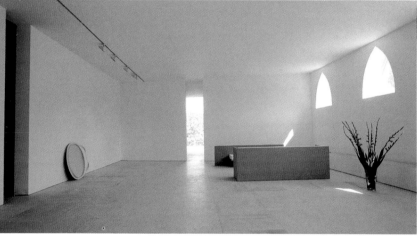

The principal material is stone, used for most of the furniture and for the flooring of the entire house. The walls are plaster, painted white.

HOUSE 2/5

Shigeru Ban Architects | © Hiroyuki Hirai | Nishinomiya, Japan

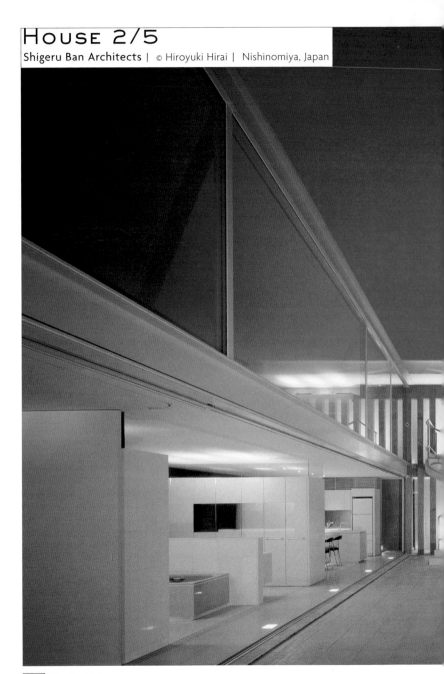

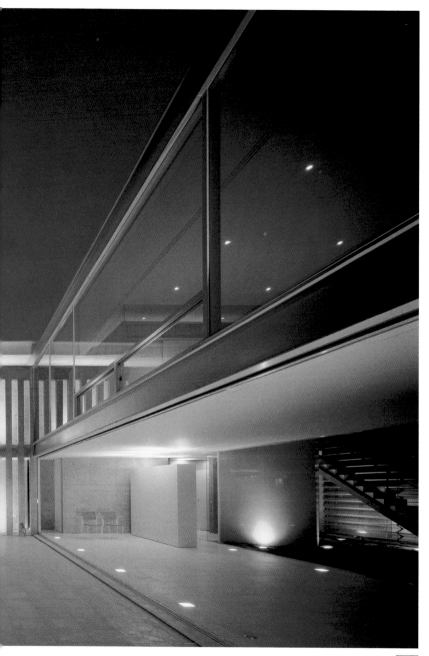

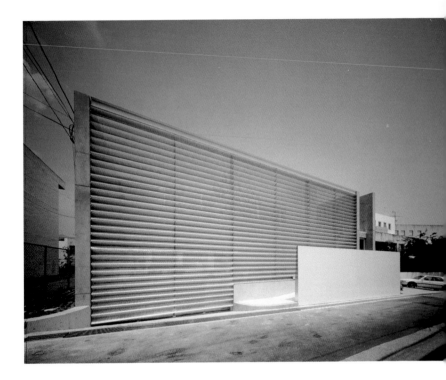

First floor

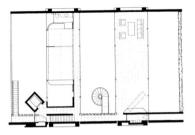

Second floor

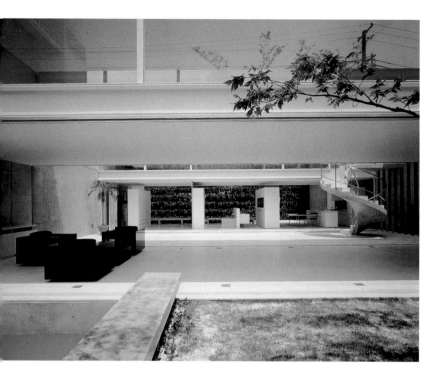

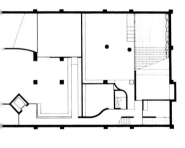

third floor

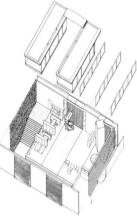

Perspective

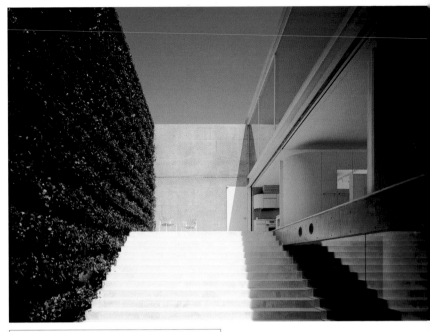

On the east-west axis, the concrete façades are two stories high; on the north face, thick PVC netting secludes the residence; and on the street front, a perforated, corrugated aluminum screen provides a view of the garage ramp.

Section

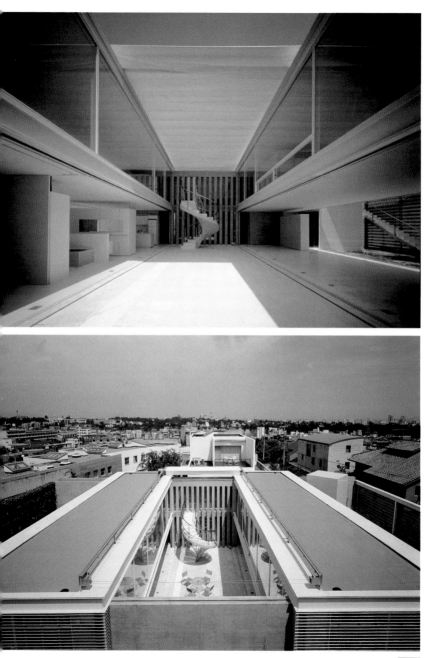

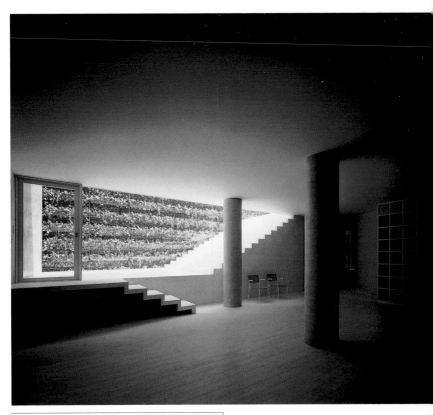

Shigeru Ban integrated the patios with the interiors through
sliding glass doors that open to form an enormous common
area with a dense hedge that serves as the back wall.

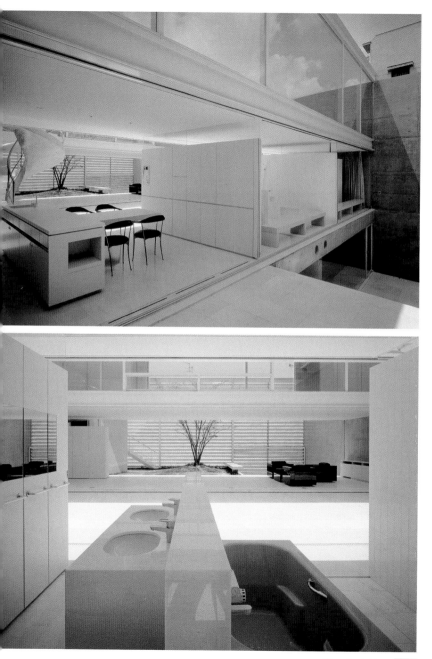

FLEX HOUSE

Archikubik | © Eugeni Pons | Barcelona, Spain

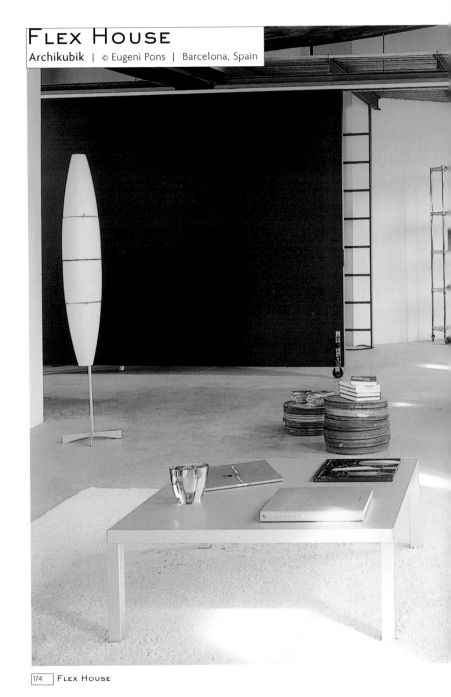

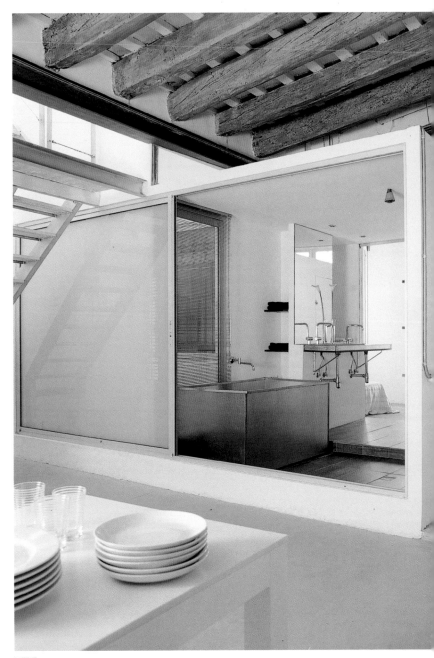

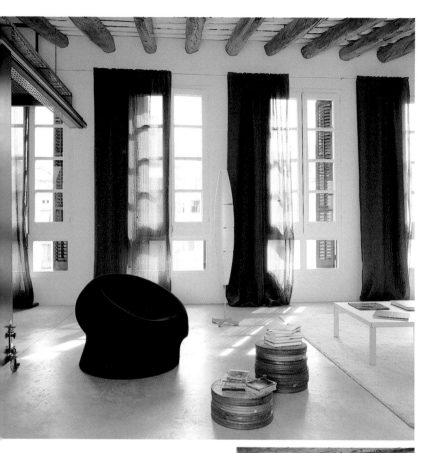

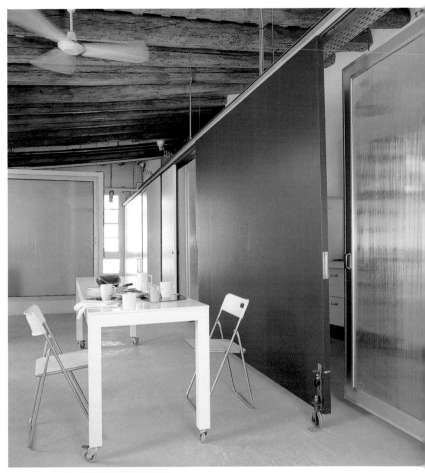

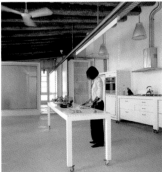

Although all of the furniture is versatile and easy to move, the interior decorators emphasized the dining room, which easily converts to a practical work area, by placing it close to the large windows—the area with the most light.

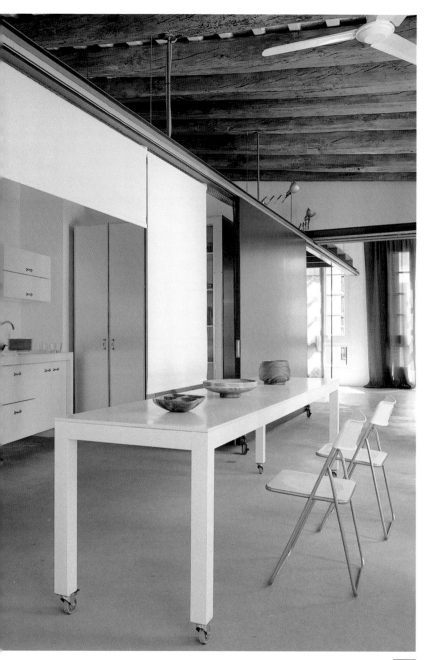

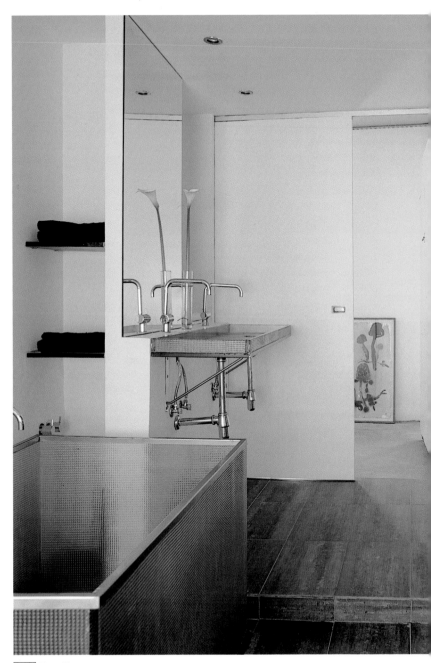

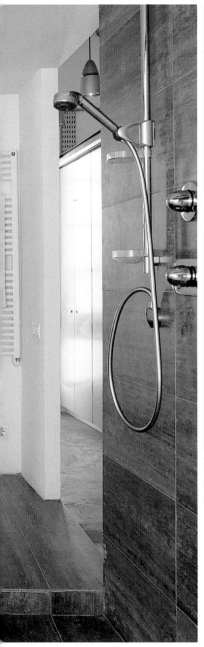

The living room area and the bedroom are separated by a large cube that contains the bath. Sliding doors of translucent glass let the light in, while respecting privacy.

TRANSFORMABLE LOFT

Carlo Berarducci | © Roberto Pierucci | Rome, Italy

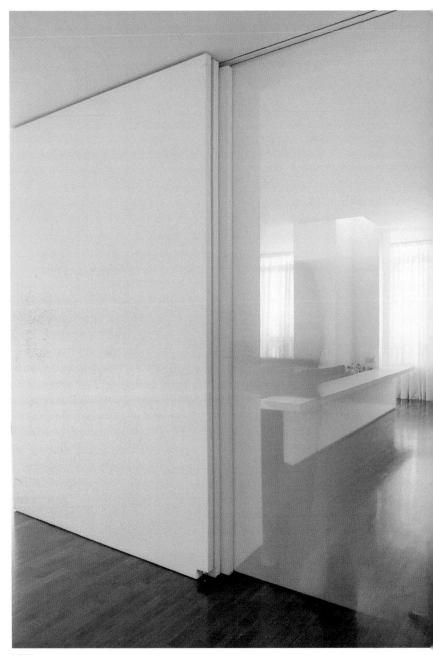

Transformable Loft

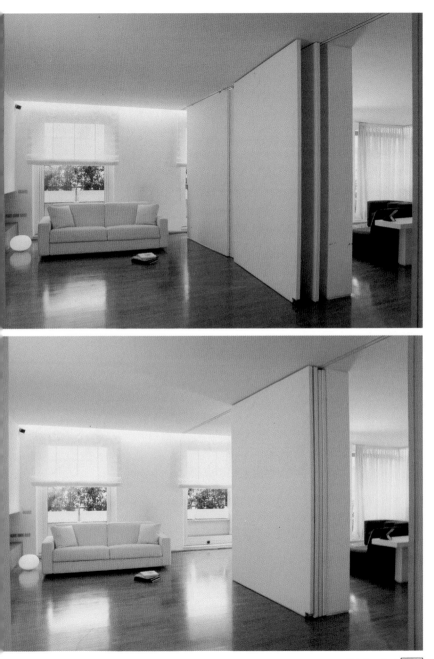

This loft consists of two areas: a large rectangular space flanked by a wall of windows, and another space with glass doors that open onto a private terrace.

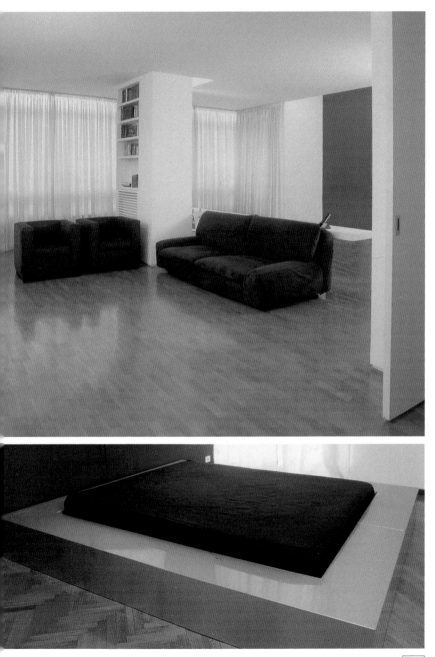

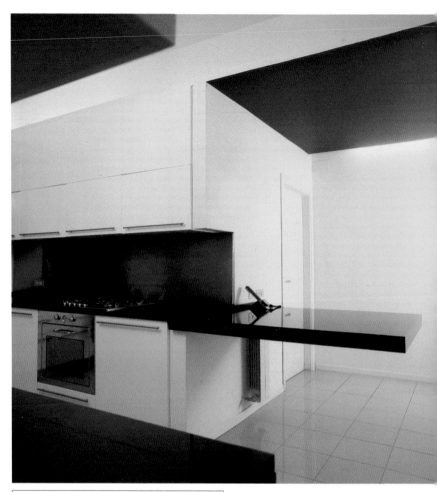

In the kitchen, the black granite countertop extends
beyond the kitchen module to serve as a breakfast table.
In the bathroom, the same intense blue that was used as a
backdrop to the bedroom, covers the floors.

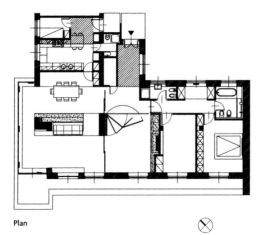

Plan

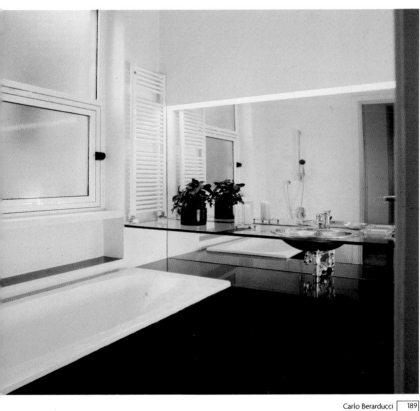

TRIBECA LOFT

Desai/Chia Studio | © Joshua McHugh | New York City, US

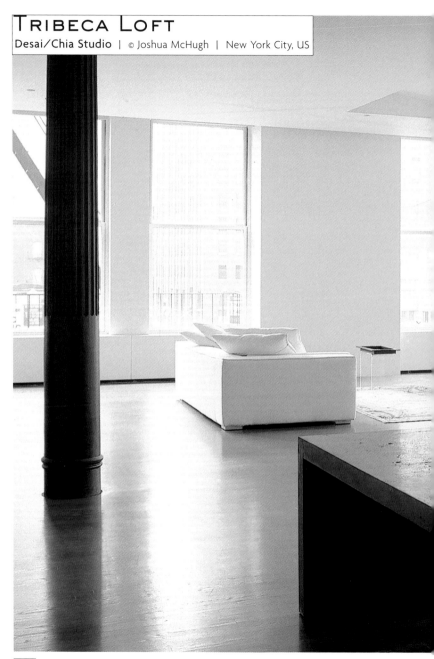

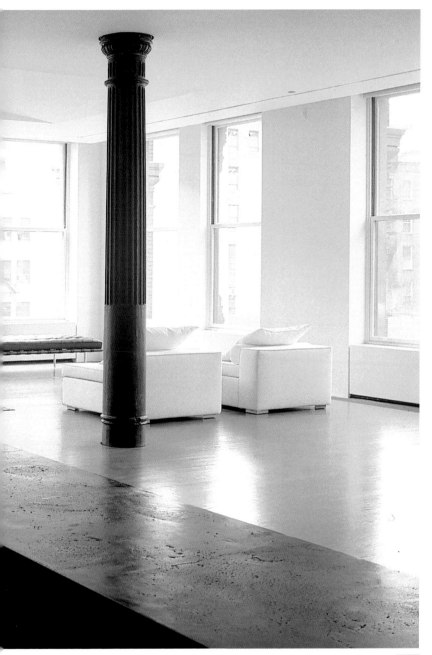

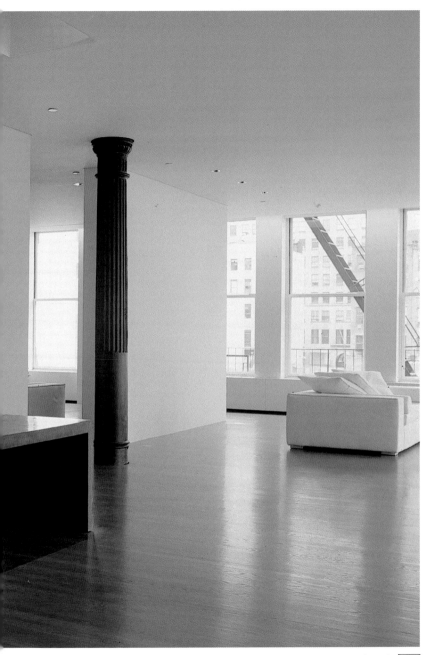

Only the bedroom and bathrooms have doors for privacy, while the remaining spaces—the library, kitchen, living area. and dining area—are screened from each other by carefully deployed partitions.

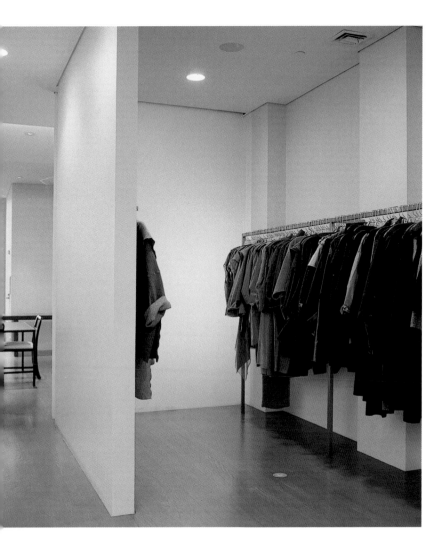

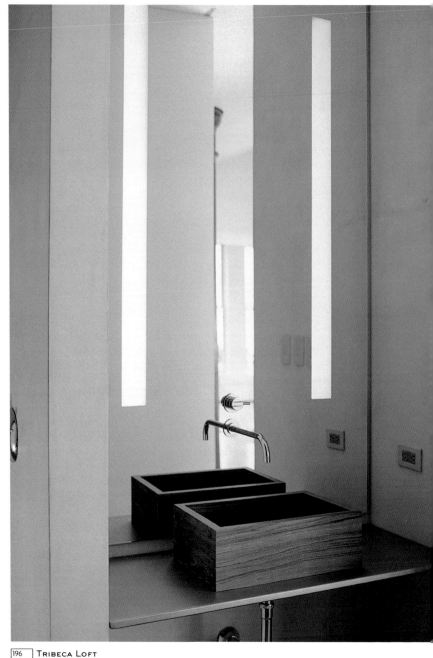

Plan

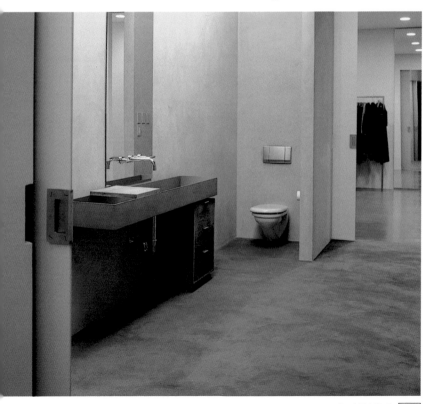

MARNIX WAREHOUSE

Fokkema Architecten | © Christian Richters | Antwerp, Belgium

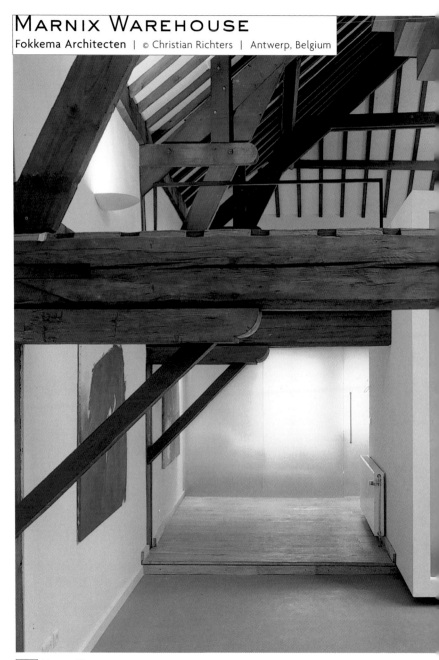

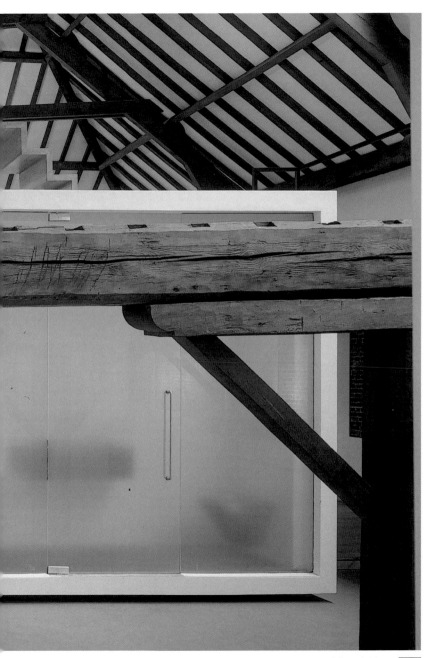

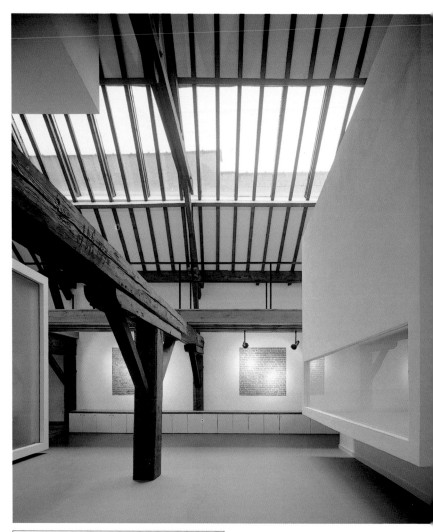

The architects attempted to reduce to a minimum all necessary elements—such as the bathrooms, bedrooms, and laundry room—in order to maximize open space and horizontal and vertical circulation.

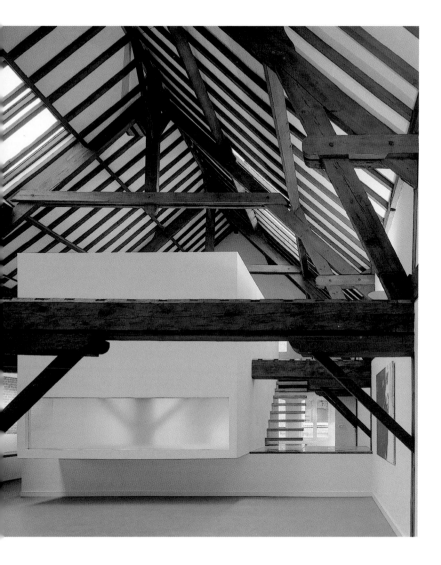

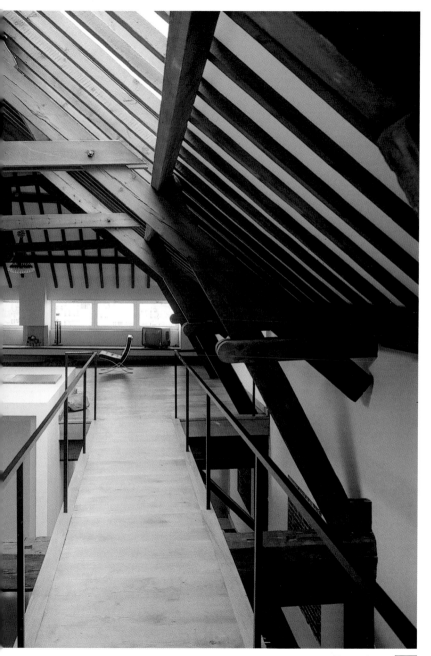

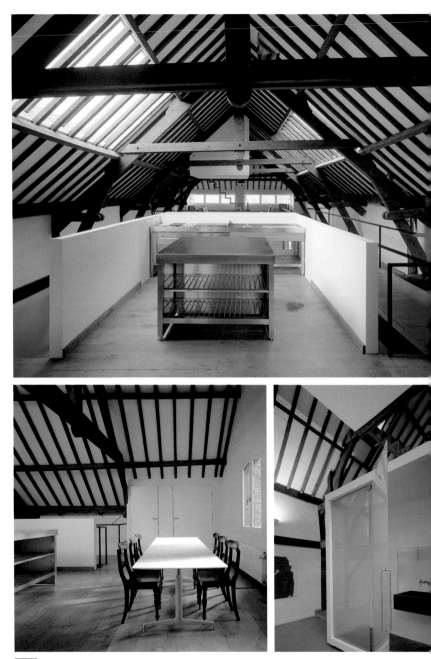

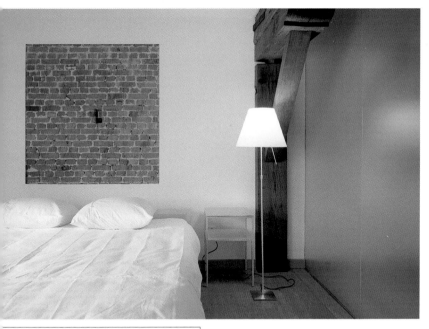

scheme chosen was to be fairly minimalist so that hectic
ily life could not only flourish, but also come to a rest.

Second floor

First floor

LOFT IN AMSTERDAM

Dick van Gameren | © Christian Richters | Amsterdam, The Netherlands

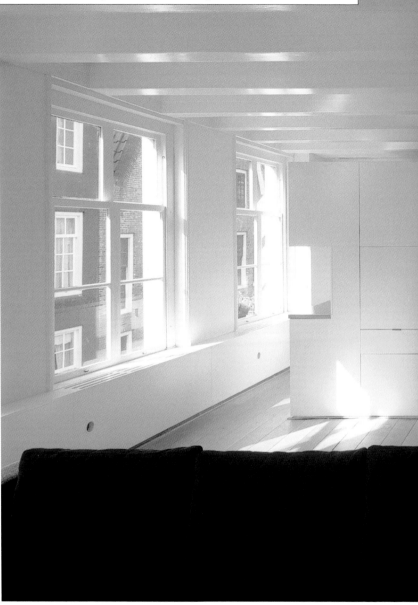

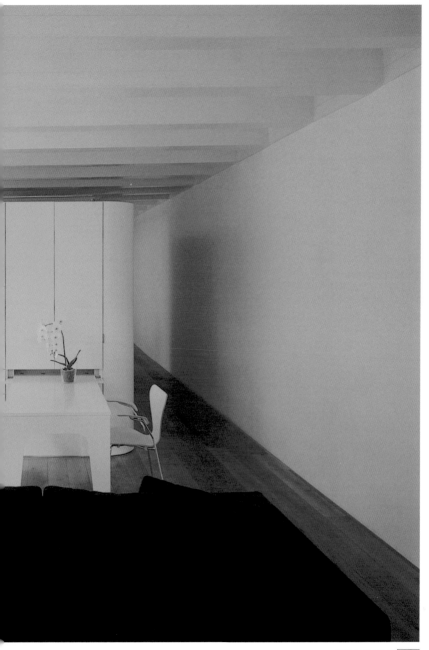

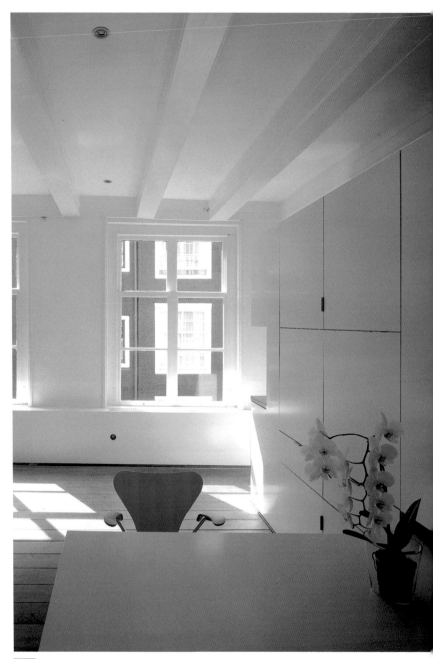

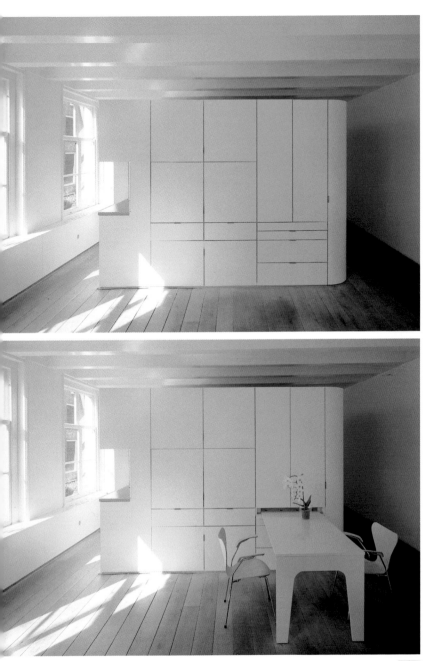

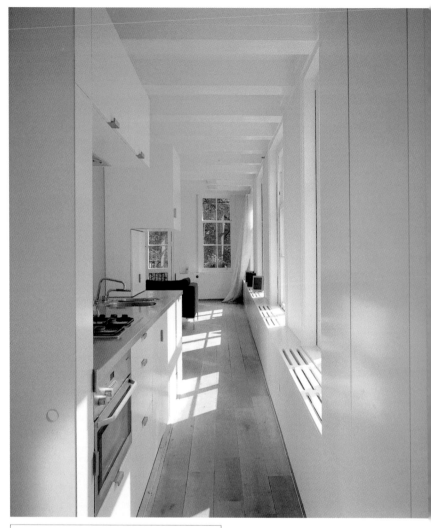

The central unit, whose walls stop short of the ceiling to maintain spatial fluidity, incorporates a seamless series of cupboards and drawers, including one that pulls out into a dining table.

Plan

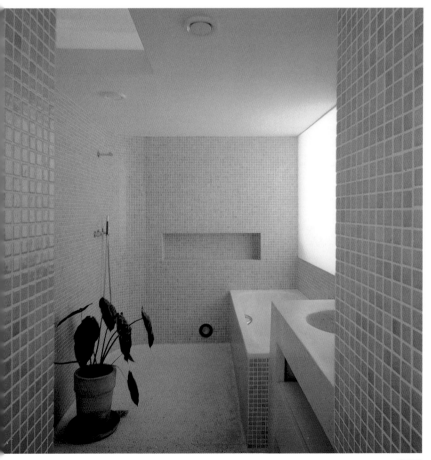

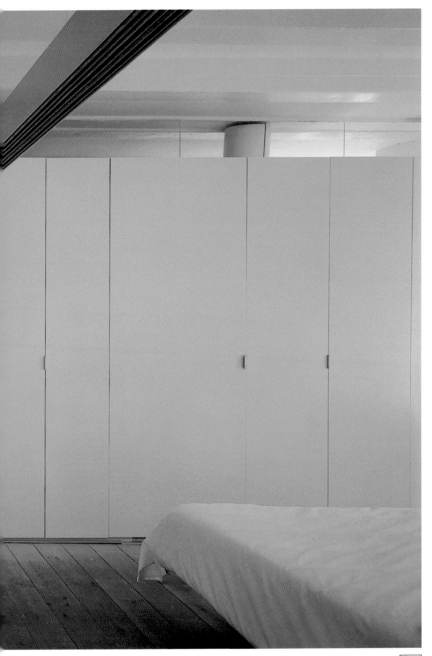

GREENBERG LOFT

Smith-Miller & Hawkinson Architects | © Matteo Piazza | New York City, US

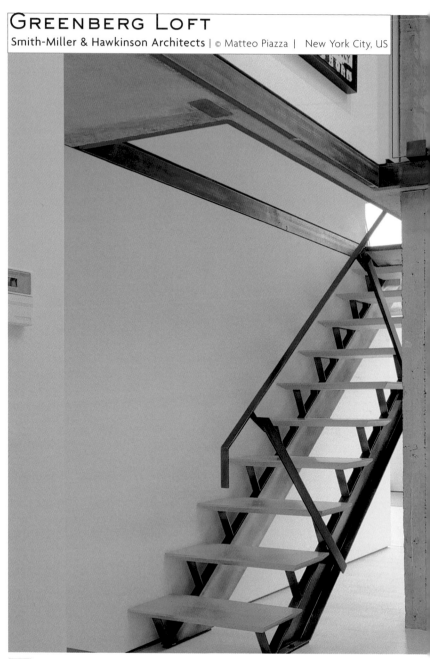

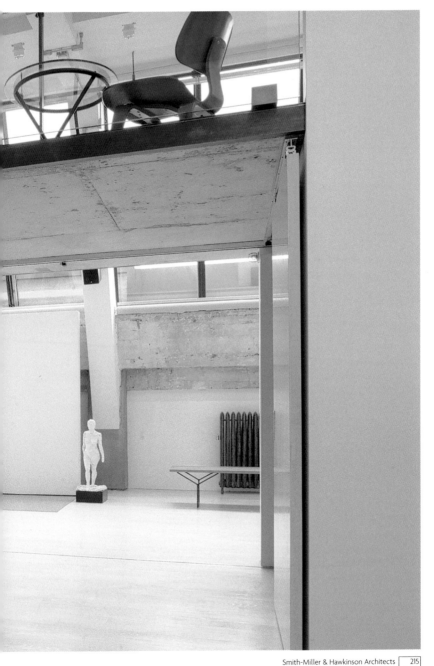

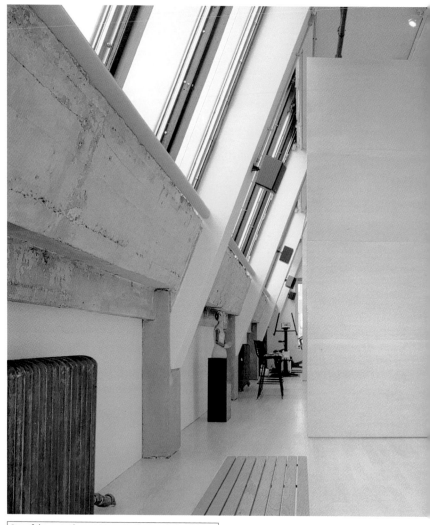

One of the project's most interesting features is the division of the space by partitions that are joined to the floor's lowered baseboard, creating the sensation of weightlessness. These elements, together with enormous sliding wood-veneer doors, create flexible, interconnecting spaces.

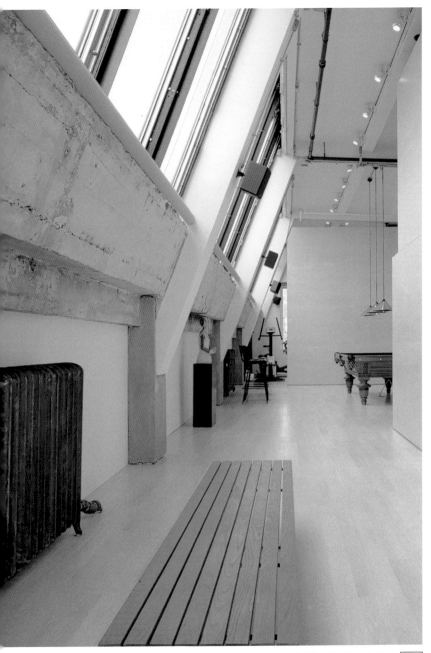

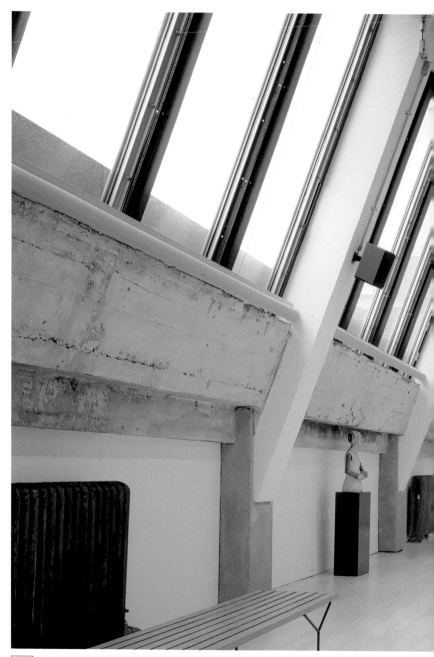

Section

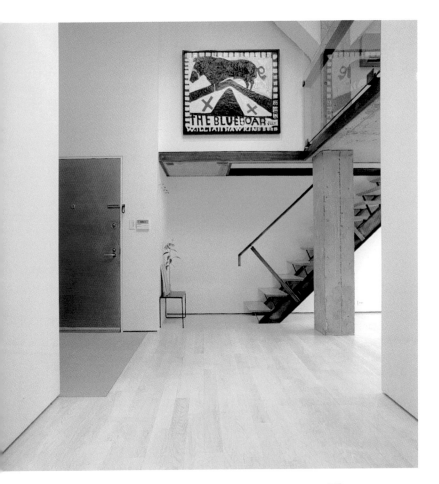

Section

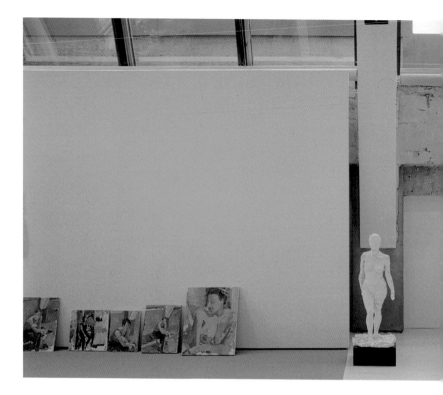

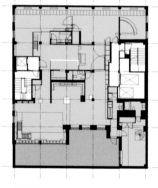

First floor

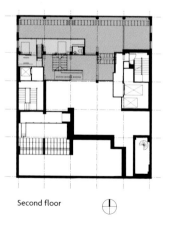

Second floor

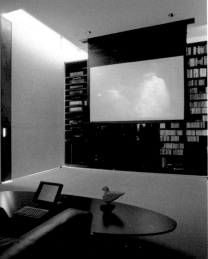

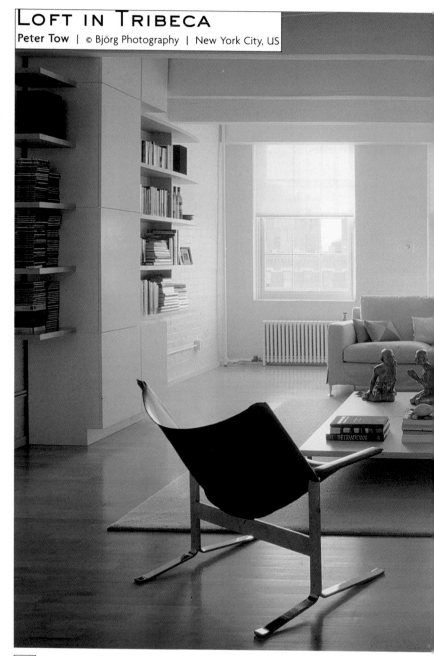

Loft in Tribeca

Peter Tow | © Björg Photography | New York City, US

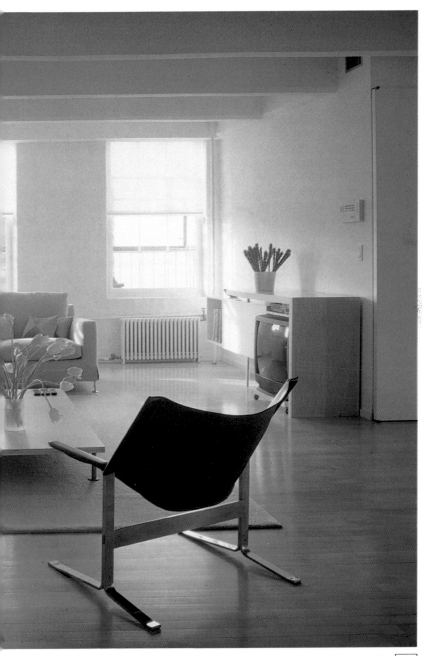

A vertical partition done in sandblasted glass separates the bedrooms from the other spaces. A shoji panel controls the varying degrees of openness.

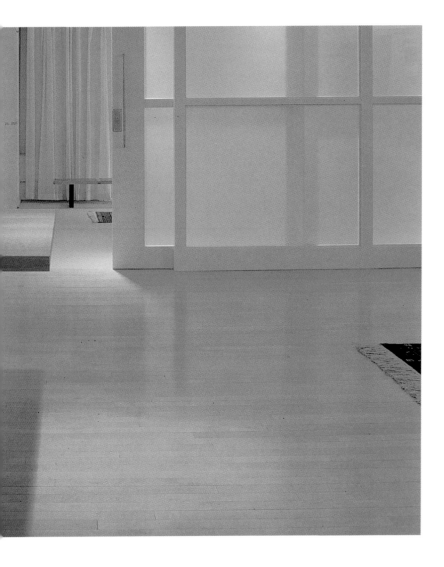

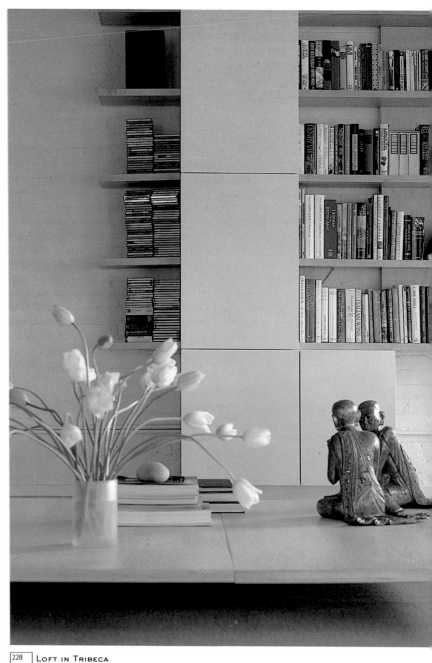

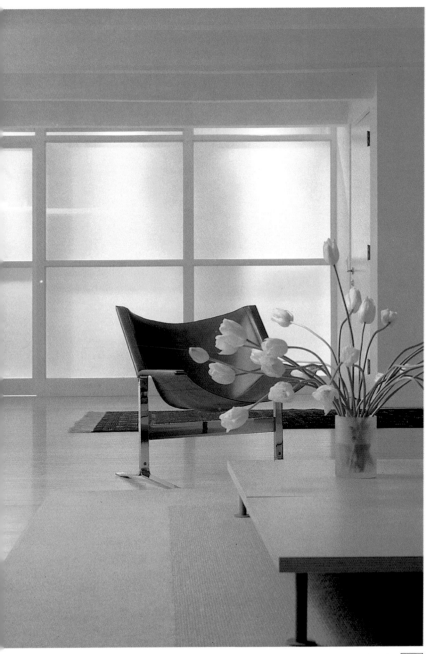

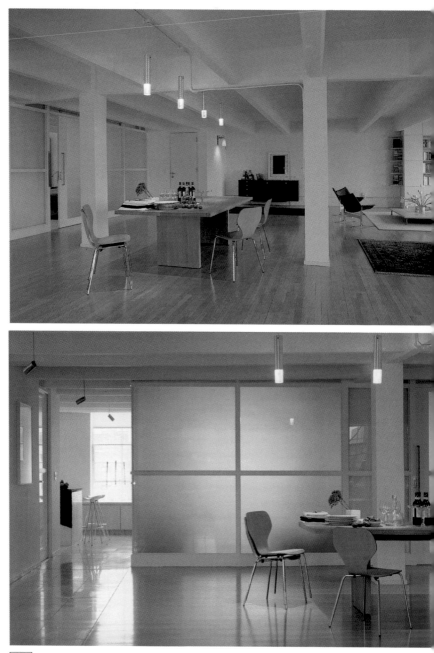

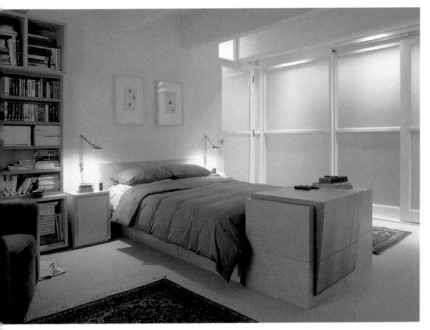

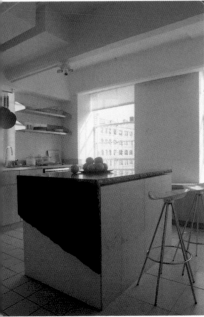

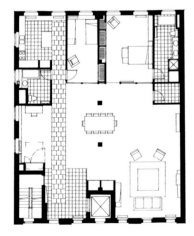

Plan

REFORMING AN ATTIC

Marco Savorelli | © Matteo Piazza | Milan, Italy

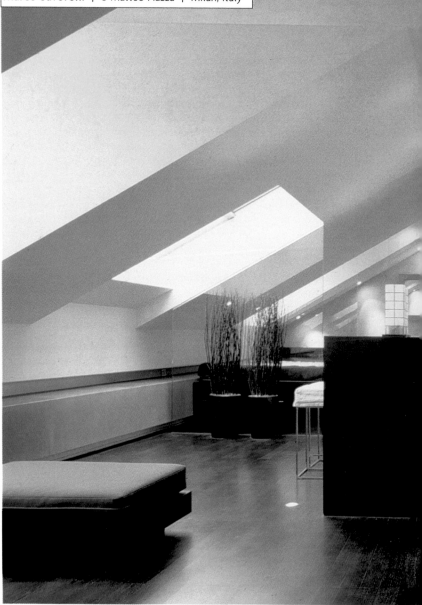

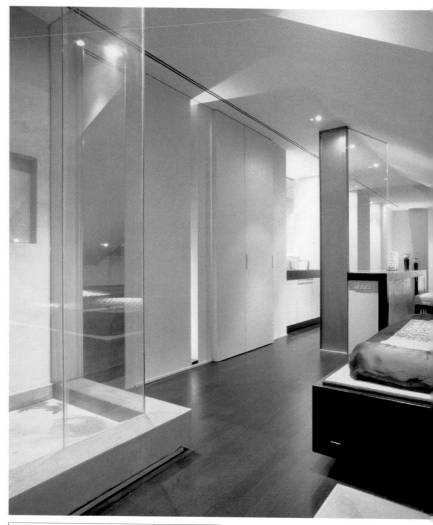

The bathtub, a quadrilateral stone, and the shower, made of glass, are located in the bedroom. Both elements appear as independent volumes that are visually connected to the rest of the space.

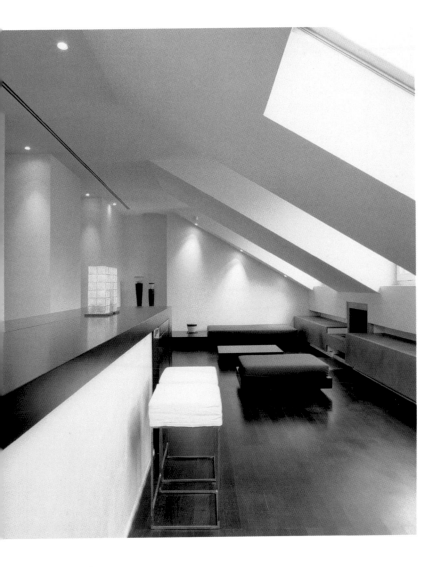

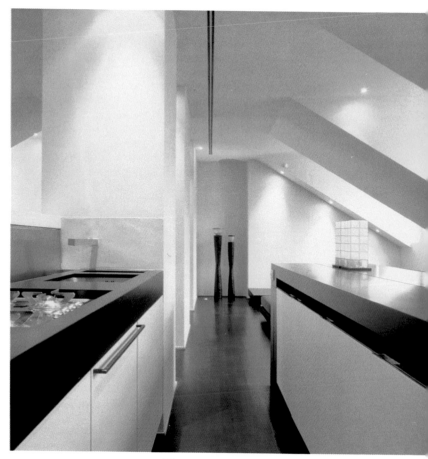

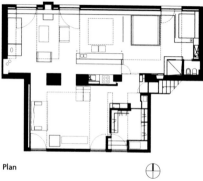

Plan

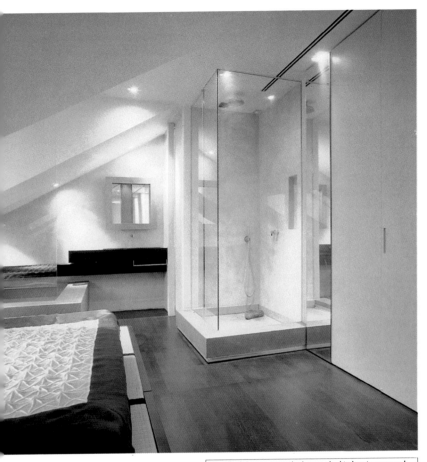

Like all of the rooms in the house, the kitchen is open and connected to the living room. The kitchen includes two cabinets, one of which contains the installations and is placed against two structural pillars that conceal the water pipes.

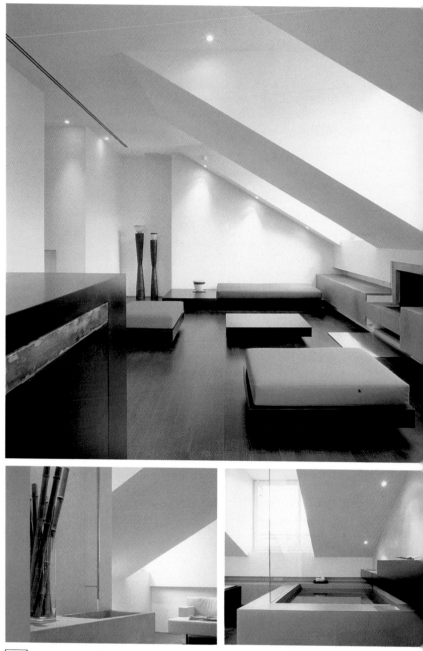

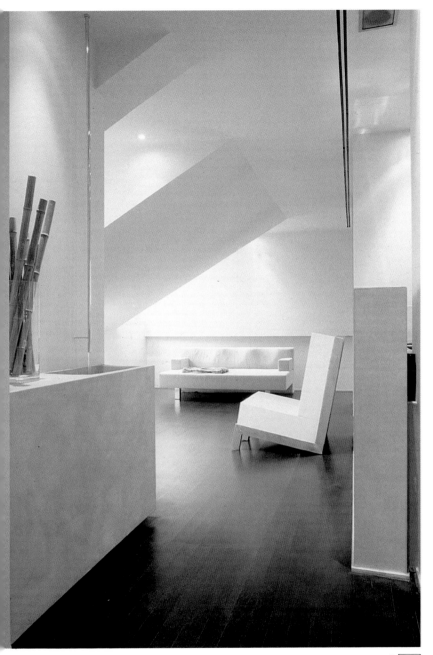

DAVOL LOFT

Moneo Brock Studio | © Michael Moran | New York City , US

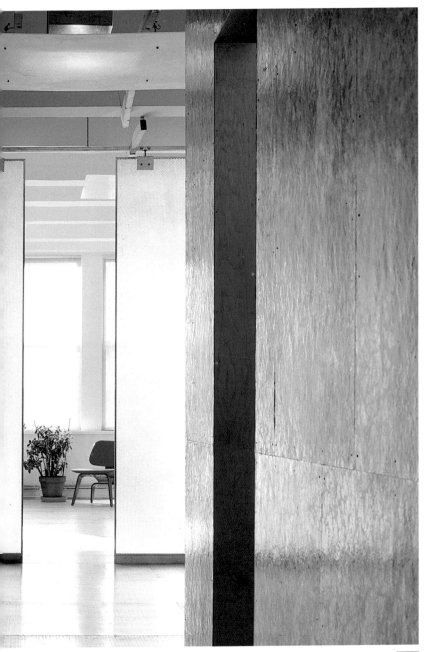

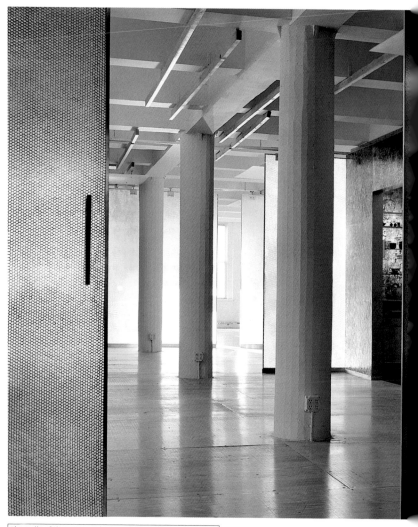

The walls of the rooms do not reach the ceiling, and
iridescent materials are used, creating magnificent reflective
patterns that accentuate the lightness of the components.

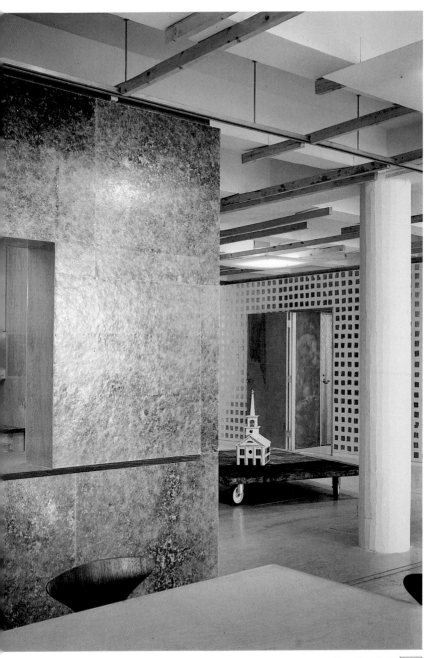

Section

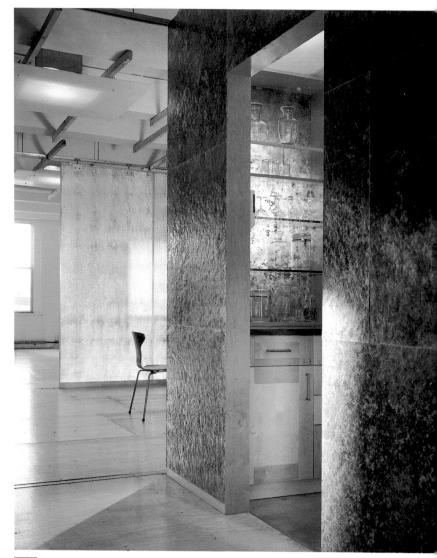

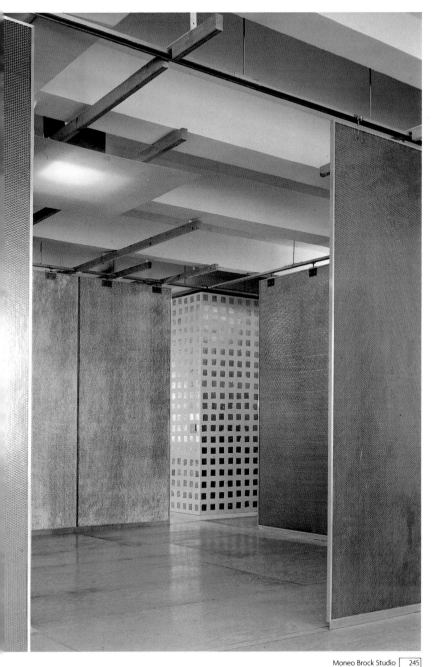

Plan

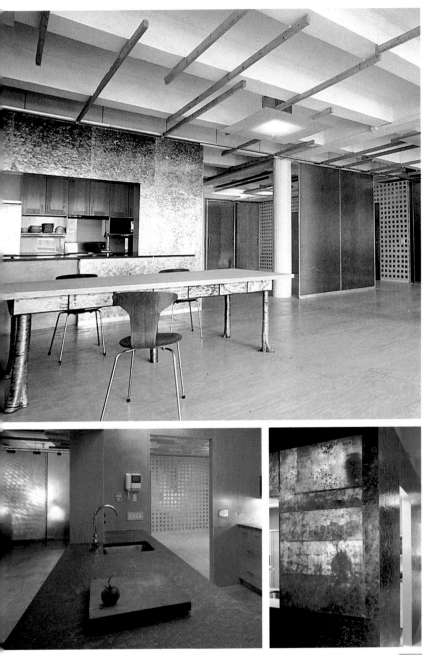

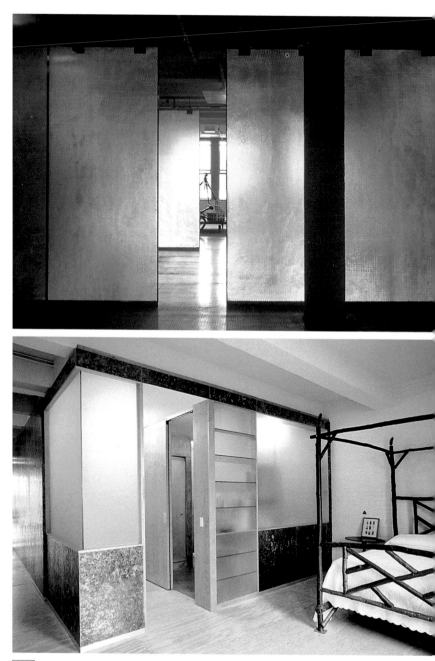

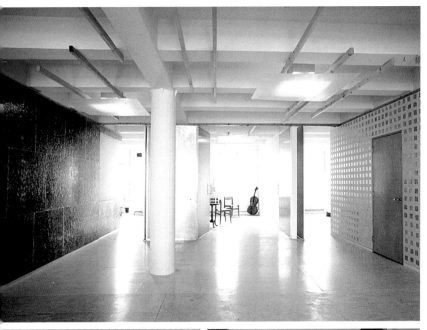

...e finishes produce a pattern of colors, reflections, and ...nsparencies. The extraordinary impression left by the ...ce results from intense experimentation with the ...terials.

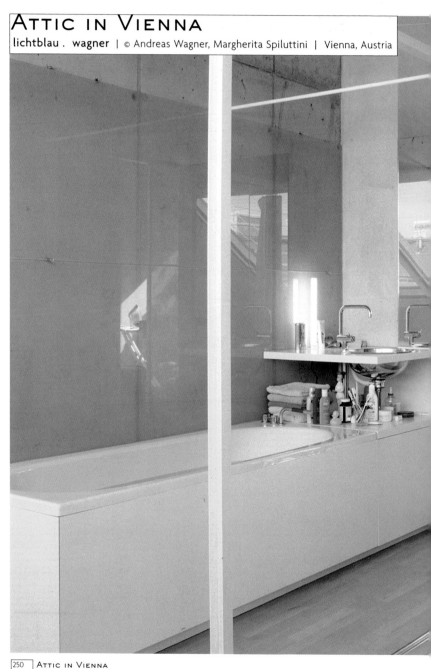

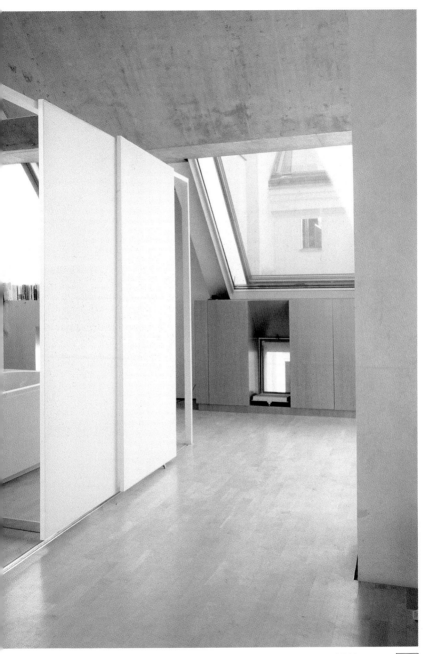

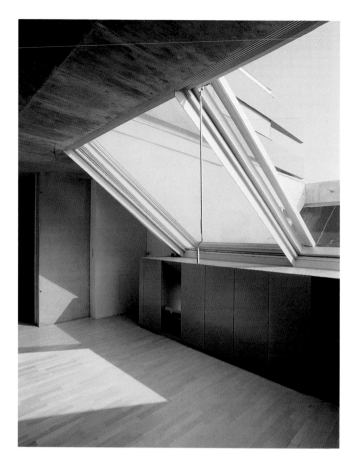

Plan

ATTIC IN VIENNA

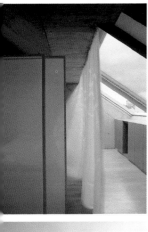

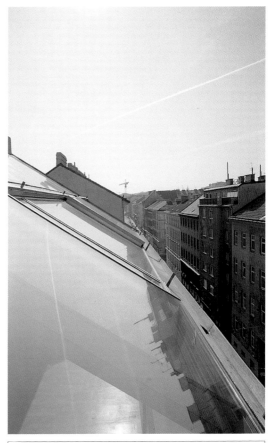

From the construction's point of view, the absence of interior walls contributes to cost reductions. Moreover, the installations are in the floor, eliminating the need for electrical sockets in the vertical partitions.

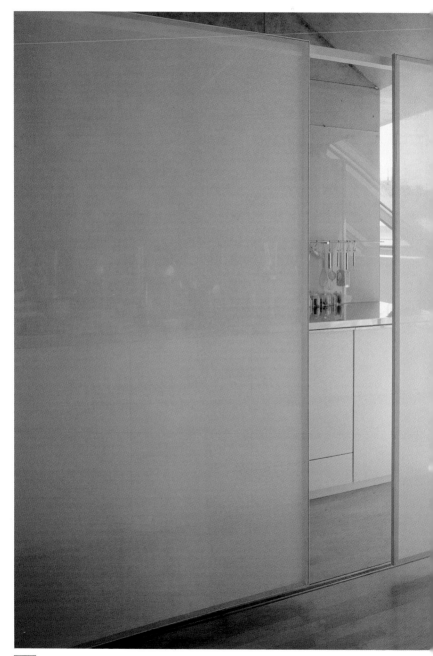

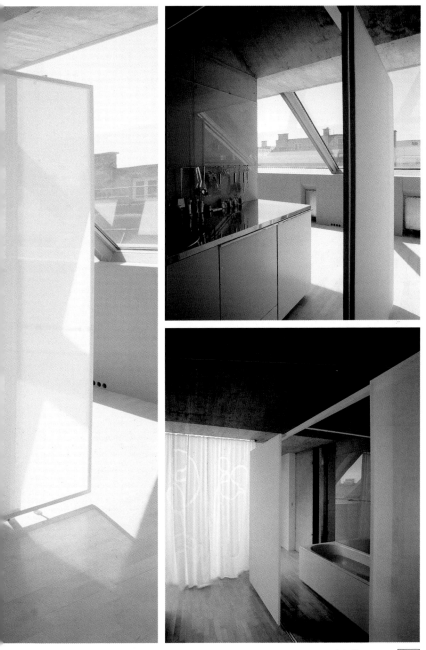

LOFT IN CHELSEA

Kar-Hwa Ho | © Björg Photography | New York City, US

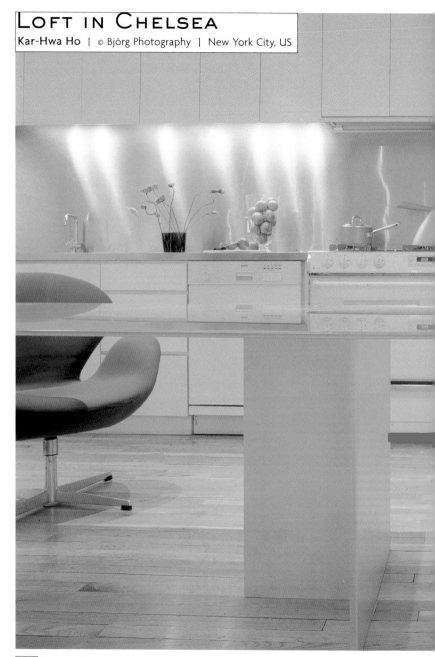

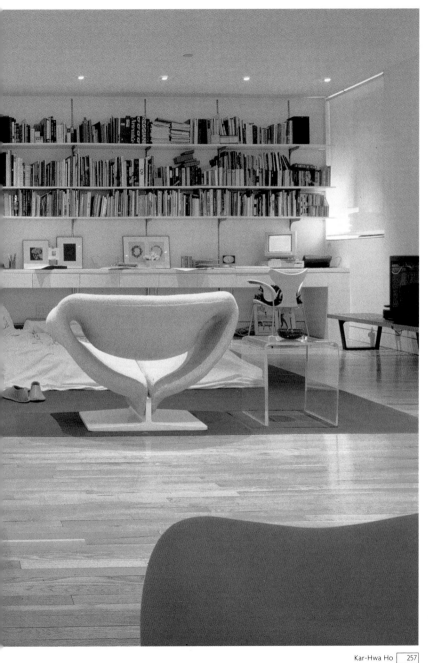

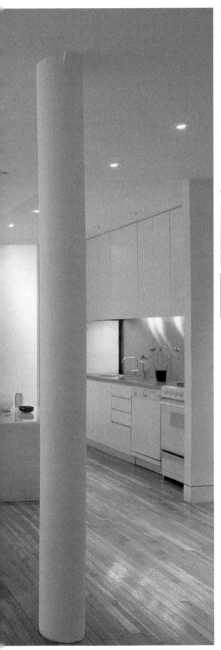

Two materials bring uniformity to the dwelling: parquet on the flooring and plaster on the walls. In the kitchen, stainless steel combines with painted white wood.

Plan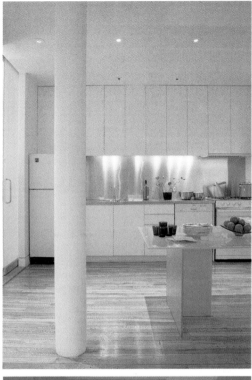

FOUR-LEVEL LOFT

Joan Bach | © Jordi Miralles | Barcelona, Spain

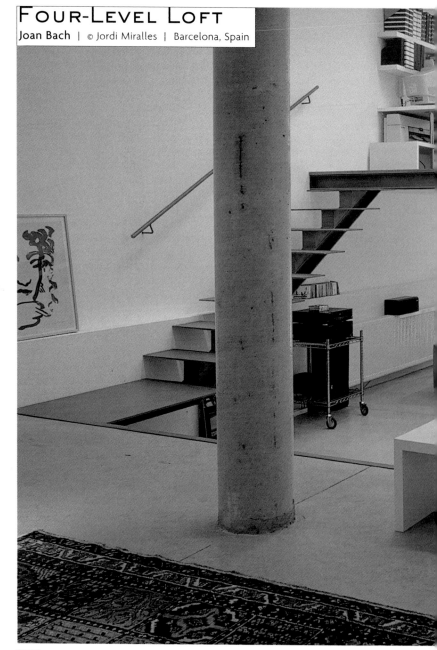

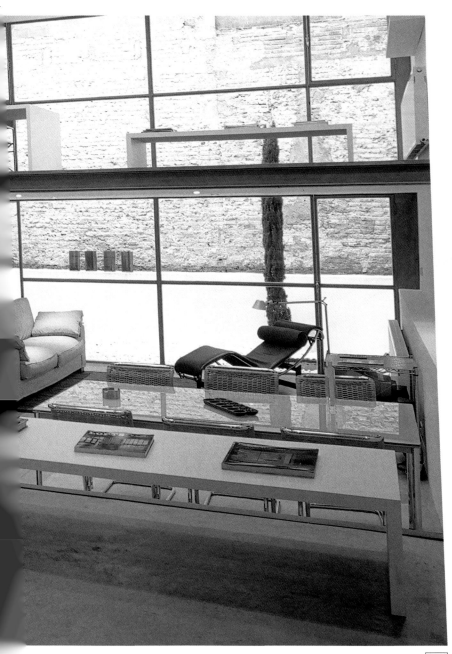

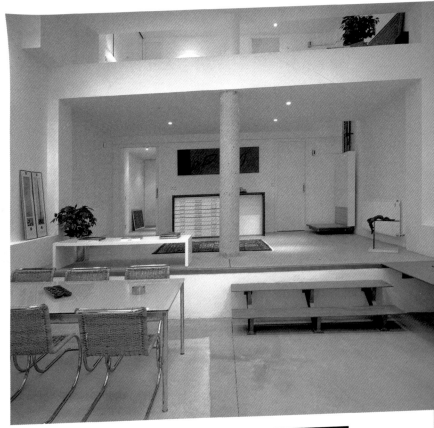

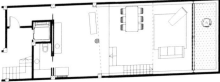

First floor

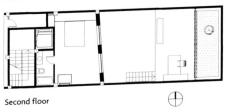

Second floor

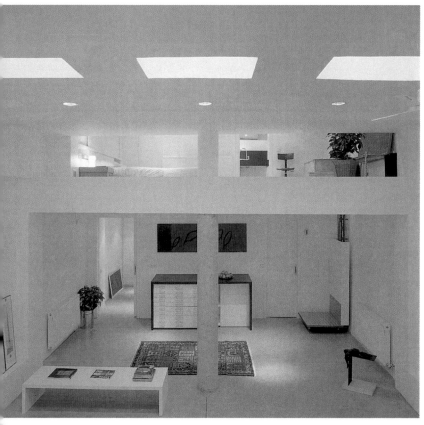

The dwelling's ceiling height, large windows, and skylights create wide spaces and luminosity.

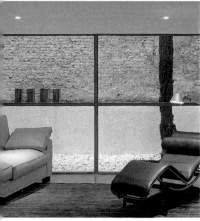

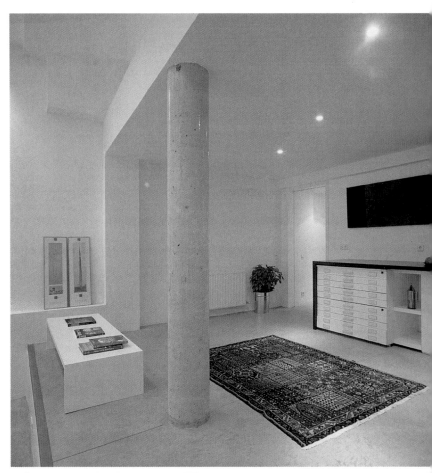

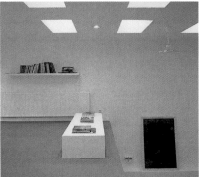

The first level houses a large foyer and a bathroom.
Use of a mechanically operated platform provides access
to the bedroom and the bathroom, which are located abo
the hall.

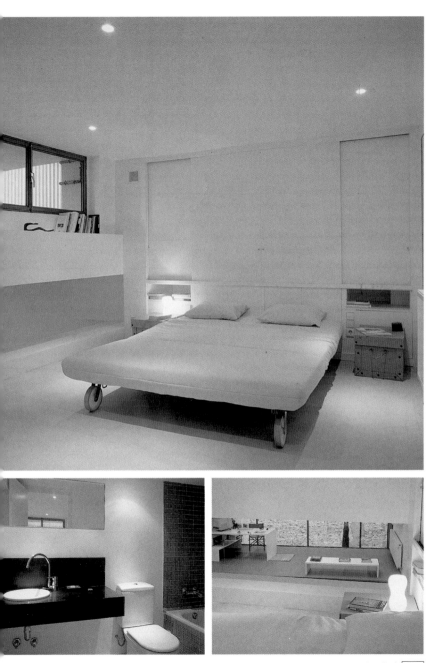

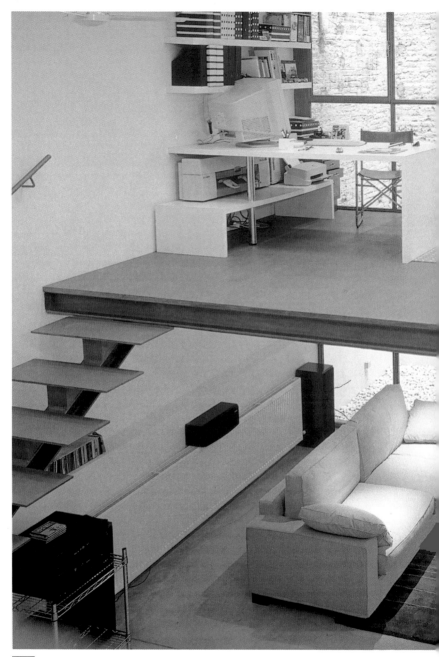

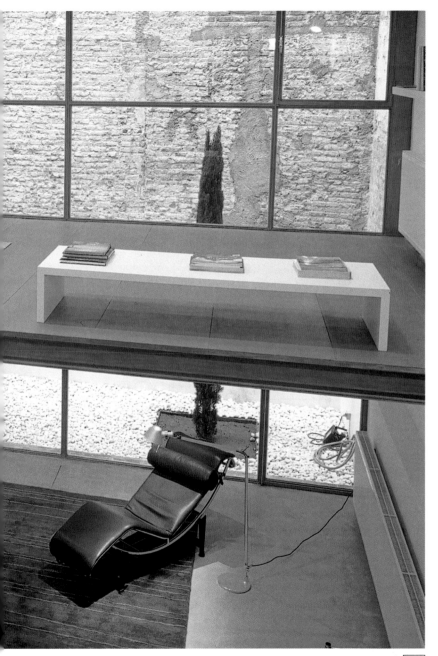

CALYPSO HILL

Non Kitch Group | © Jan Verlinde | Oostduinkerke, Belgium

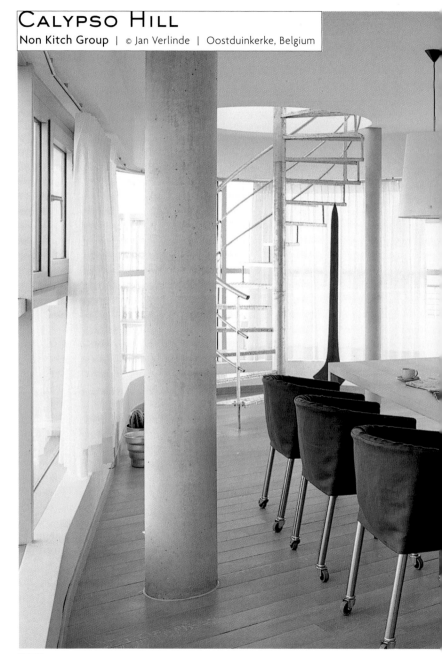

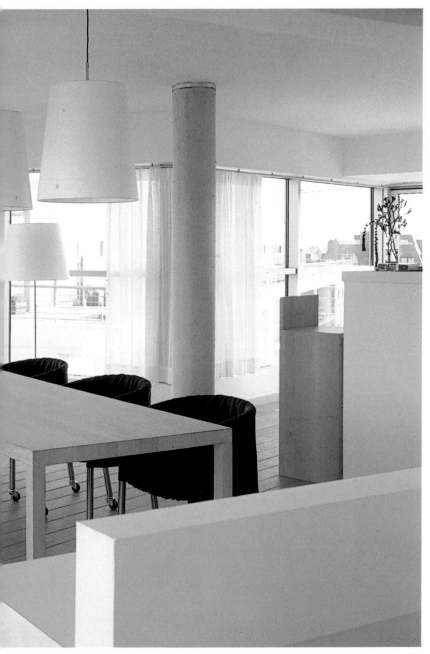

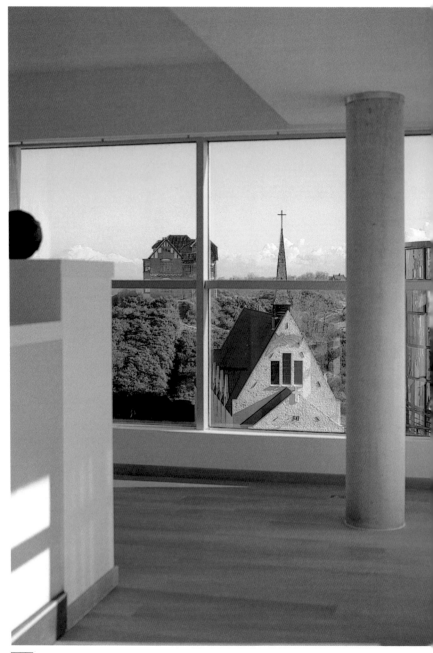

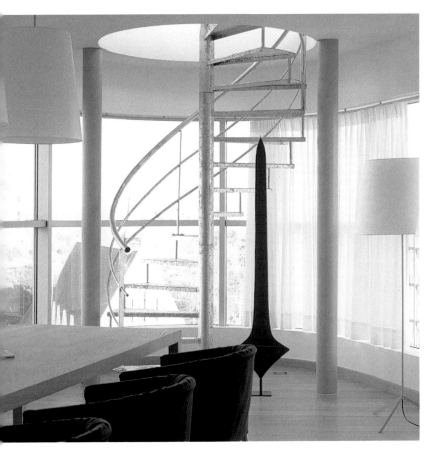

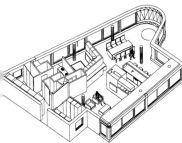
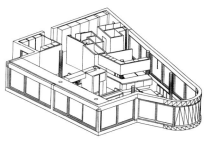

erspectives

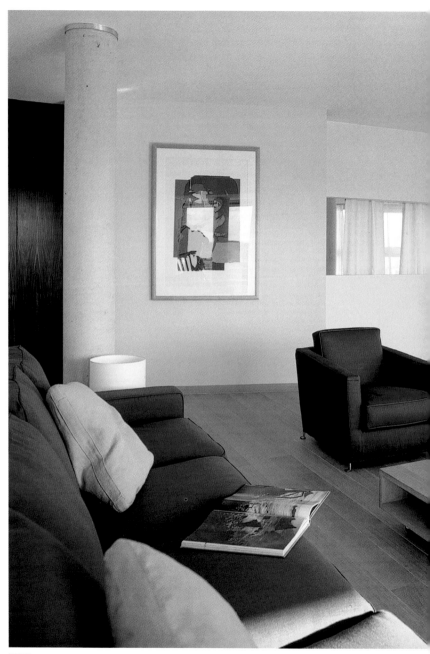

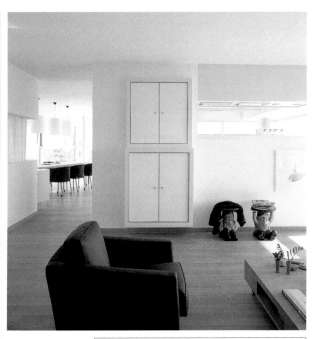

The project's key idea was to create a large living room around which to develop the other rooms, which would, of course, be open to the spectacular views.

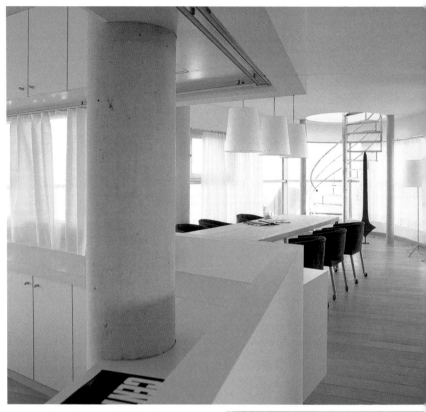

Plan

Aside from the bath, all rooms are open and interconnect
The kitchen is demarcated by two pieces of furniture: a hi
piece housing the appliances and a low piece with storage
units.

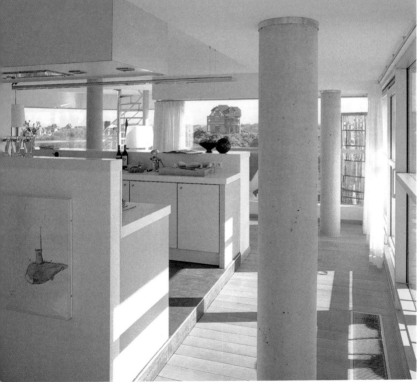

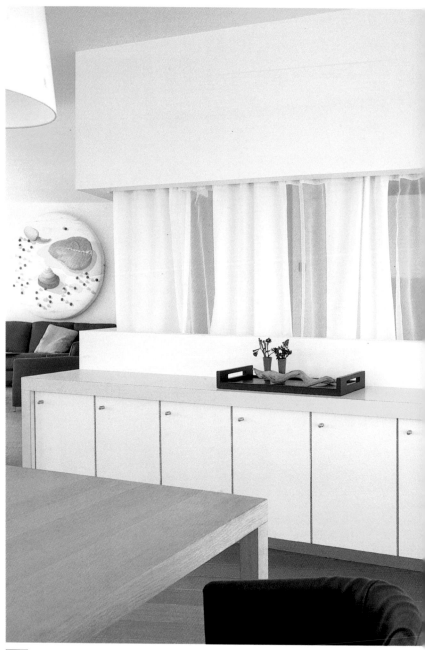

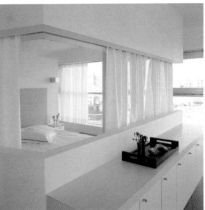
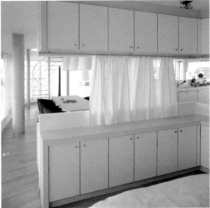

NILE STREET LOFT

McDowell & Benedetti | © Nick Hufton/View | London, UK

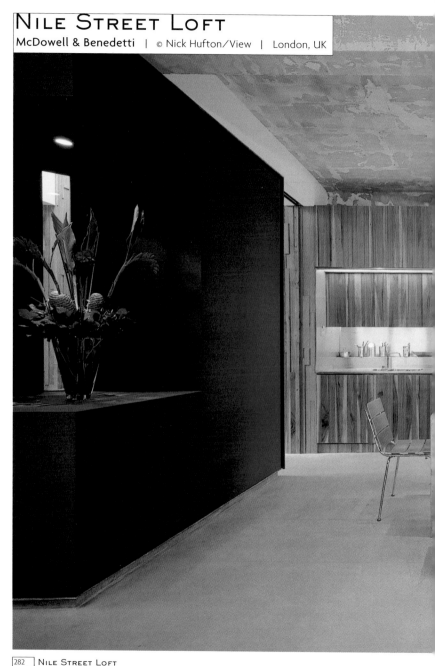

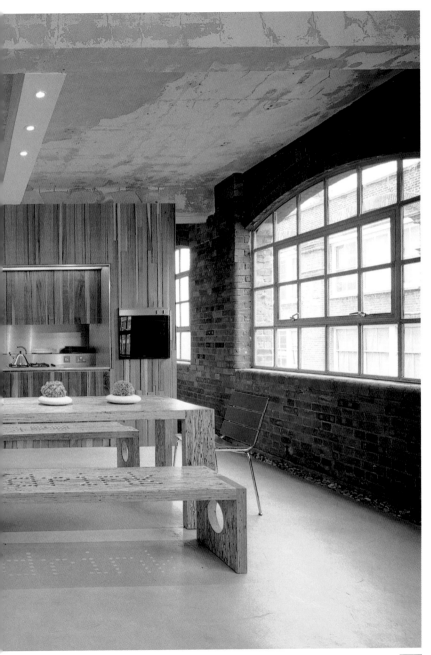

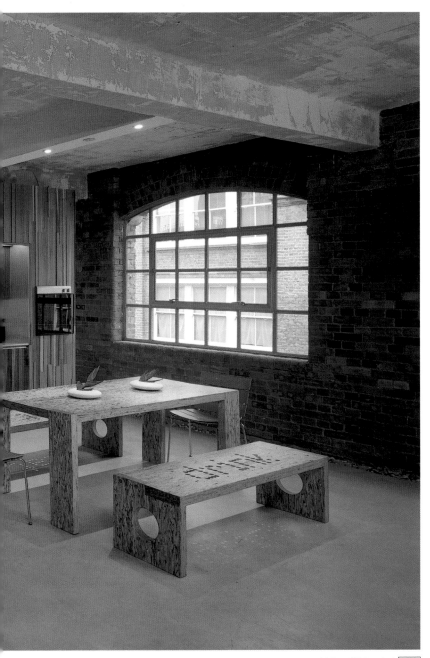

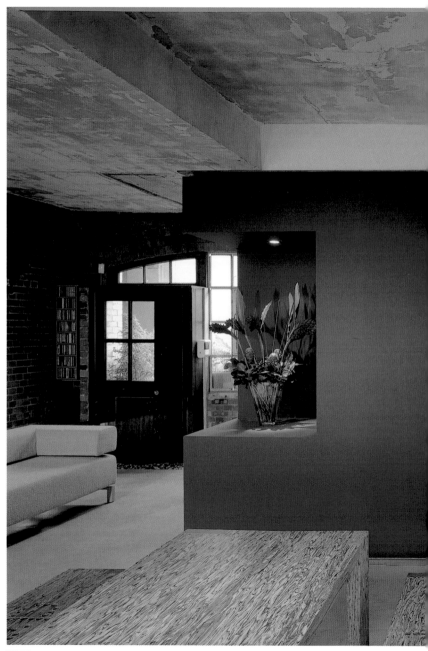

First floor

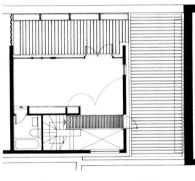

Second floor

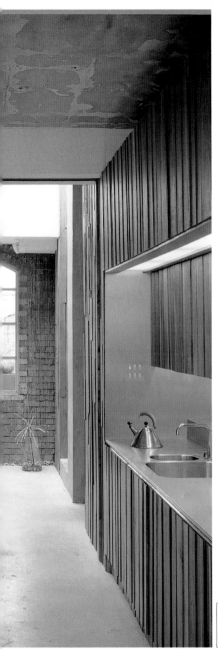

The external brick walls already in place and a concrete ceiling slab were incorporated into the design after being sandblasted.

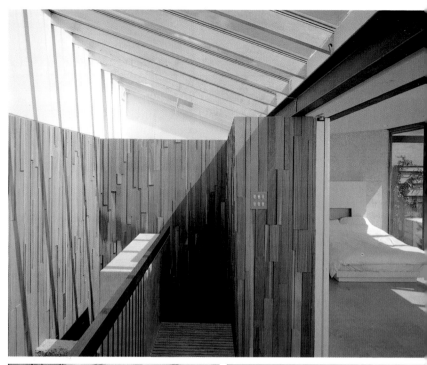

The dwelling has a multipurpose room on the upper level that can be closed off for use as a spare room.

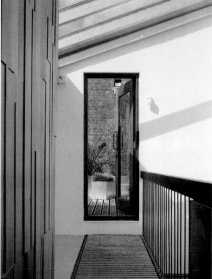

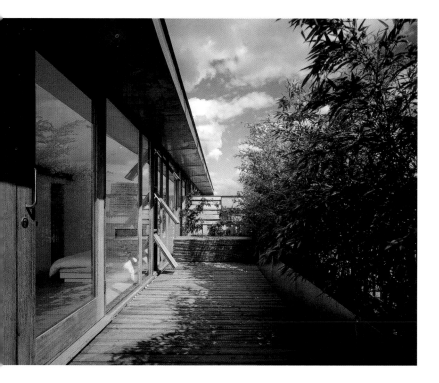

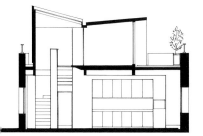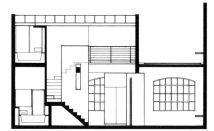

Sections

ORGANIC SPACES

Claesson Koivisto Rune Arkitektkontor | © Patrik Engquist | Stockholm, Sweden

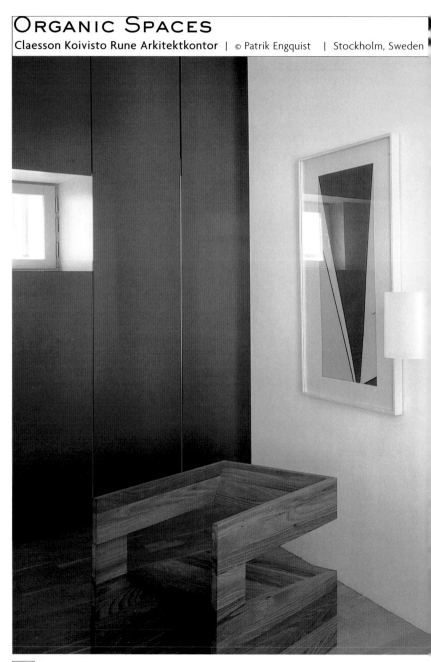

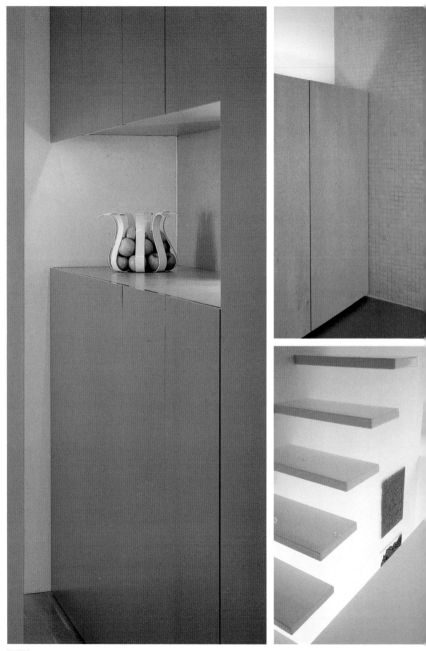

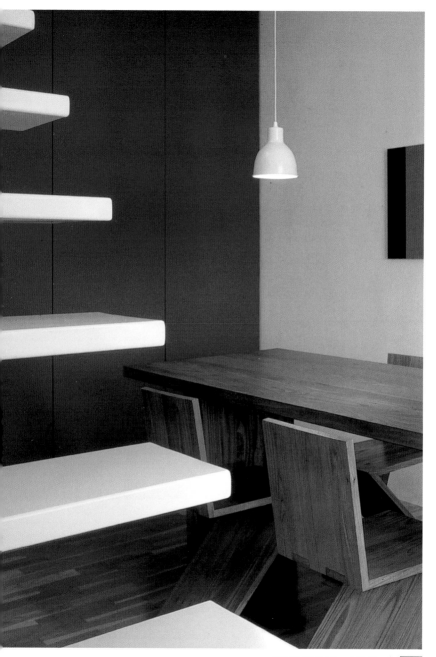

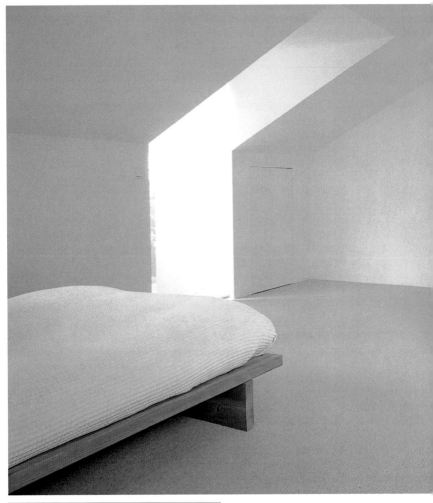

Due to the apartment's small size, 763 square feet, the
architects avoided the use of doors except in the foyer
and bathroom.

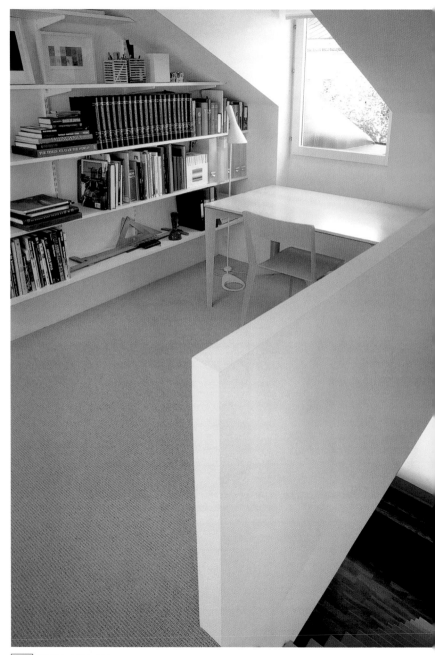

The partition wall that separates the dining room from the living room supports a set of stairs that leads to the upper level, where a small studio and a bedroom are located.

SWEDISH SERENITY

Claesson Koivisto Rune Arkitektkontor | © Patrik Engquist | Stockholm, Sweden

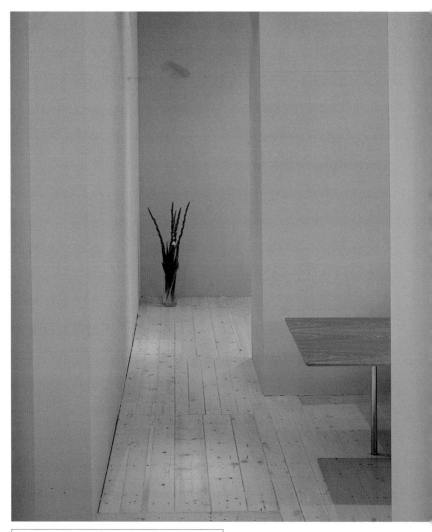

The plan was to create a flowing visual cross communication between elements. From the entrance hallway, a corridor leads to the first axis that contains the bathroom, kitchen, and bedroom. The intersecting axis runs through the kitchen into the living room.

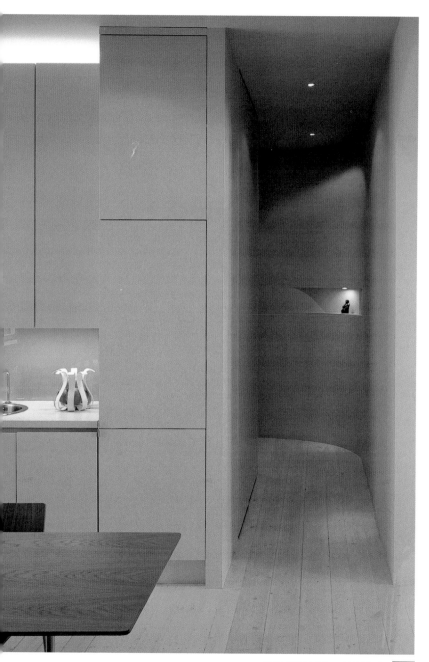

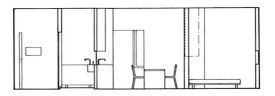

Sections

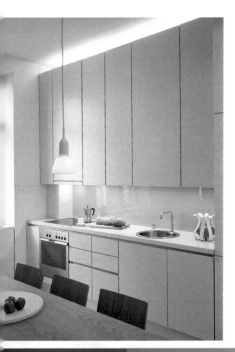

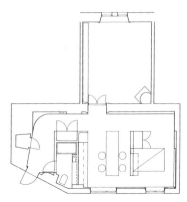

Plan

ONE SIZE FITS ALL

Jonathan Clark | © Nick Hufton/View | London, UK

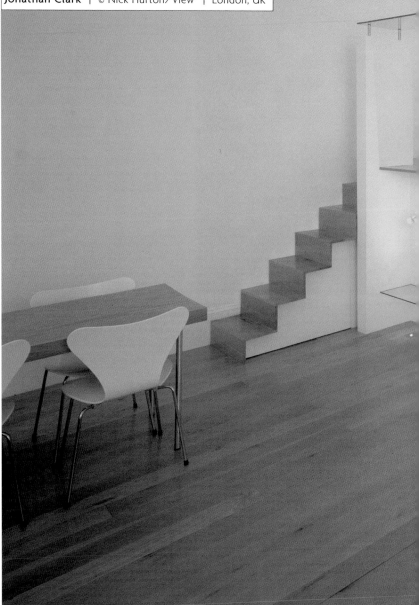

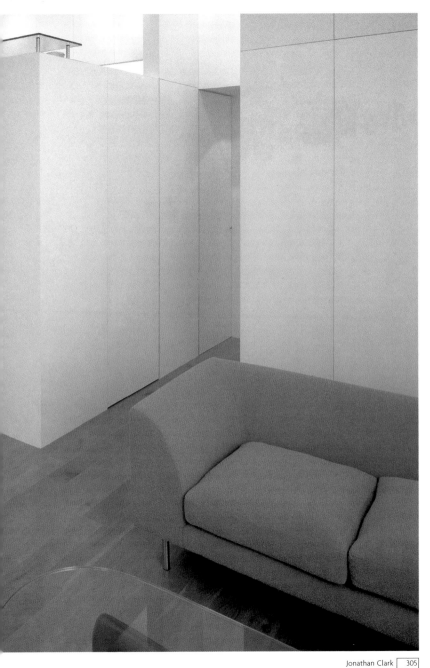

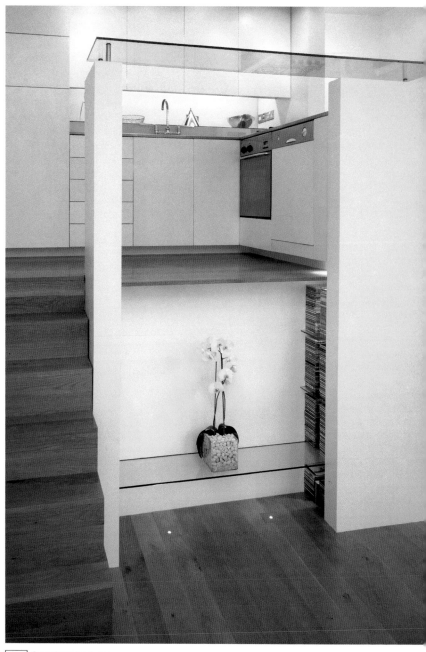

...ezzanine level was constructed to incorporate the ...chen and bathroom and to take advantage of the 12-foot-...h ceilings. Materials like glass and stainless steel reflect ...t and minimize visual disruption.

Plan

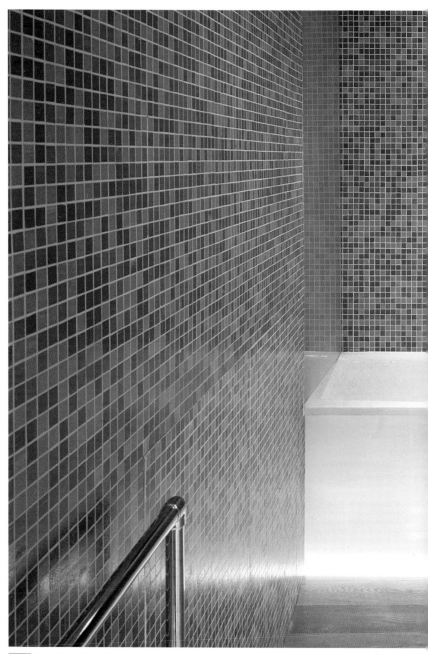

ONE SIZE FITS ALL

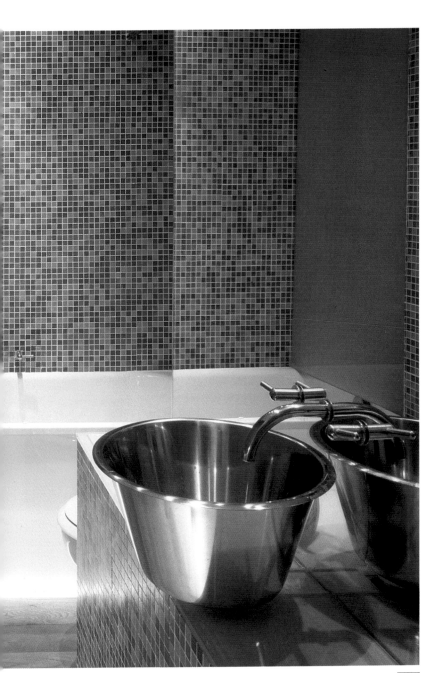

APARTMENT IN LISBON

Inês Lobo | © Sergio Mah | Lisbon, Portugal

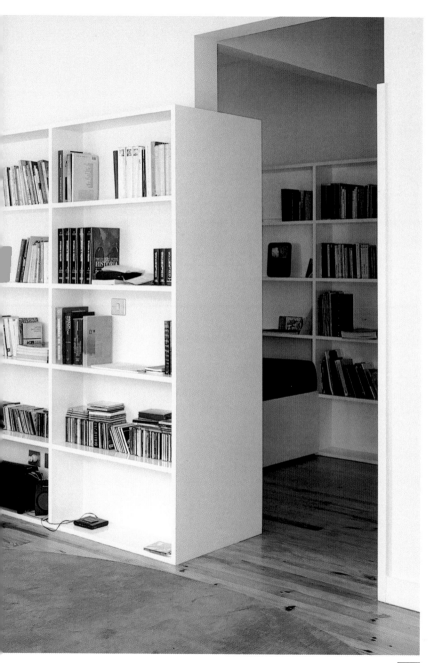

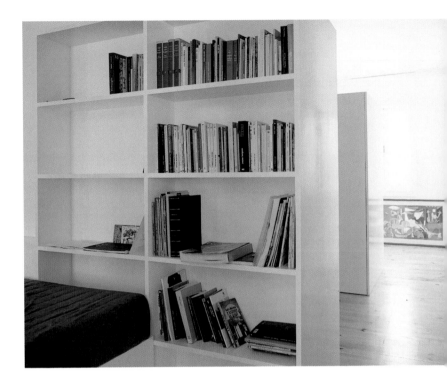

Perspective

A set of shelves runs the length of one wall like a second skin. The piece divides the space into four different sections that define the different functions of the apartment.

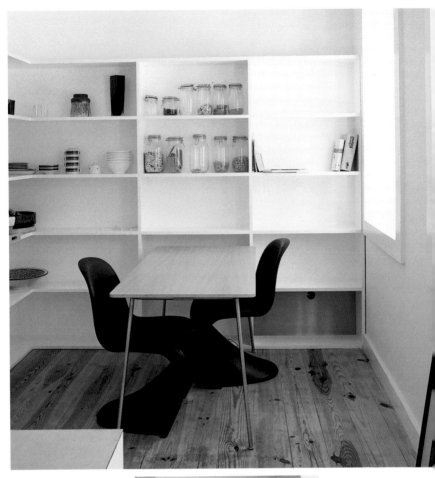

The shelving can house books, clothes, or kitchen utensils, according to the needs of the moment. At the same time, it also sections off the space, relating it to the rooms.

THE HAKUEI HOUSE

Akira Sakamoto | © Nácasa and Partners | Osaka, Japan

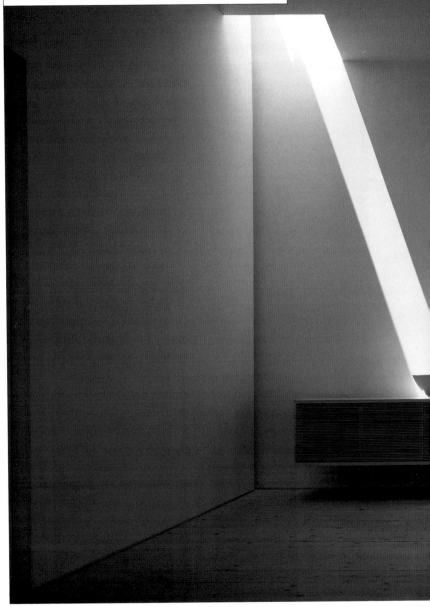

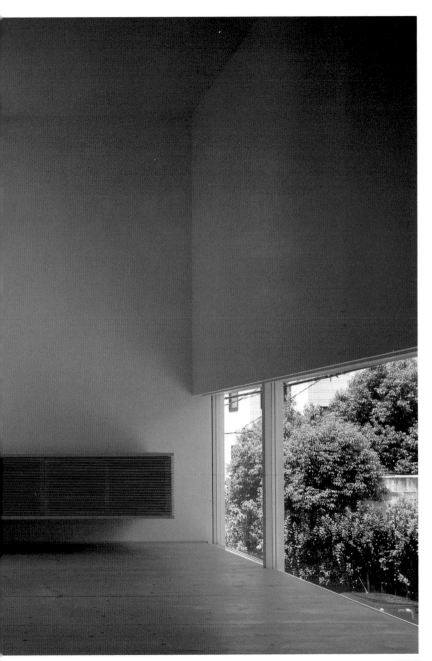

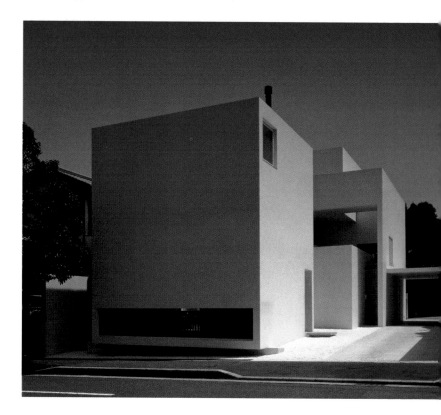

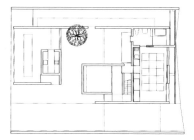

First floor

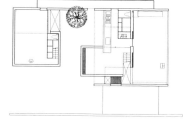

Second floor

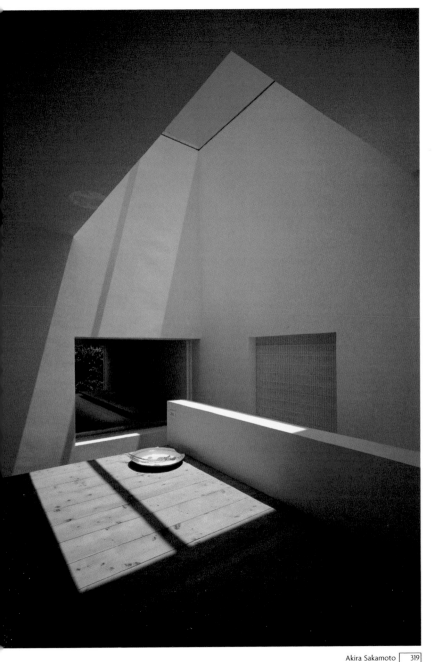

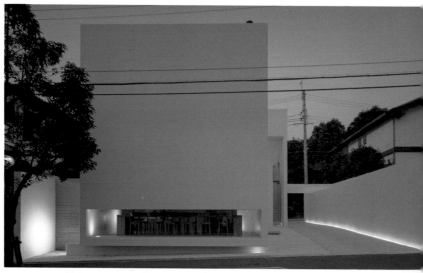

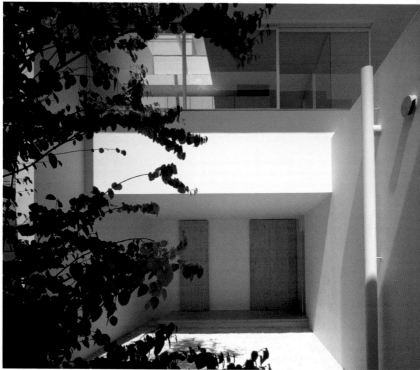

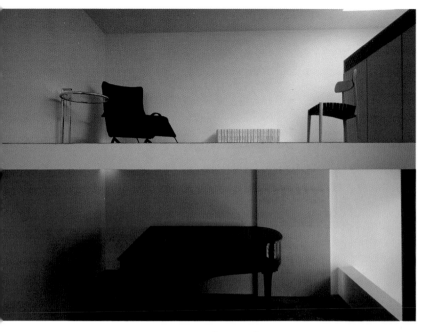

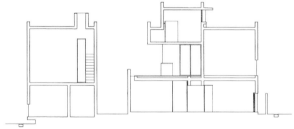

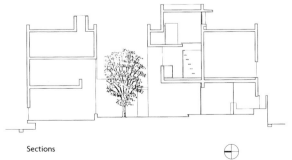

Sections

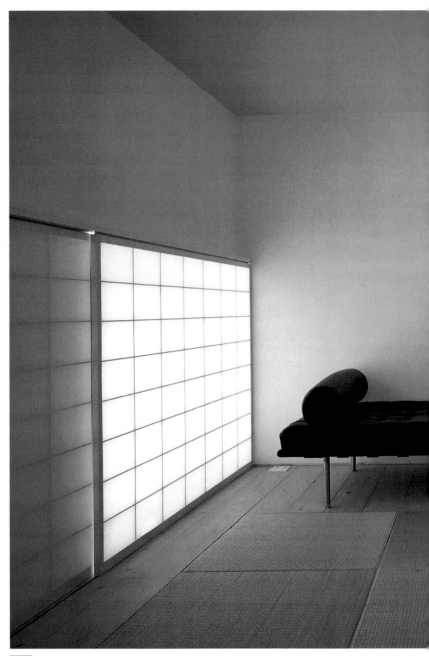

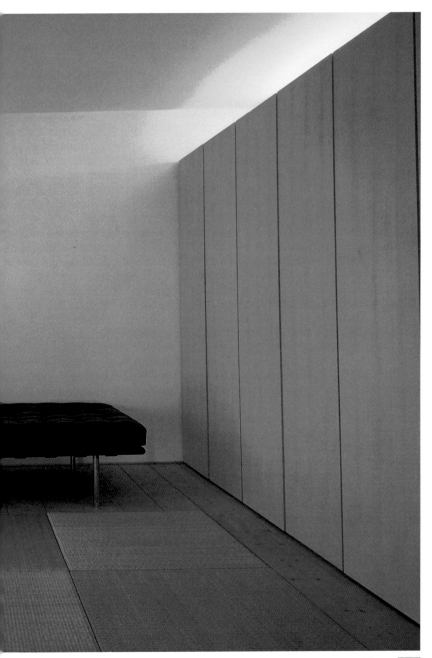

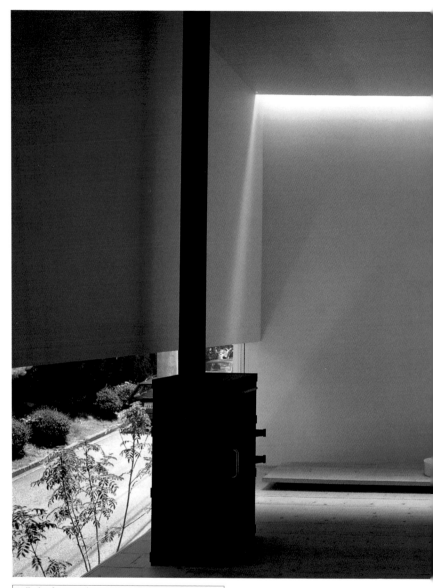

Walls that fragment the space provide the articulating element, while openings produce good fluidity and continuity. People can gather around the patio and deck.

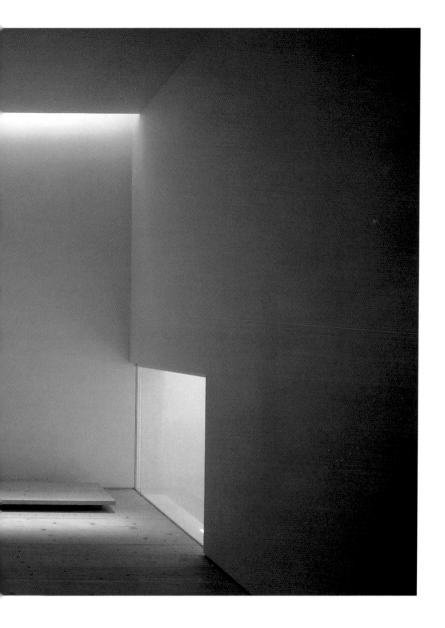

ALTERATIONS TO AN APARTMENT

Simon Conder | © Chris Gascoigne/View | London, UK

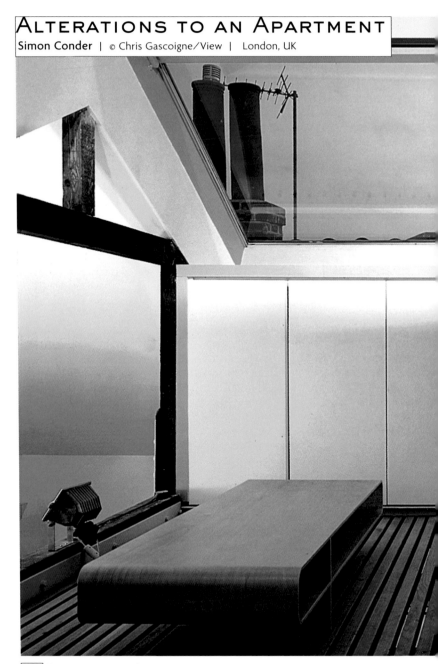

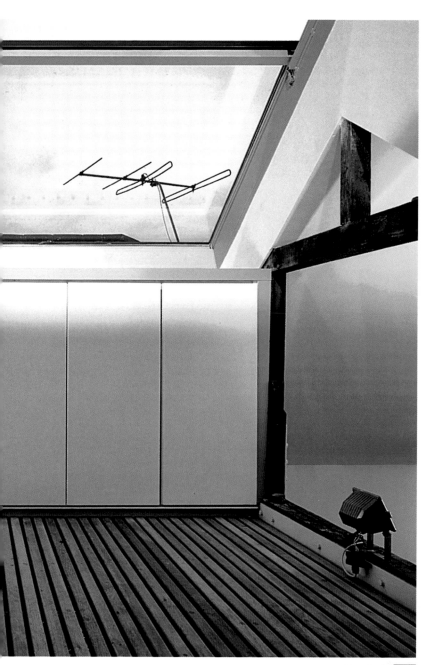

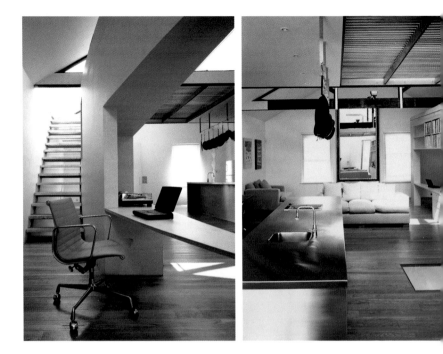

First floor

Second floor

Third floor

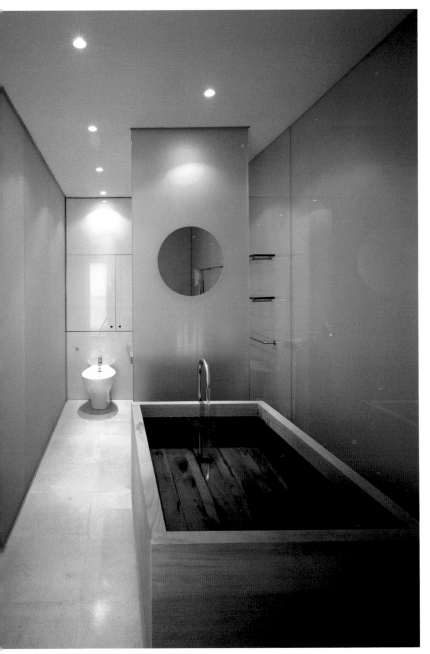

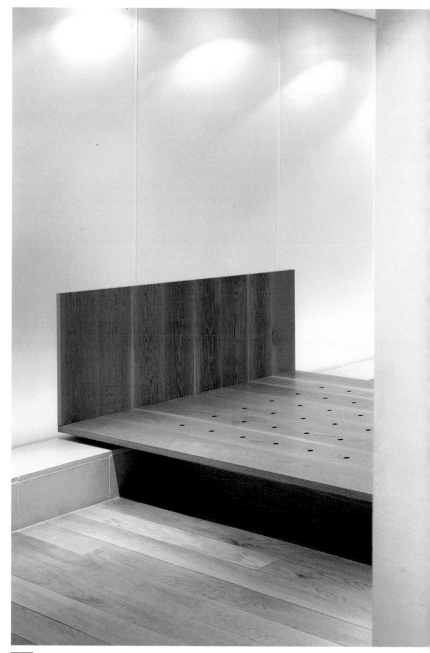

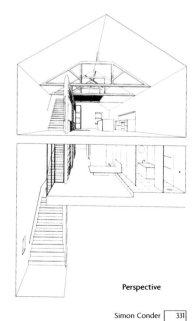

Perspective

THE HOUSE WITHOUT WALLS

Shigeru Ban Architects | © Hiroyuki Hirai | Nagano, Japan

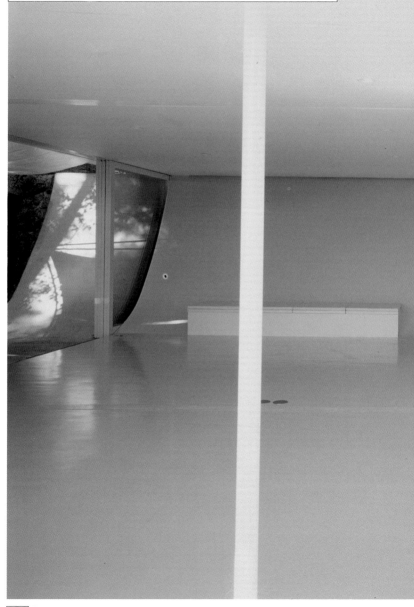

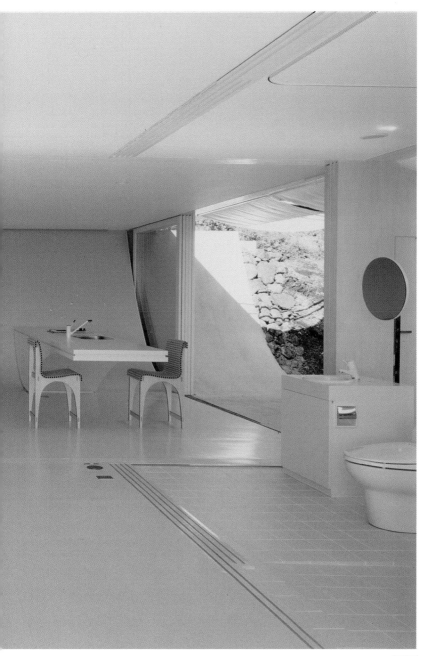

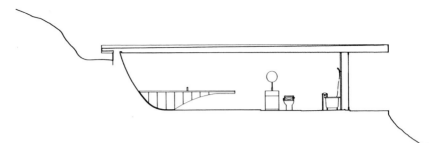

Section

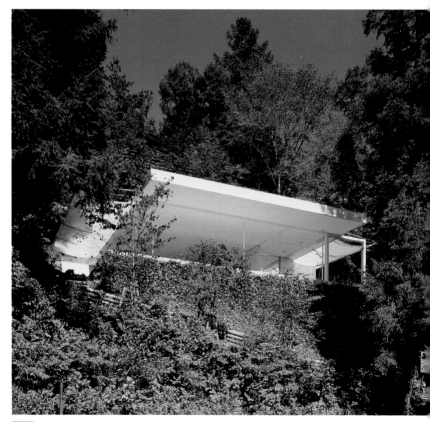

THE HOUSE WITHOUT WALLS

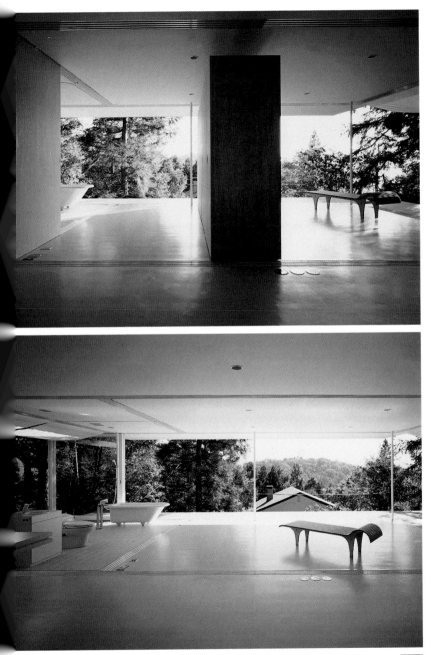

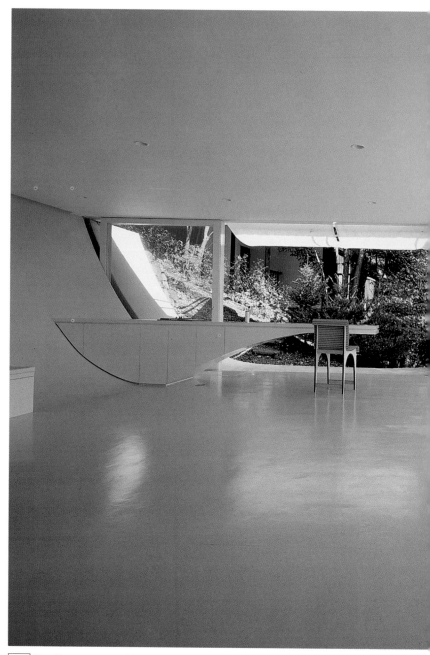

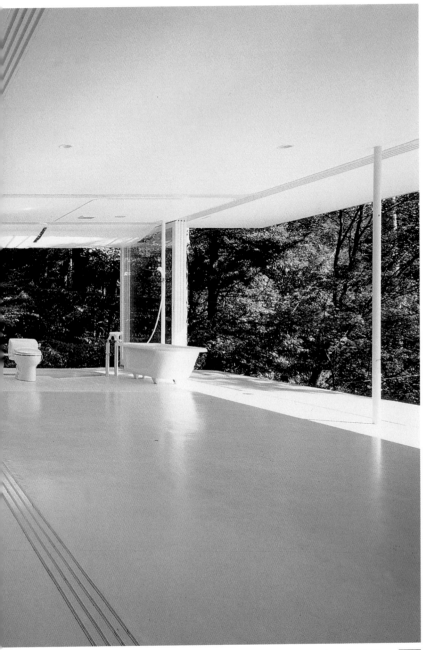

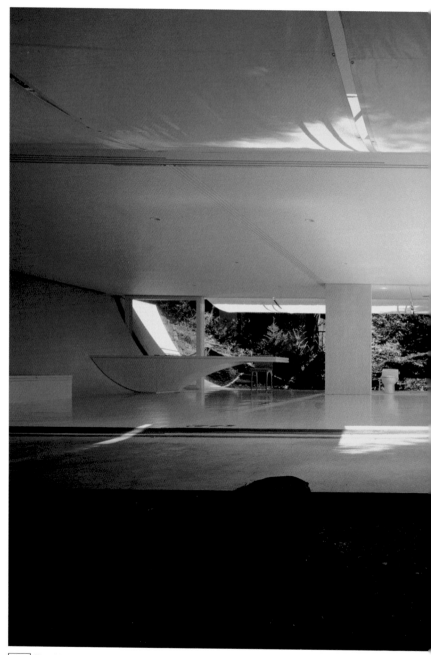

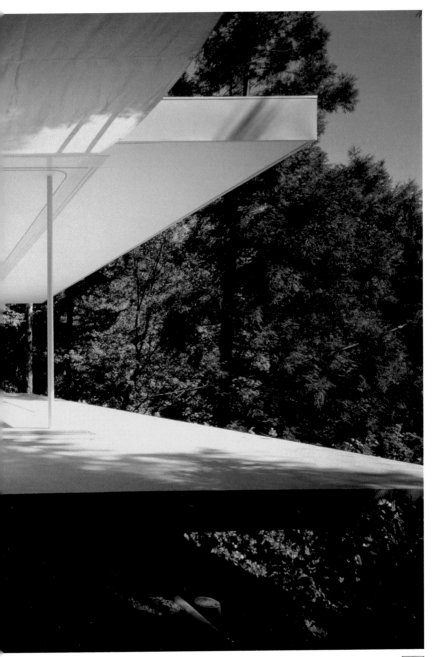

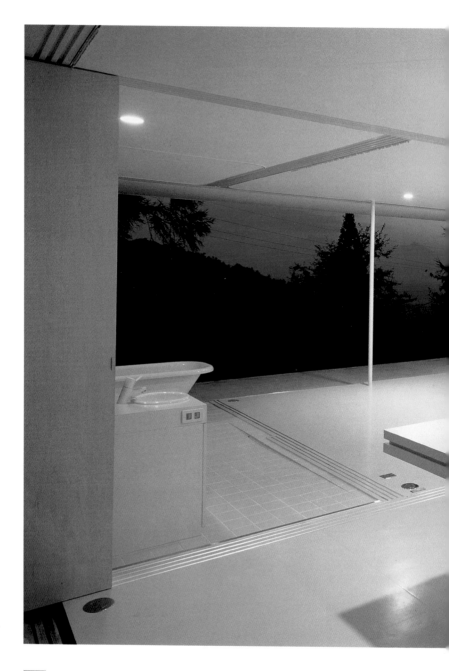

THE HOUSE WITHOUT WALLS

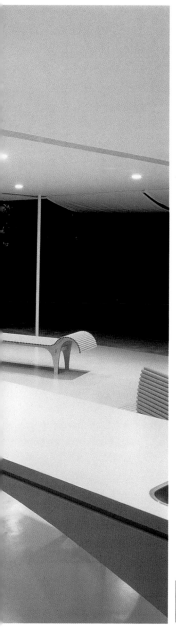

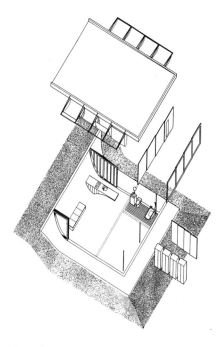

Perspective

This house establishes spatial continuity in a juncture of inside and outside. The inner space has no partitions and even the bathroom is open to view.

HOUSE IN IBIZA

Stéphane Bourgeois | © Pere Planells | Ibiza, Spain

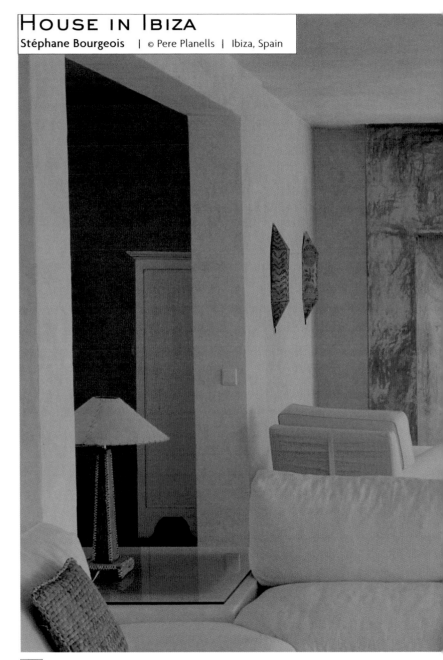

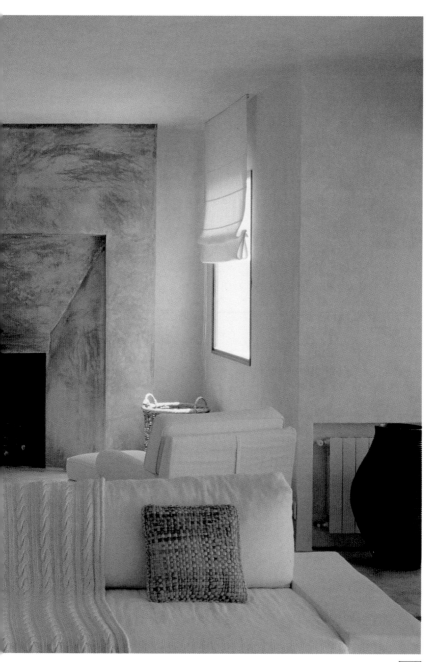

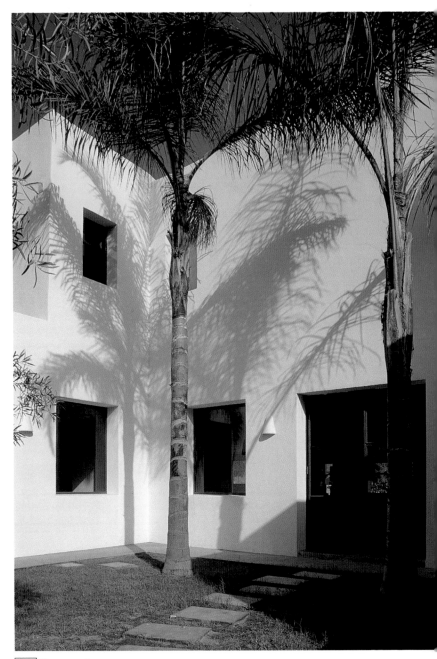

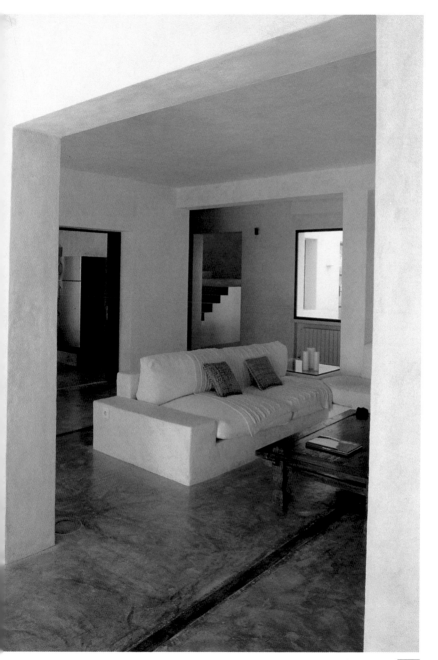

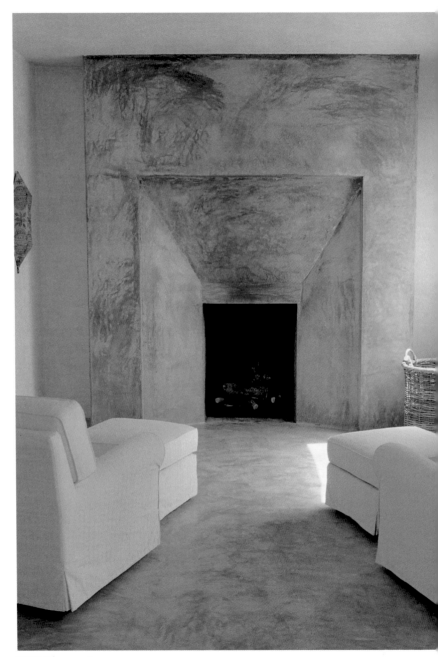

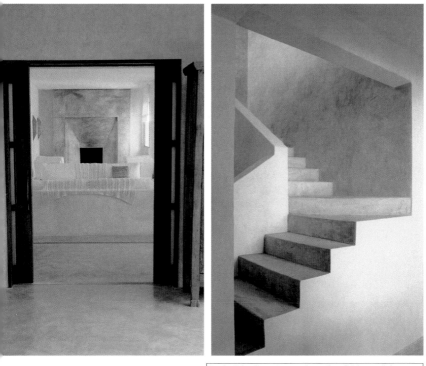

Emphasis has been given to the surface finishes, and the range of materials and colors has been reduced. The interior partitions are stucco, and the floors are covered in stone.

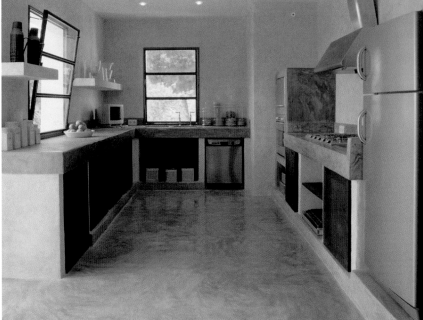

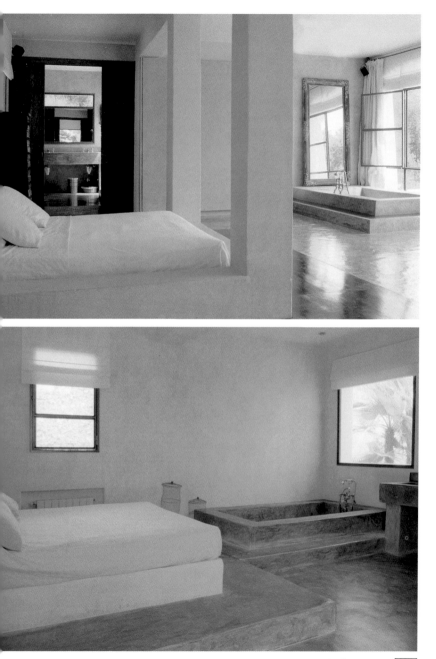

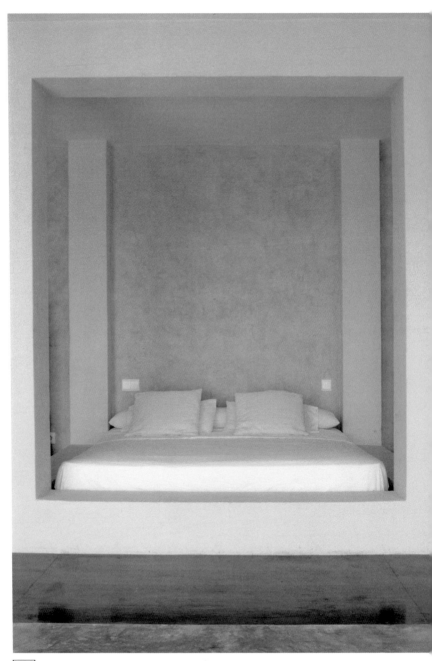

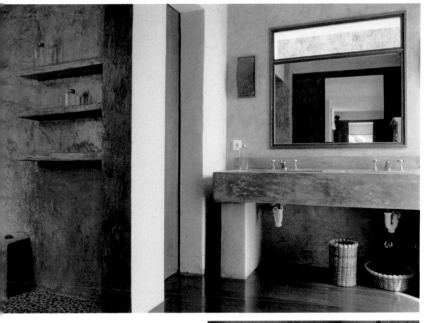

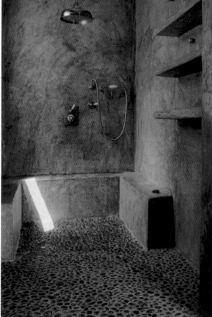

tiles have been used, not even in the bathroom; the
room floor is finished in polished pebbles. The coherence
he project owes much to the built-in furniture.

APARTMENT ON THE THAMES

Claudio Silvestrin | © Claudio Silvestrin | London, UK

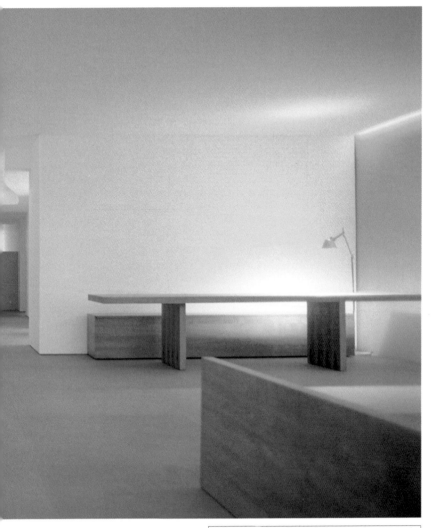

By focusing purely on the visual, this space is less warm and welcoming. The translucent screen divides the bedrooms from the daytime areas.

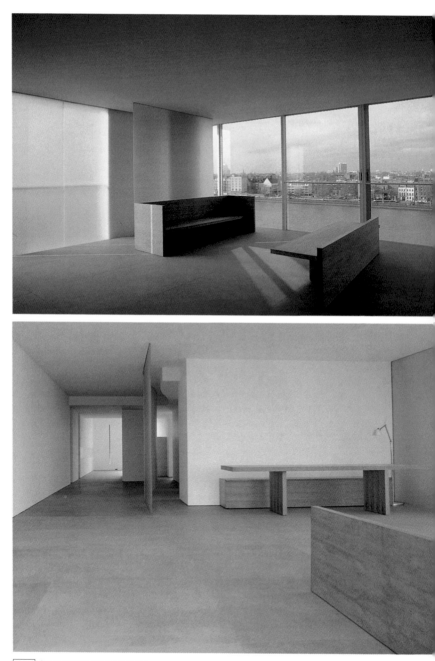

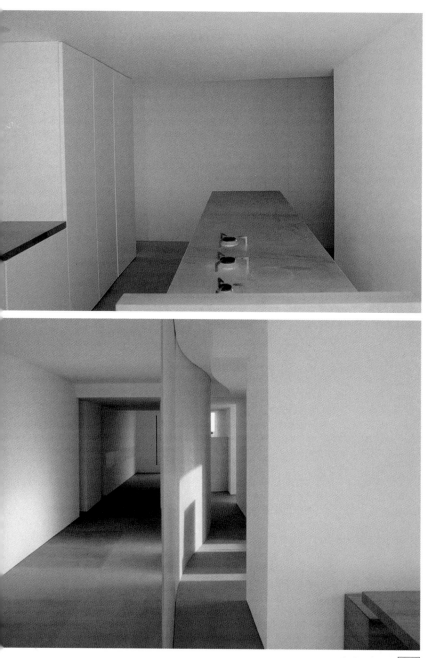

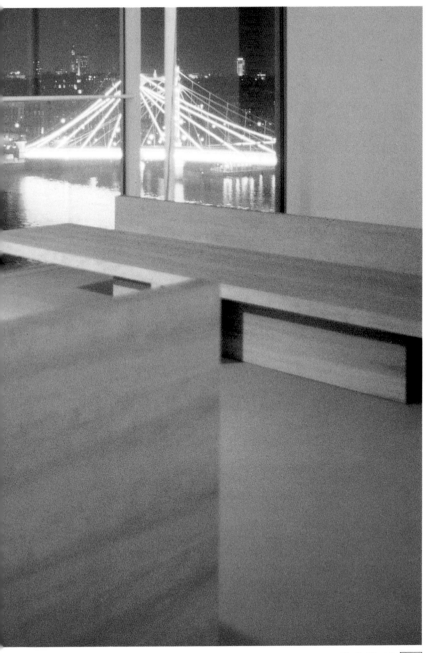

ABELL RESIDENCE

1100 Architect | © Michael Moran | New York City, US

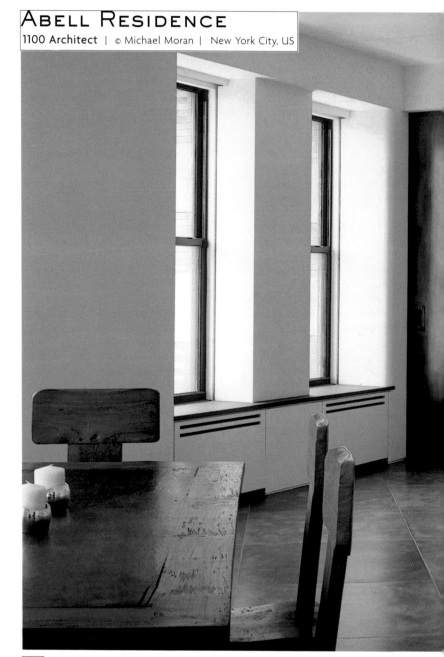

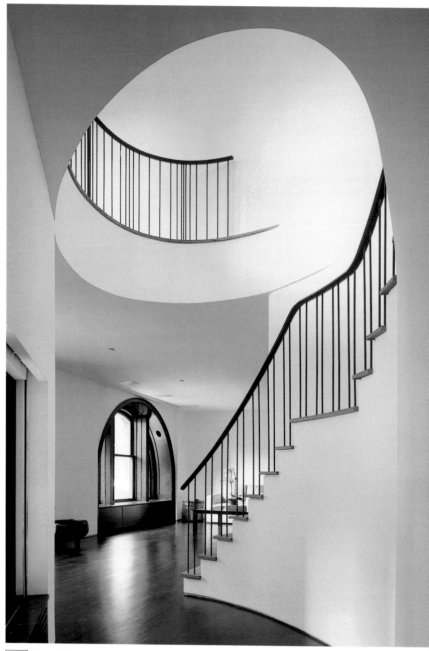

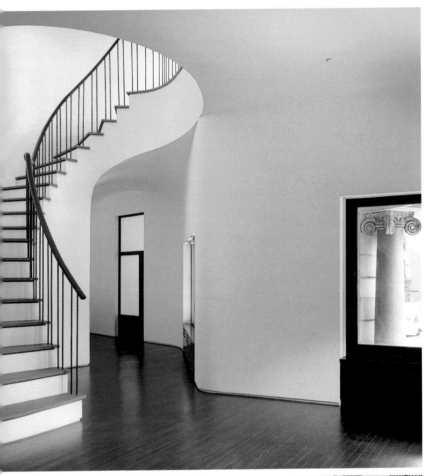

The main aim of the design of this downtown Manhattan residence is to integrate two separate floors into a single space. The spiral staircase and light well are unifying elements in the flowing strategy, suggesting a liquid element.

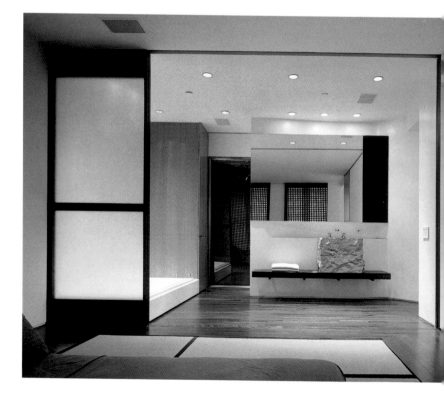

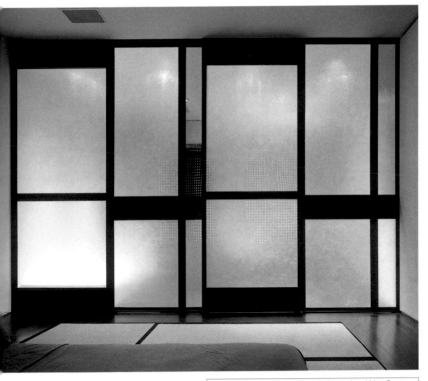

Crisp white walls are set off by dark wood and blue floors. The master bedroom suite is a minimalist interpretation, redefining the client's Asian home with its floor-level bed, floor mats, and translucent panels.

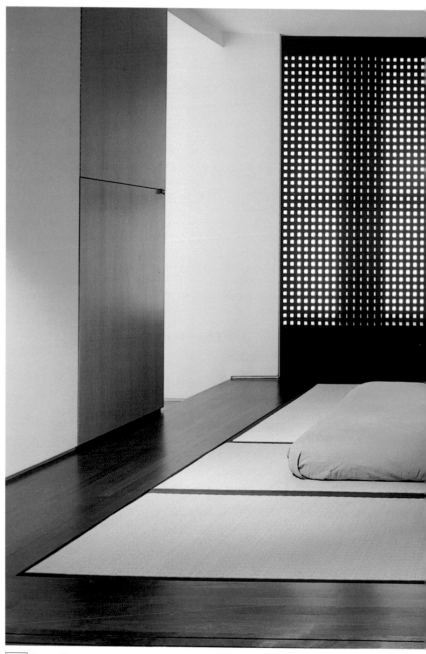

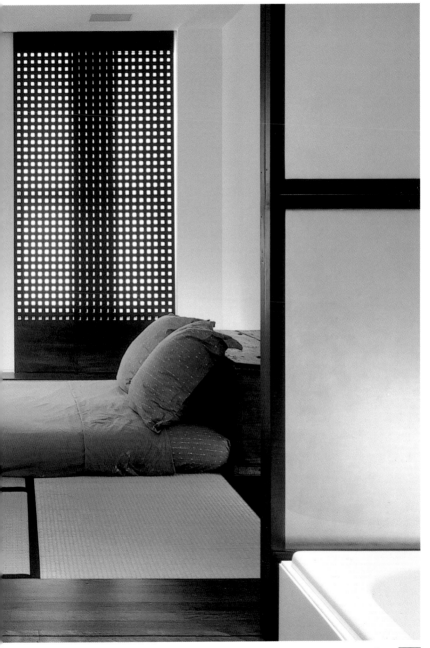

ARCHITECTS' RESIDENCE

Kashef Mahbood Chowdhury, M. Tabassum | © Kashef/URBANA | Dhaka, Banglades

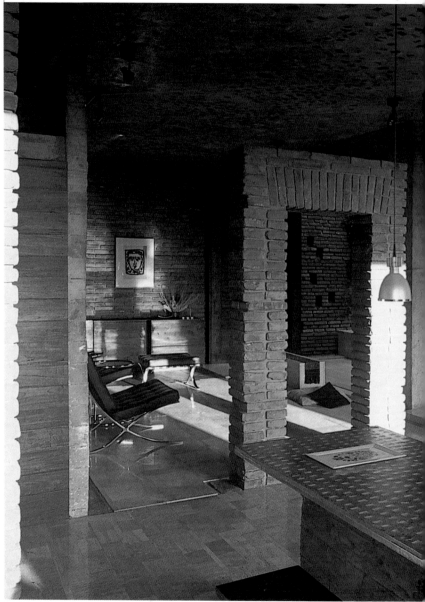

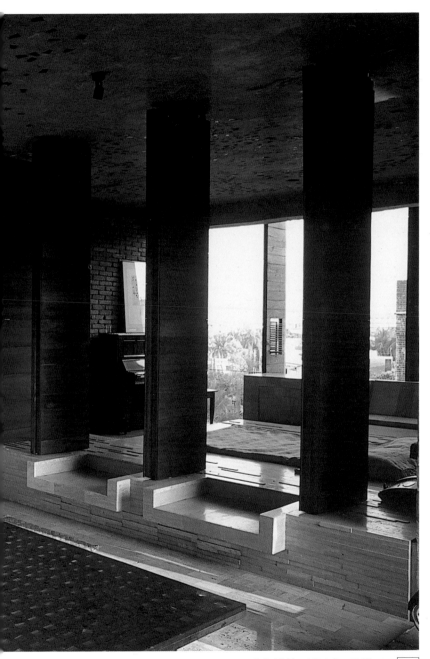

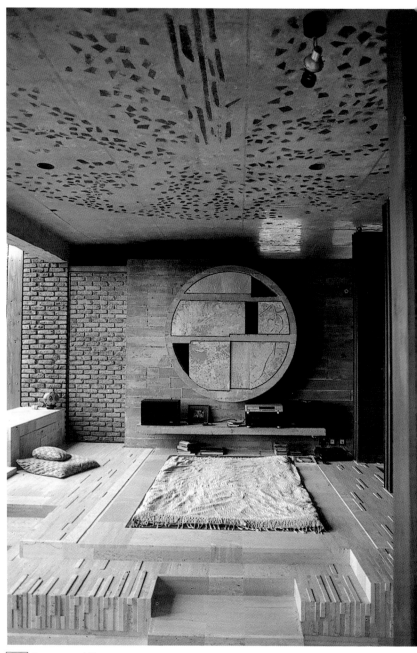

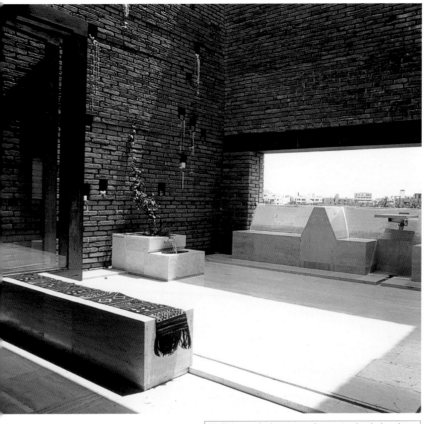

The living area looks out onto the courtyard and when the glass shutters are moved to one side, a veranda is produced. The dining area, which includes the kitchen, is organized like a courtyard.

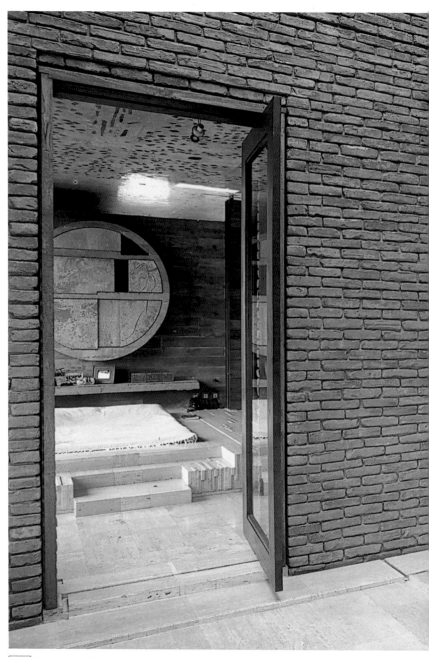

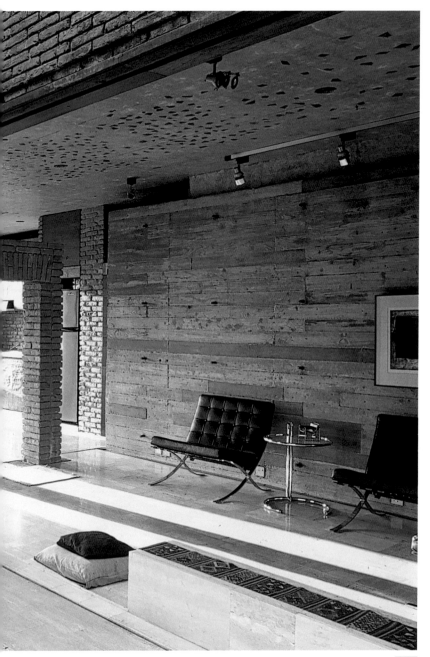

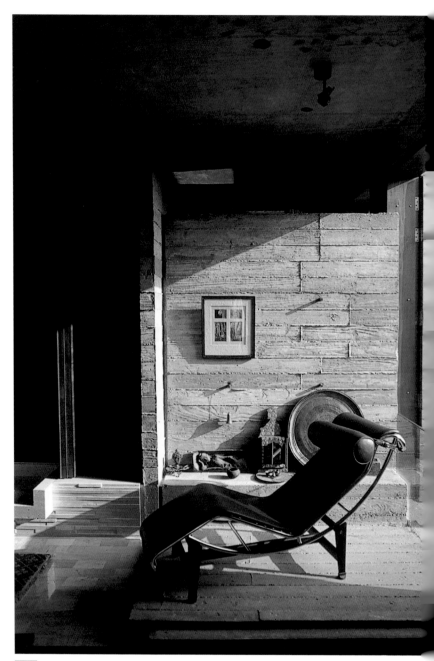

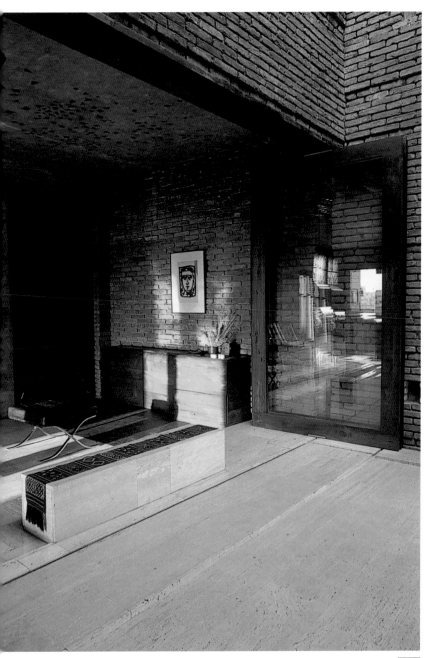

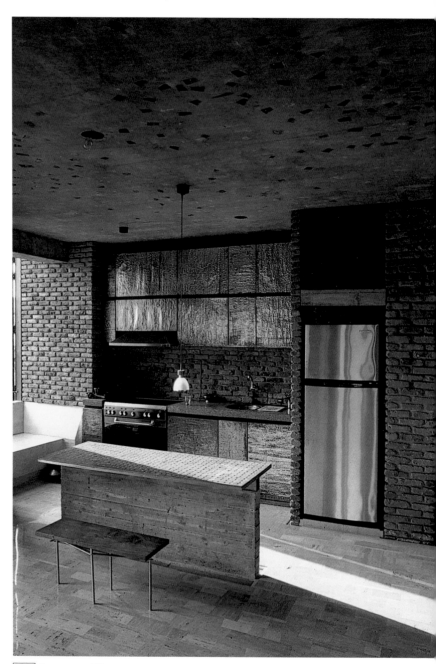

LOFT IN LONDON

Child Graddon Lewis | © Dennis Gilbert/View | London, UK

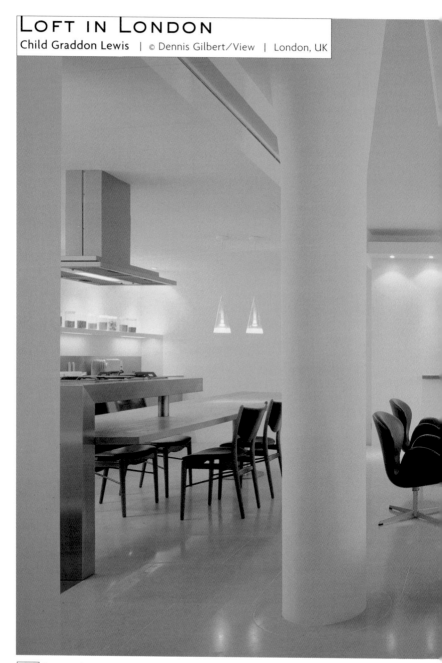

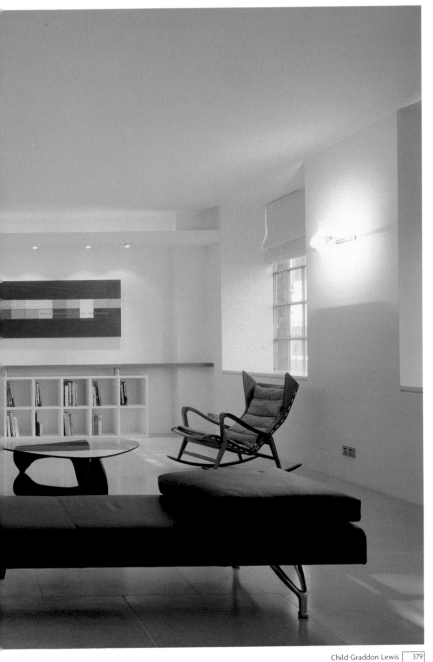

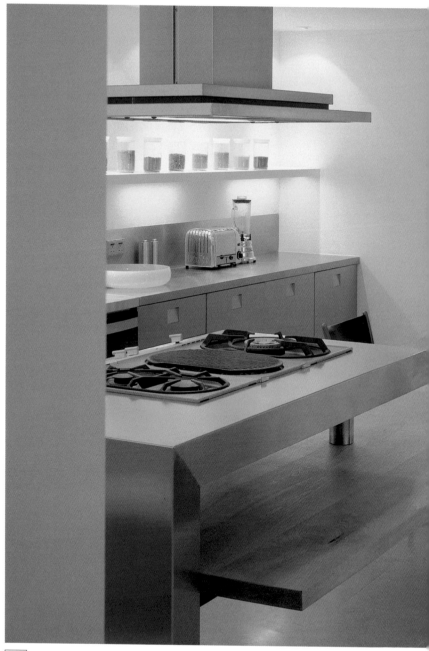

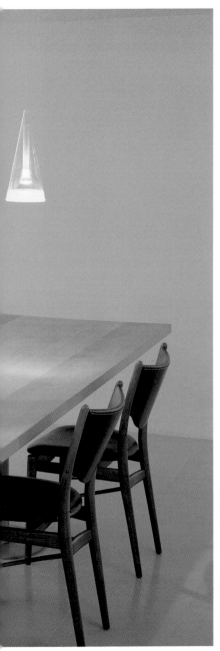

The architects planned a system of combining units on the vertical and horizontal axes to create spaces with different surfaces.

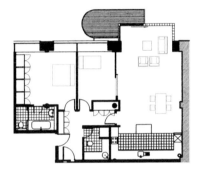

Plan

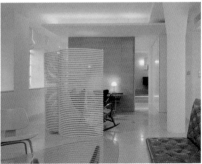

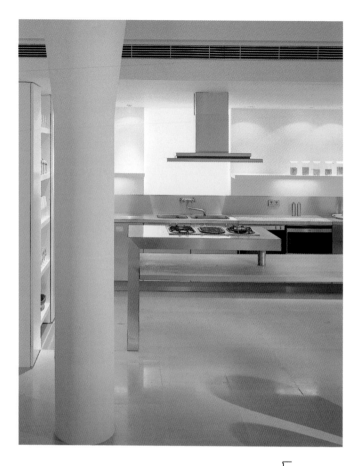

Section

LOFT IN LONDON

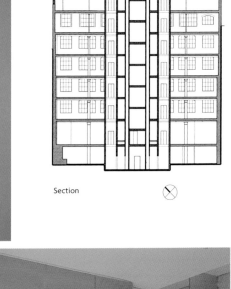

Section

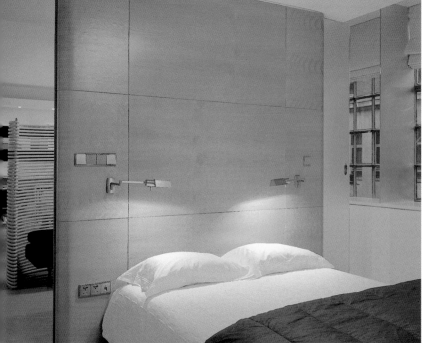

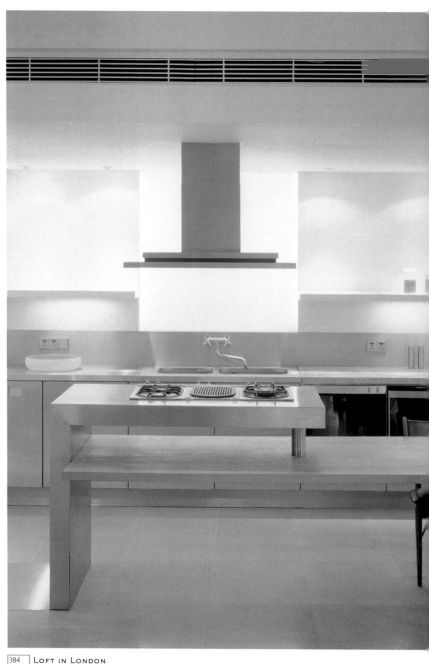

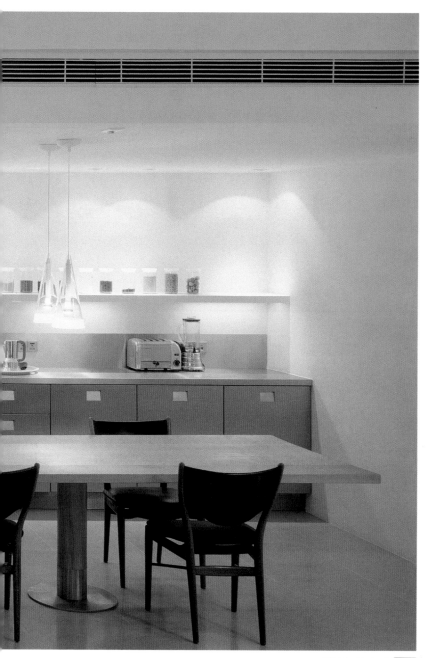

FORMER MANSION

B&B Estudio de Arquitectura, Sergi Bastidas | © Pere Planells | Barcelona, Spain

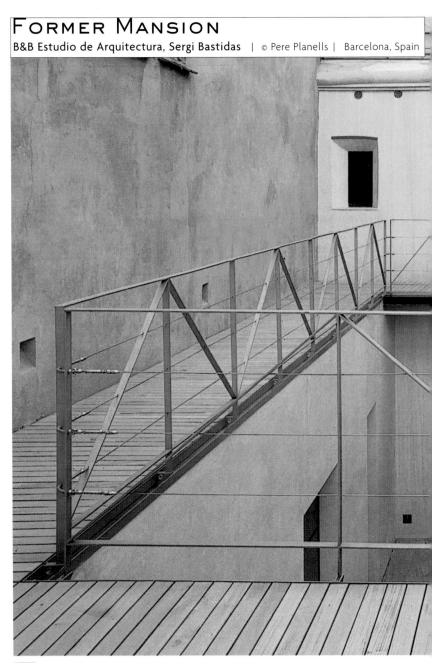

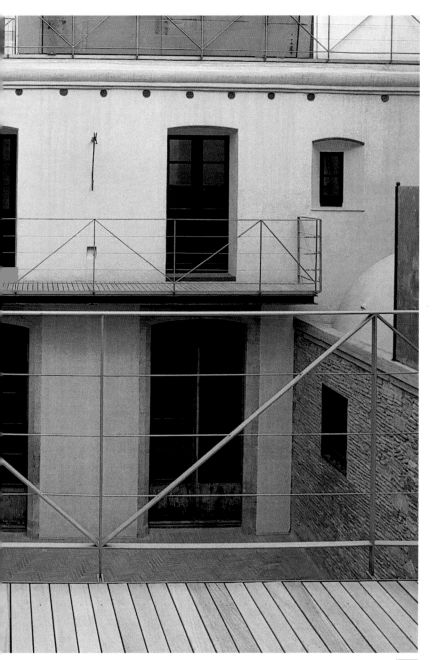

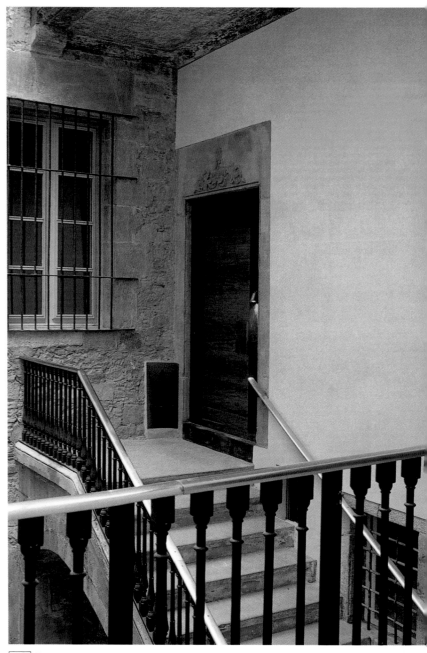

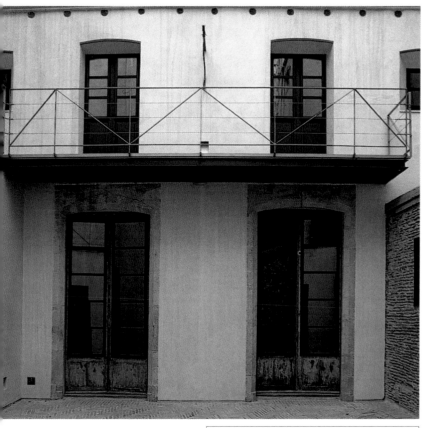

This apartment block is in an old manor house on one of the most traditional streets of the Gothic Quarter of Barcelona. The refurbishment of the whole building, which is part of the city's historical heritage, was intended to restore the original architecture.

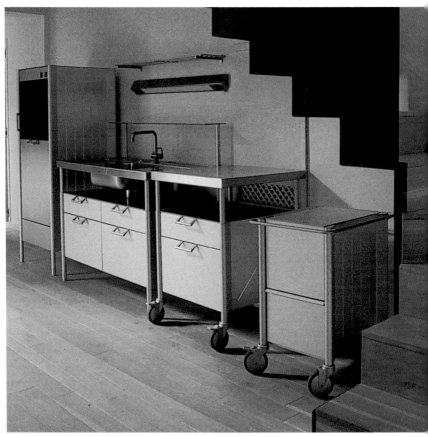

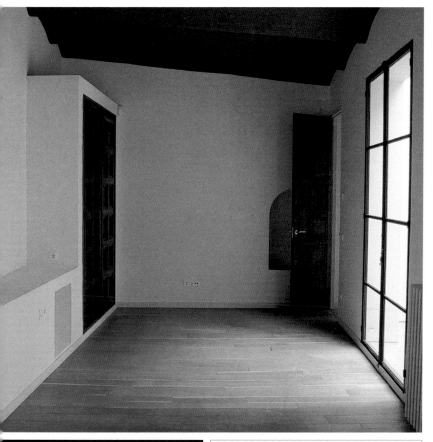

During the renovation process, rich and carefully worked polychromatic coffering from the 16th and 17th centuries was discovered, along with a Baroque chapel.

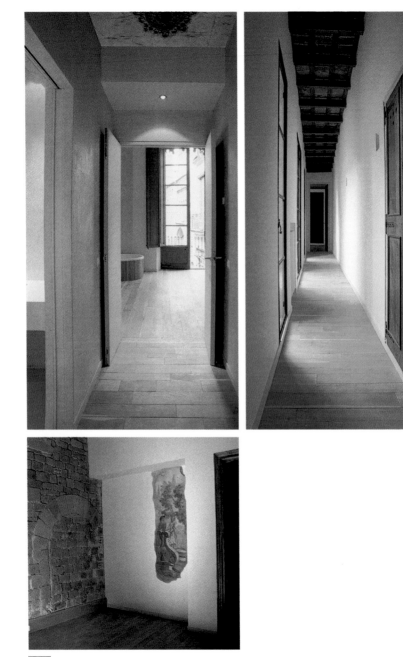

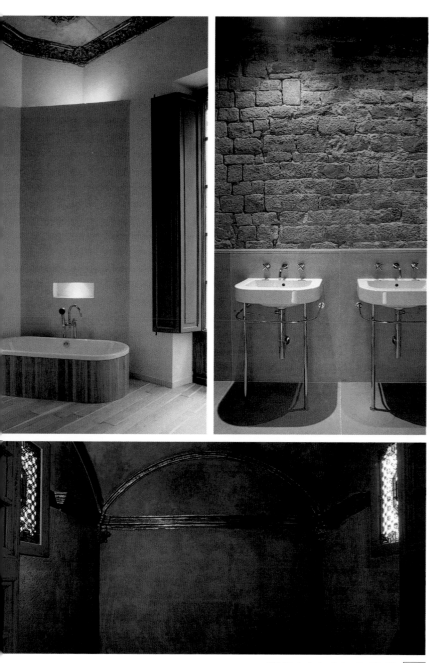

LOFT IN MILAN

Child Laura Agnoletto & Marzio Rusconi Clerici | © Matteo Piazza | Milan, Italy

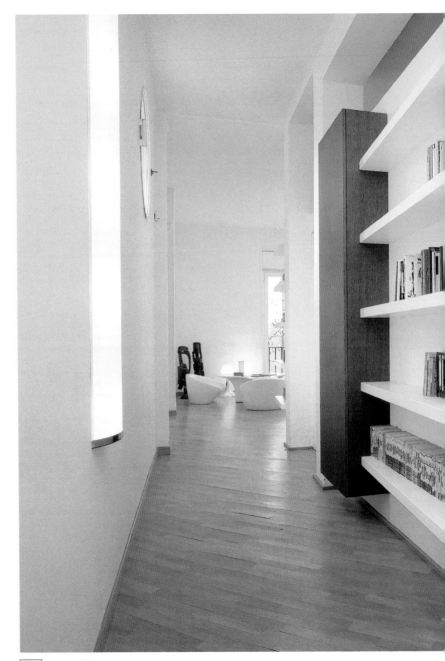

Interior perspectives

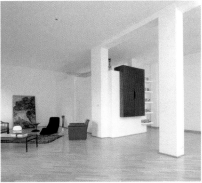

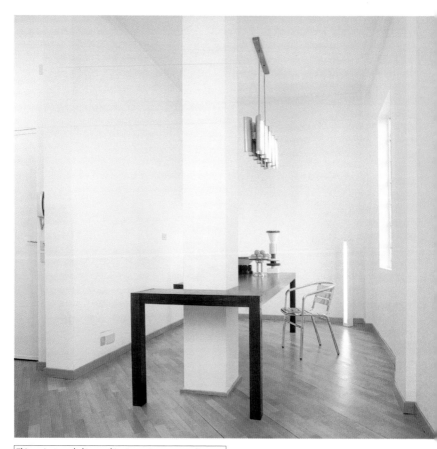

This project needed to combine two autonomous units and create a single unit with flexible ambience. The result is a large structured space that assigns a strict relationship among its three main elements: the living room, dining room, and library.

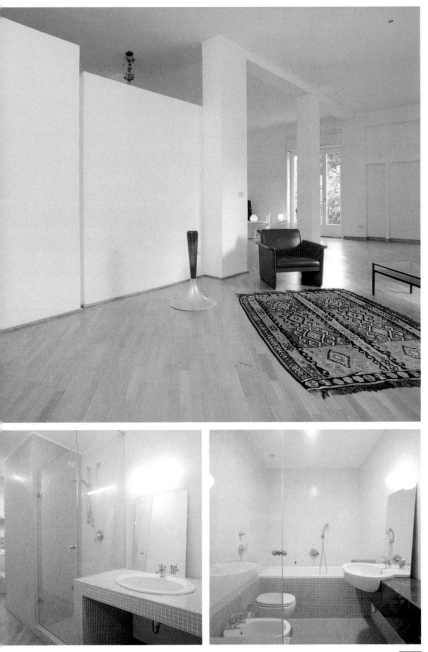

Child Laura Agnoletto & Marzio Rusconi Clerici

PUBLIC SPACES

VILLABLINO HOSPITAL

Tonet Sunyer | © Eugeni Pons | León, Spain

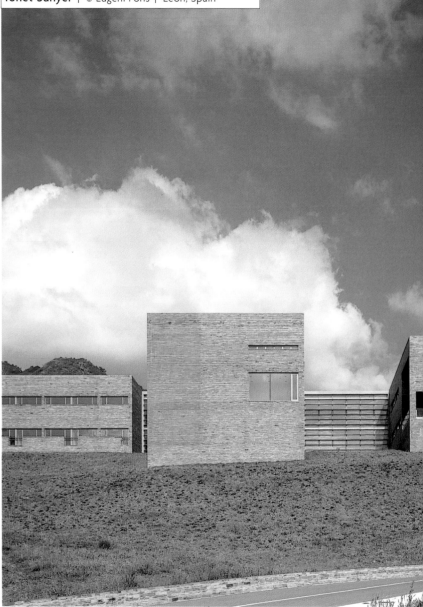

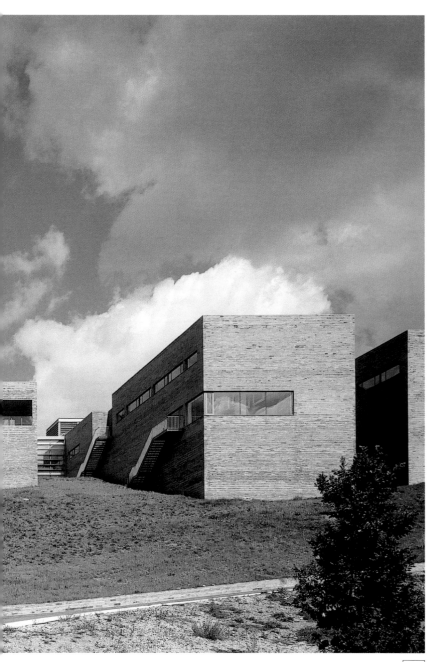

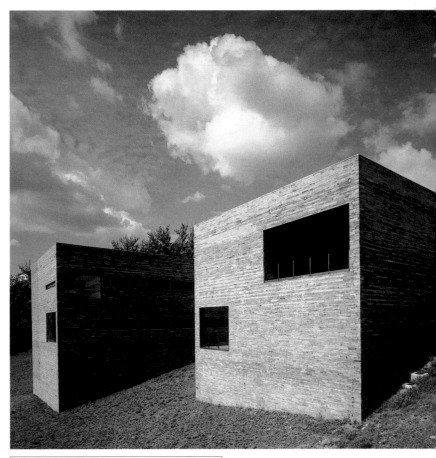

The exterior of the building is comprised of blocks that are apparently independent, but when examined closely are seen to link with a central axis. The building is integrated into the landscape on a low level.

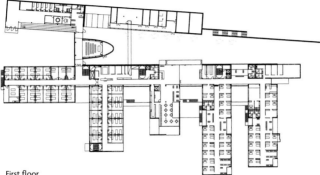

First floor

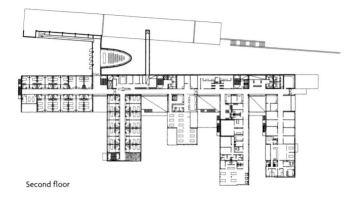

Second floor

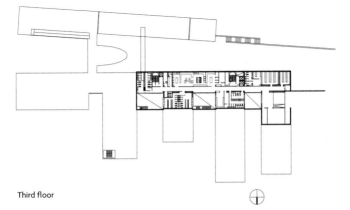

Third floor

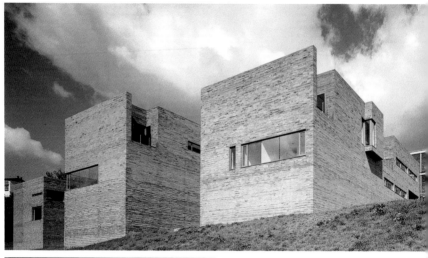

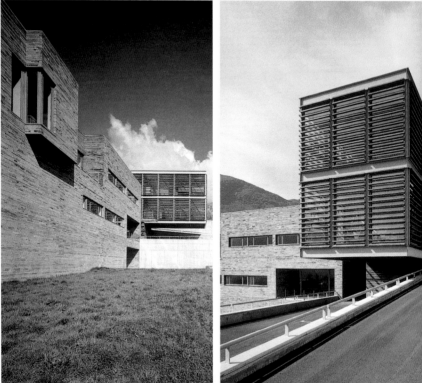

VILLABLINO HOSPITAL

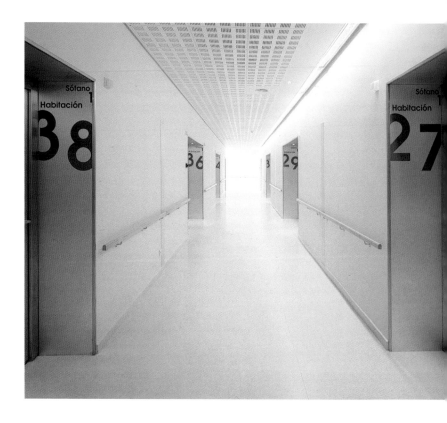

Elevation

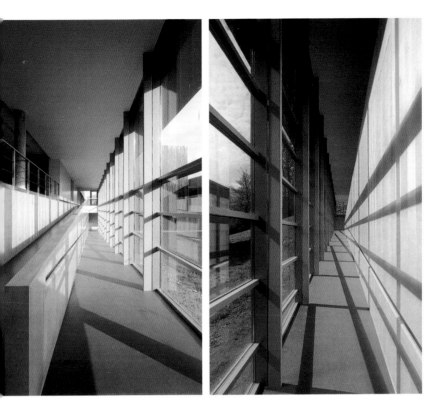

Elevation

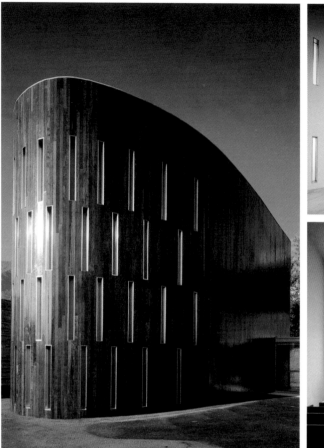

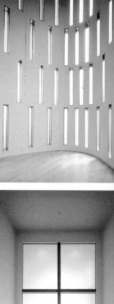

In the hospital chapel, natural wood was used to give the space warmth. The natural light participates in this task, penetrating the many windows.

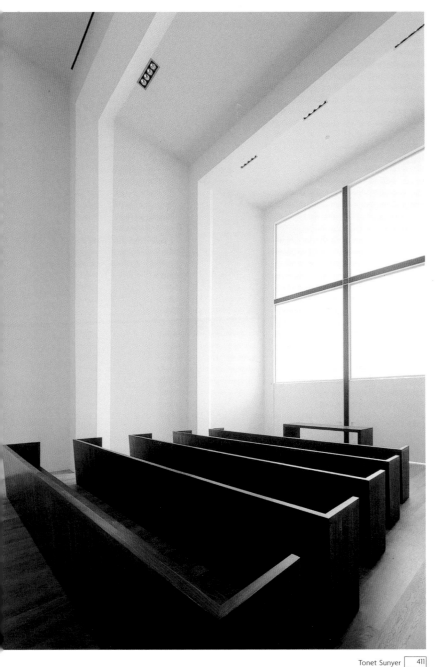

MUSEUM IN SARREBOURG

Bernard Desmoulin | © Michel Denance, Sebastien Andrei | Sarrebourg, Switzerland

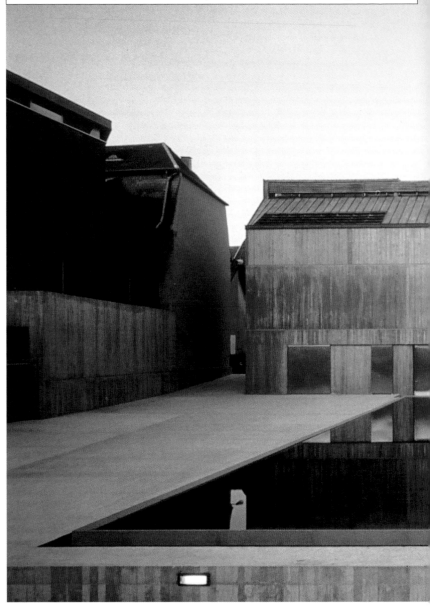

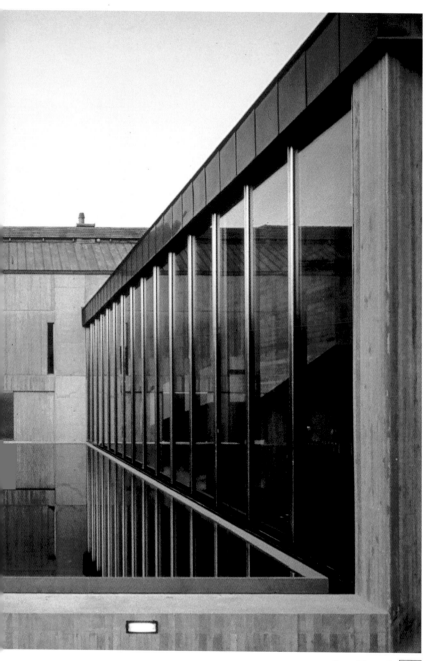

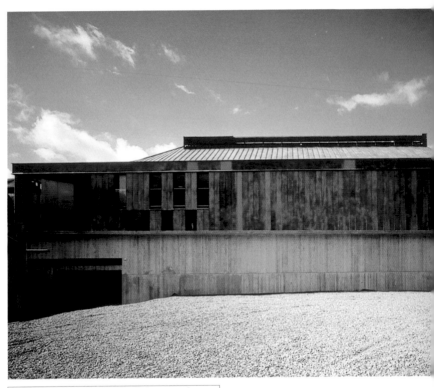

An architectural expression that gave coherence to the surroundings was sought in this rural location. The buildings, based on simple geometric forms, meet the needs of the climate and the different uses assigned to them. The admirably precise aesthetic of the location's farms and industrial buildings served as reference points.

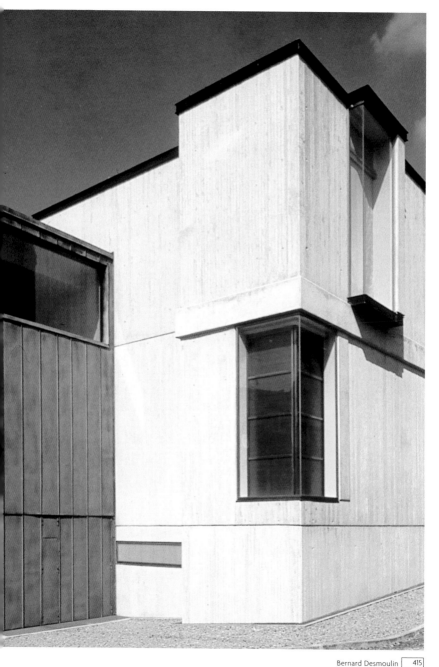

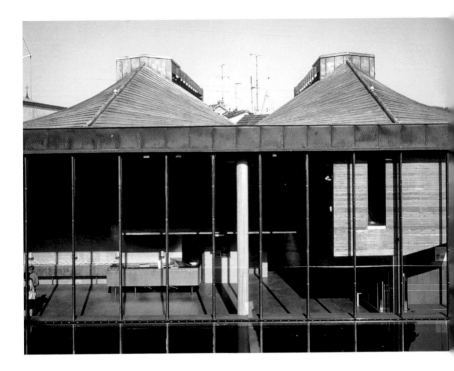

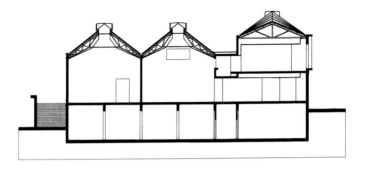

Section

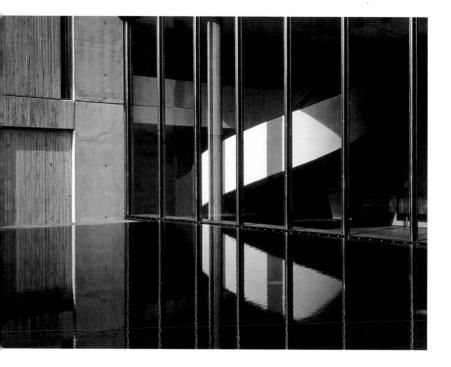

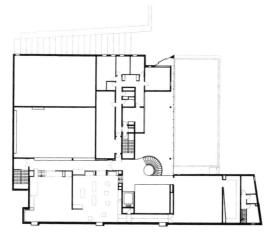

Plan

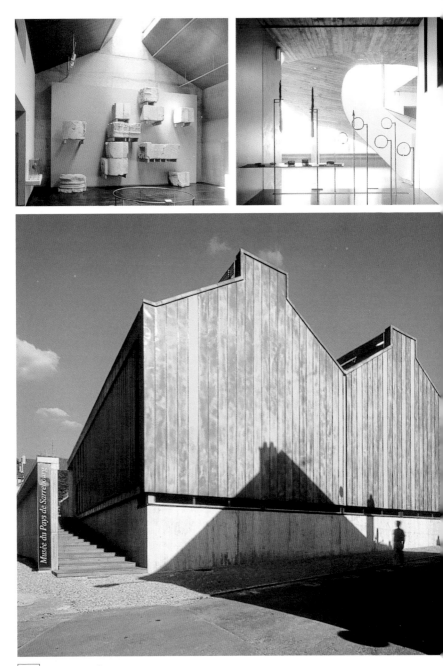

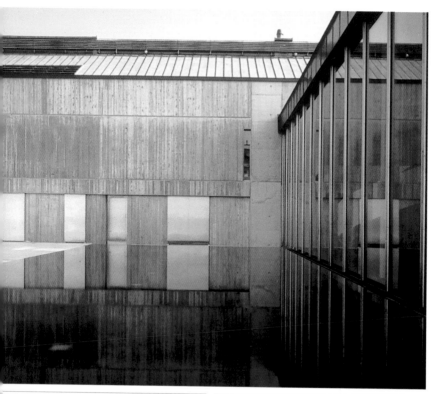

he aesthetic referents, born from manual labor, use a
mple volume made of copper or glass sheets and
xtaposed concrete blocks.

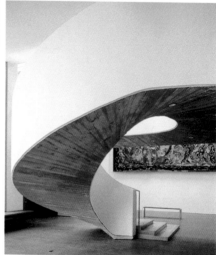

Church in Villalba

Ignacio Vicens, José A. Ramos | © Eugeni Pons | Madrid, Spain

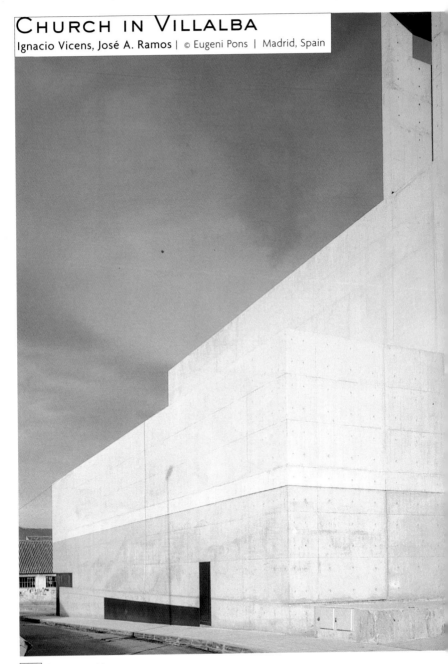

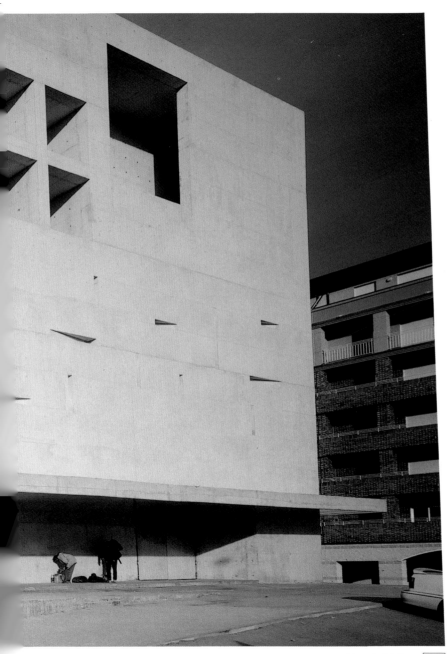

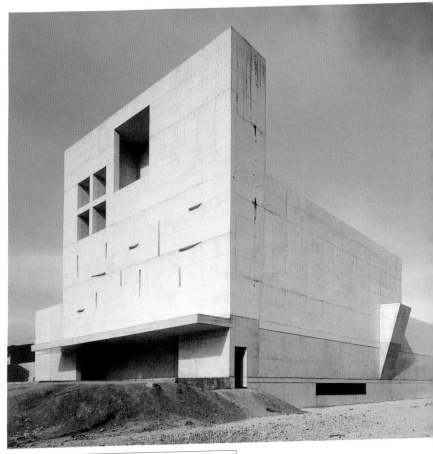

The treatment of the light in this building is the main feature. A succession of concrete screens, set parallel to each other, softens the light coming in from above. This light modulates to illuminate the space strikingly and play up the whole.

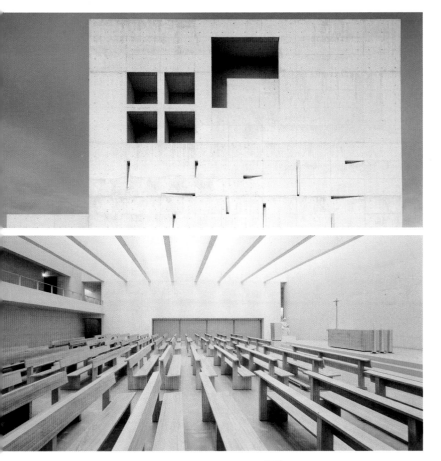

Section

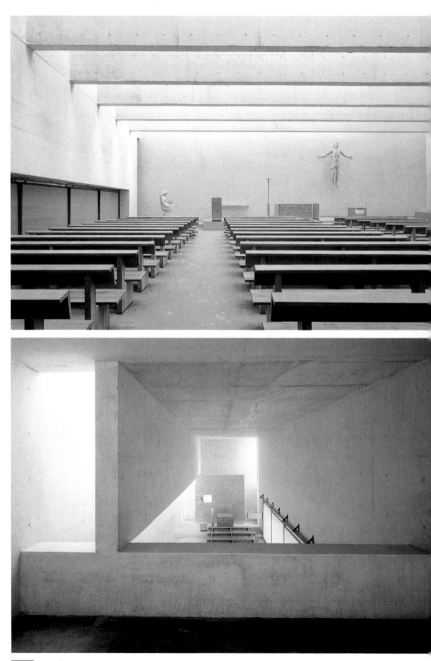

Church in Villalba

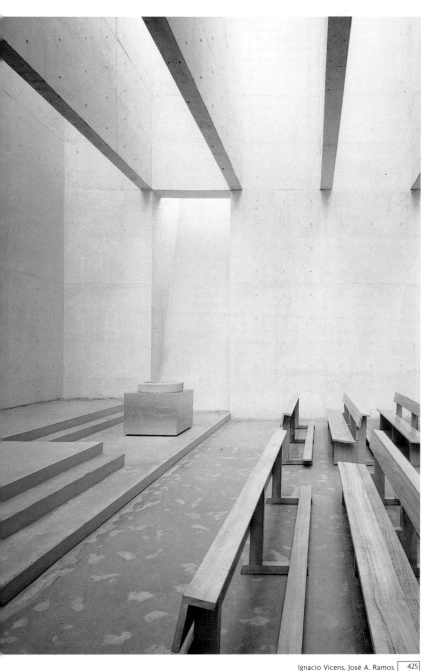

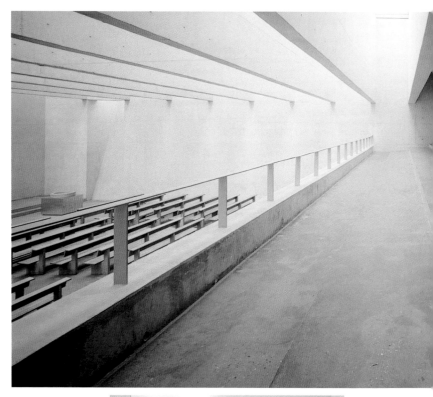

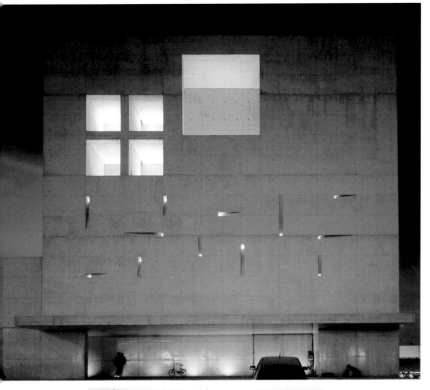

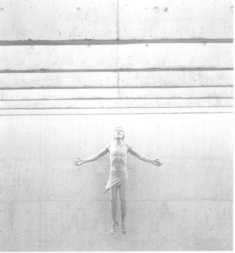

MORTUARY IN TERRASSA

BAAS | © Eugeni Pons | Terrassa, Spain

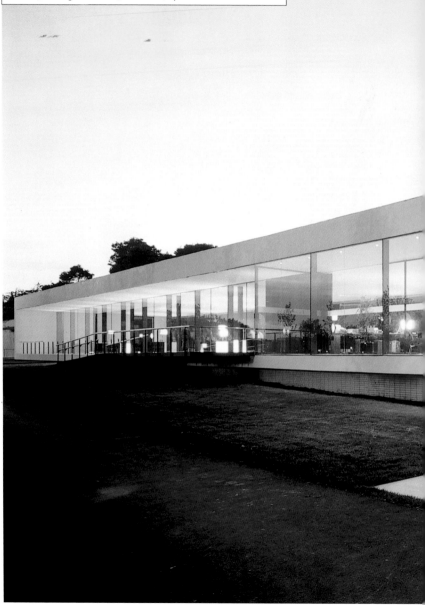

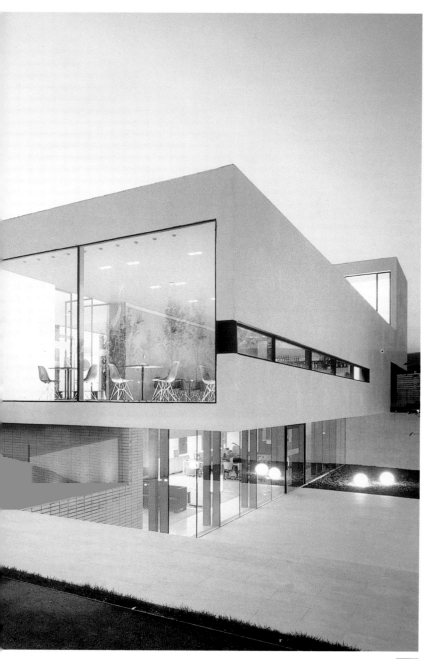

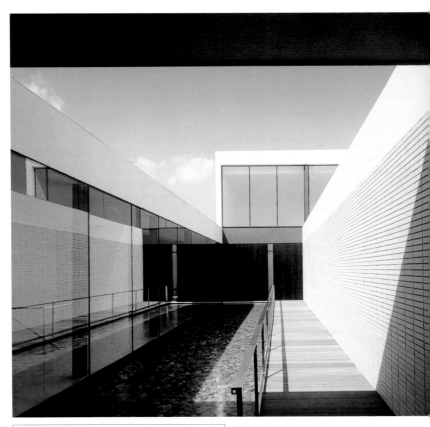

The play between the spaces is the main protagonist here. The glass façade of the open interior patios visually extends the surface. Natural materials like wood and water blend with the coldness of the glass, metal, and concrete.

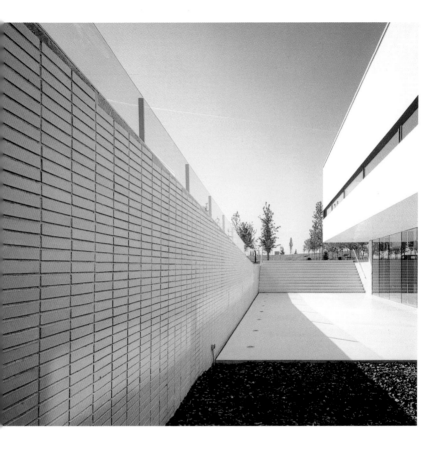

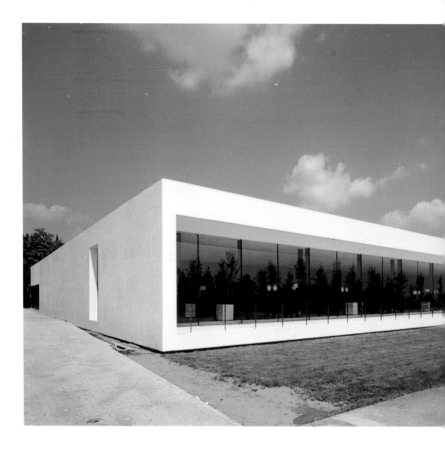

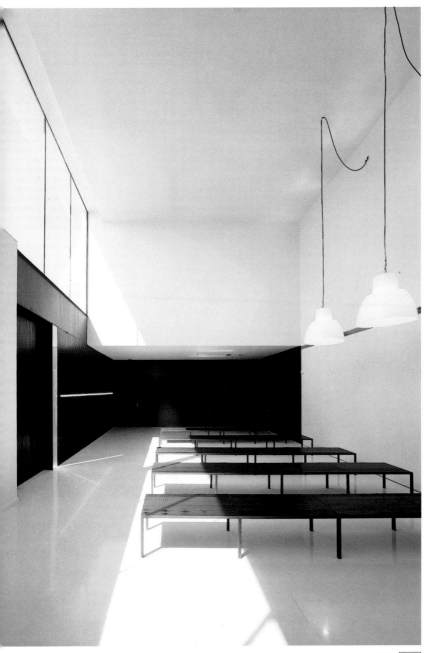

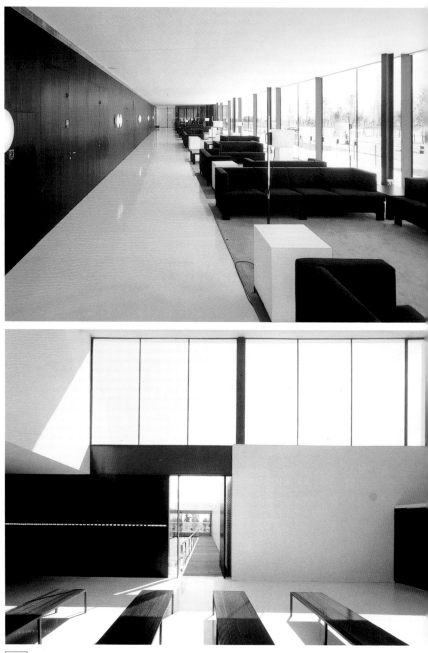

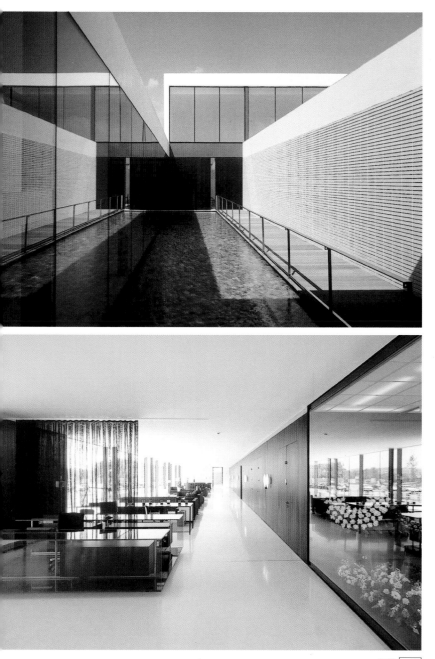

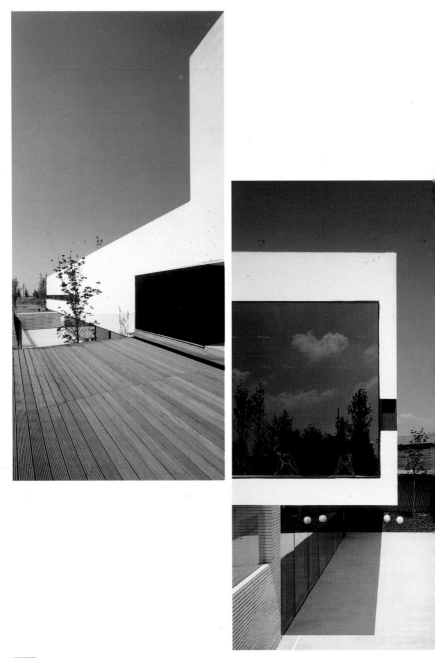

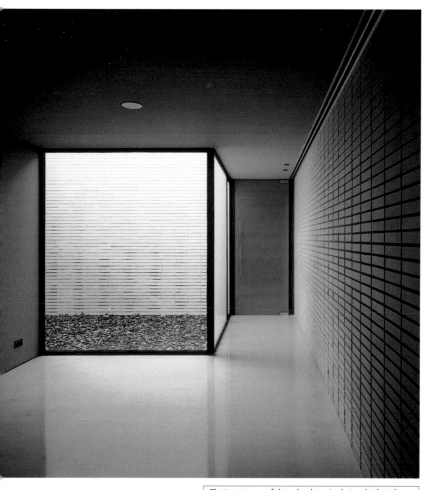

The importance of the cube shape is obvious both in the building's structure and in the openings, which are designed to maximize the use of natural light.

MATSUNOYAMA NATURAL SCIENCE MUSEUM

Tezuka Architects/Mias | © Katsuhisa Kida | Niigata, Japan

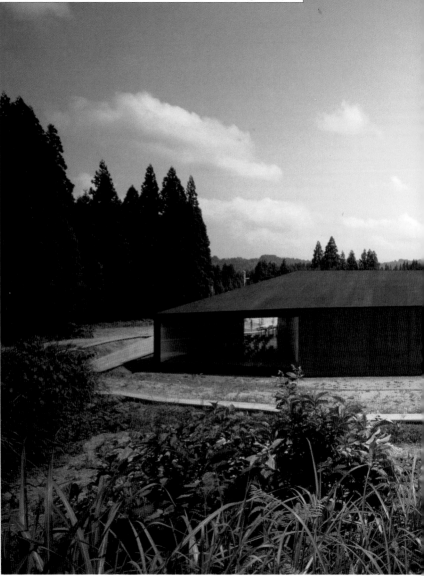

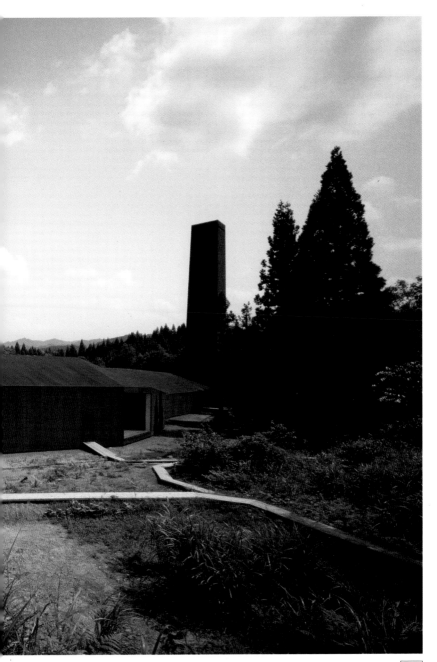

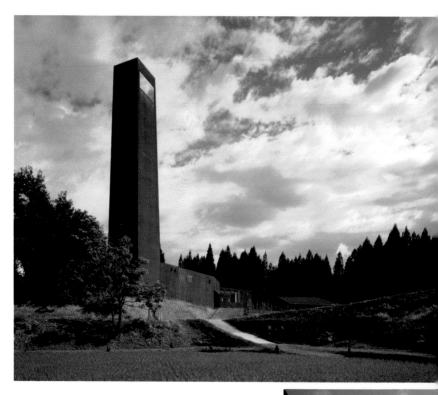

Plan

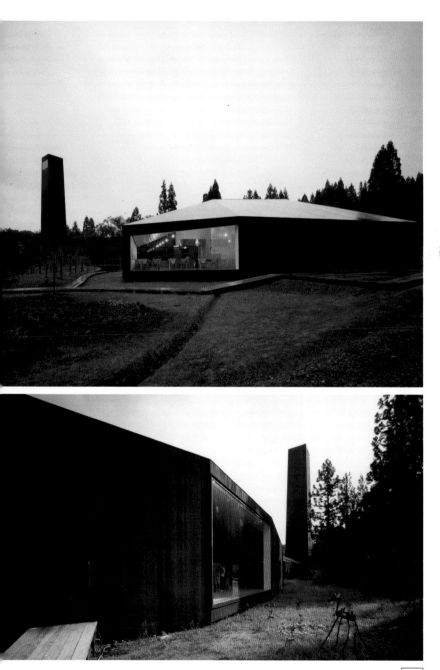

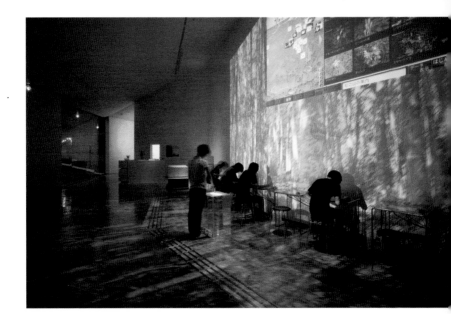

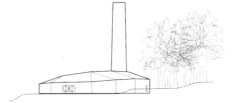

Elevations

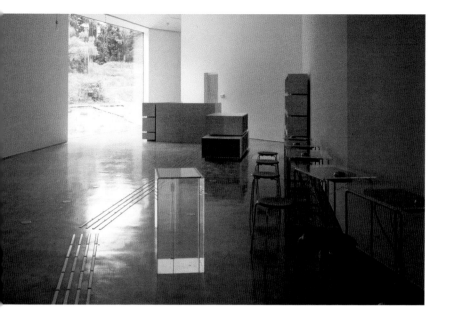

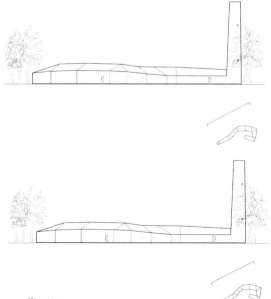

Elevations

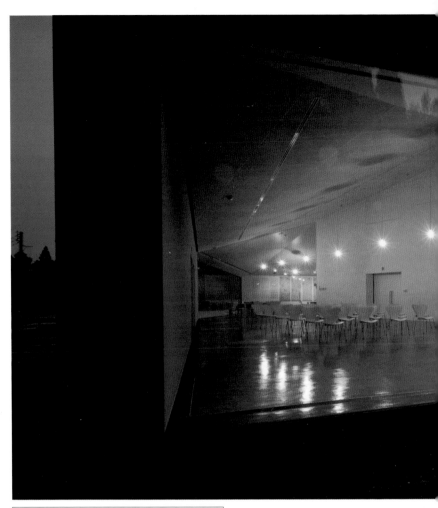

This 525-foot-long building adopts the form of a snake. It is finished in one-quarter-inch-thick monochromatic steel panels capable of withstanding pressures similar to those to which a submarine is submitted.

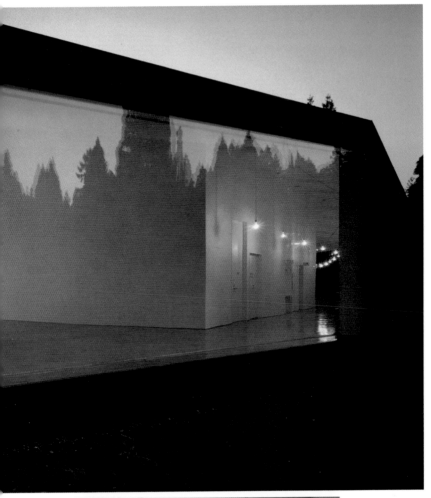

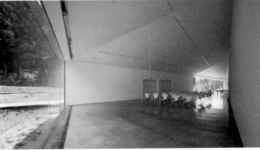

LIBRARY IN MONGAT

Eduard Sabater, Marc Soldevila | © Eugeni Pons | Barcelona, Spain

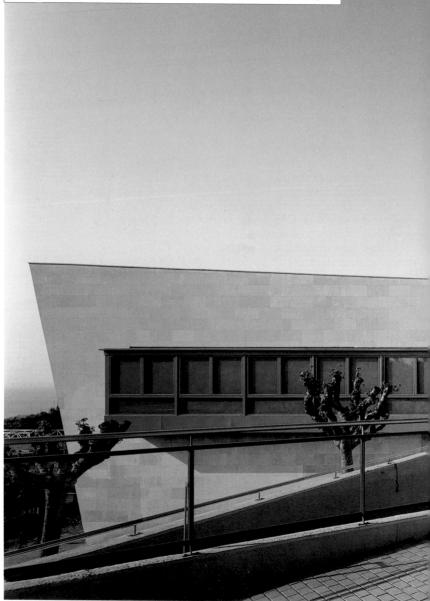

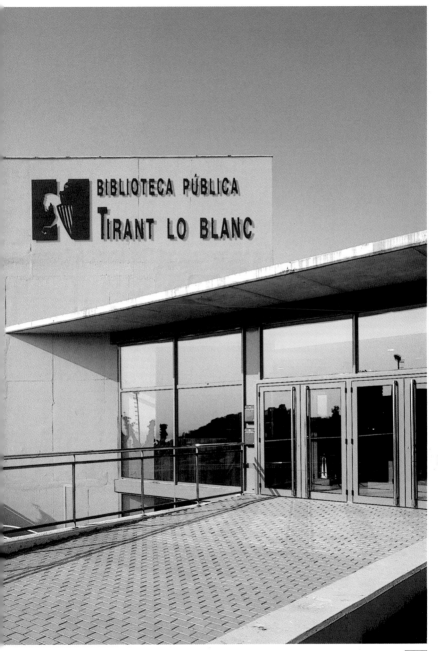

BIBLIOTECA PÚBLICA
TIRANT LO BLANC

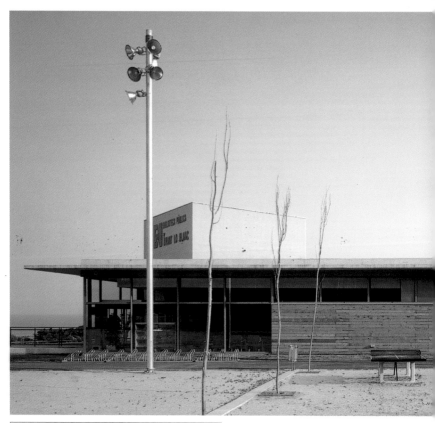

The play of horizontal lines forms the contour of this building: two compact volumes, one heavy and the other light, are firmly set into the slope to strengthen their integration into the surroundings.

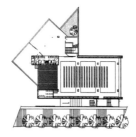

Basement

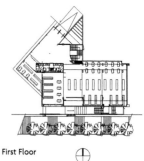

First Floor

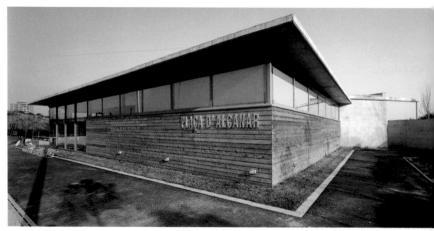

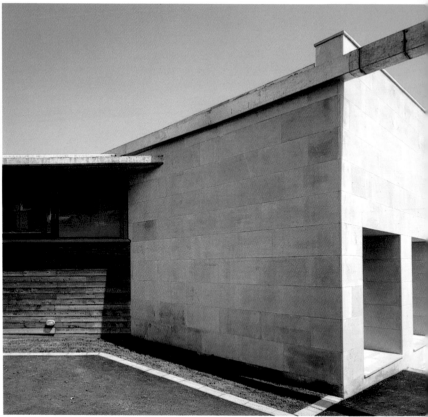

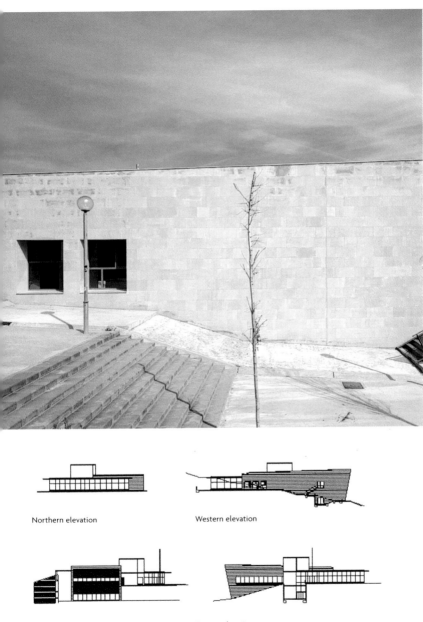

Northern elevation

Western elevation

Southern elevation

Eastern elevation

The public/private concept is generated and distributed around the vertical axis. Natural light flows into the patio to emphasize the intersection of the volumes.

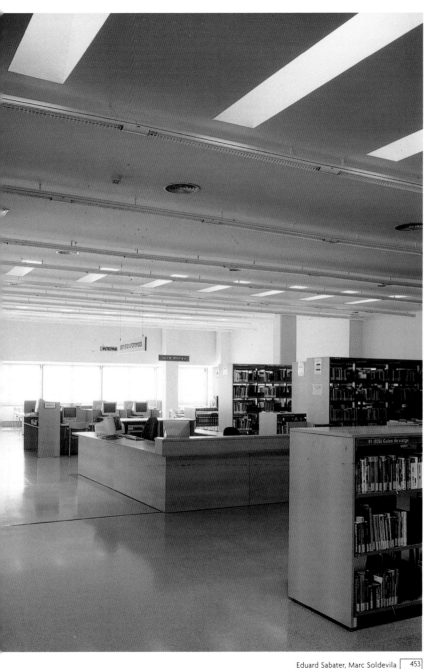

LAW SCHOOL

Aranda, Pigem & Vilalta | © Eugeni Pons | Girona, Spain

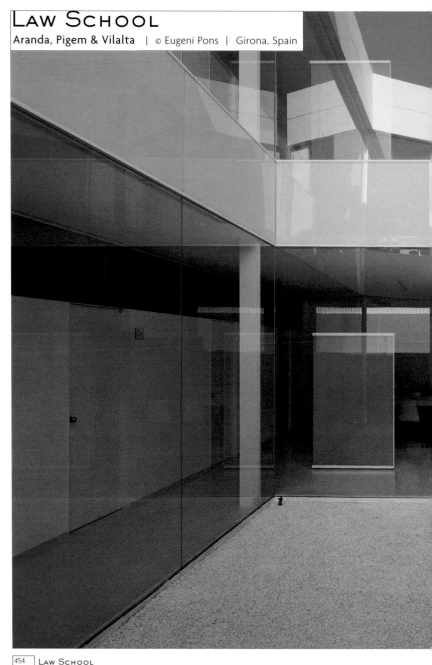

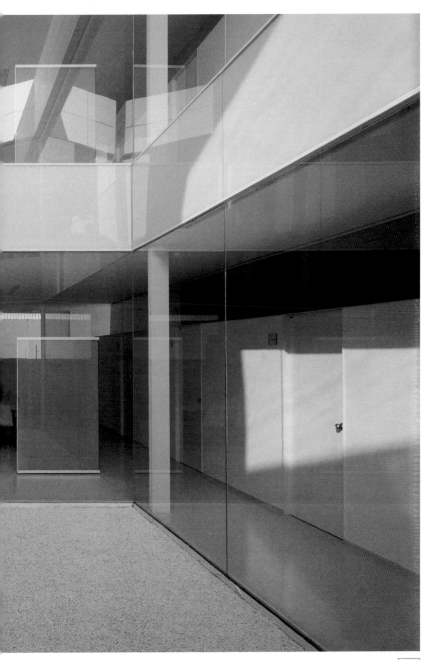

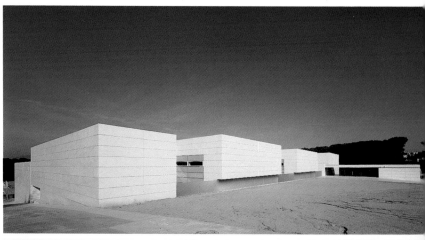

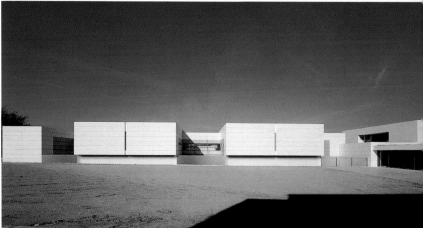

The project plays with occupied and unoccupied spaces.
The latter are open-air patios and terraces that connect to
the two-story interior passages and walkways.

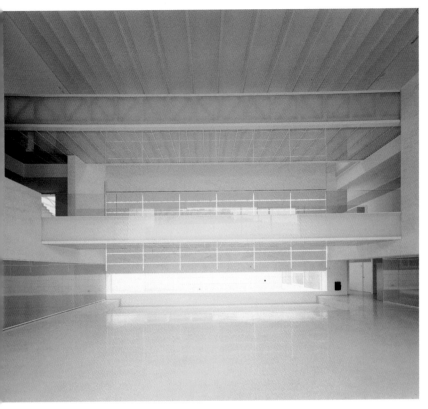

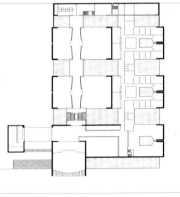

Plan

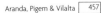

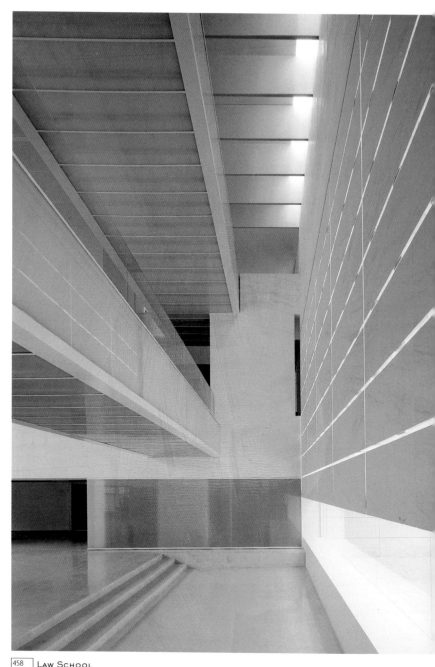

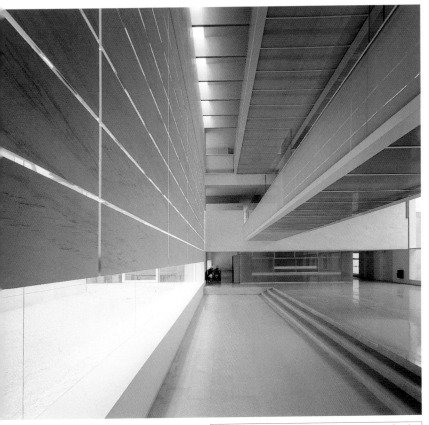

A functional interior "hides from" the exterior. Every façade employs the same material and lets natural light enter uniformly to give the building an integrated appearance.

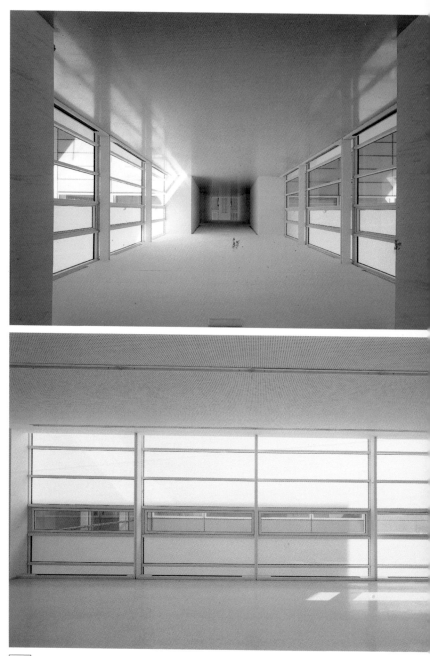

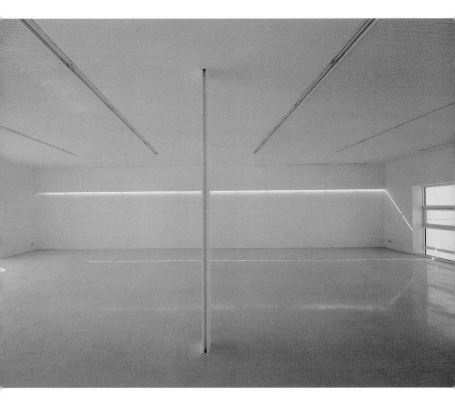

Ma Gallery

Hiroyuki Arima + Urban Fourth | © Koji Okamoto | Itoshima-gun, Japan

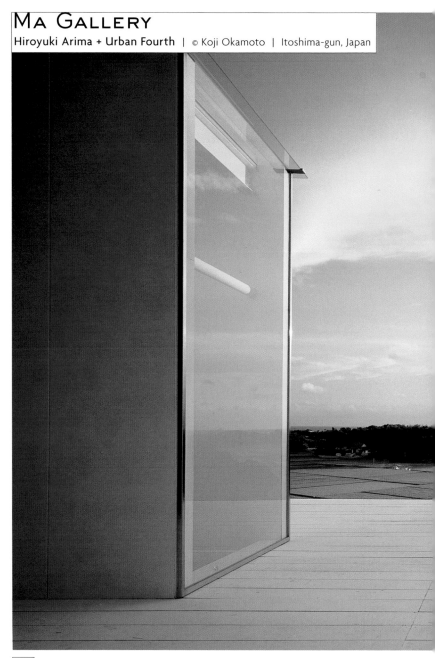

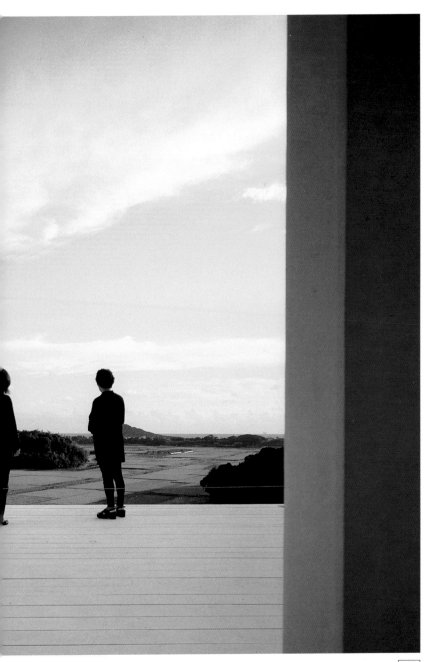

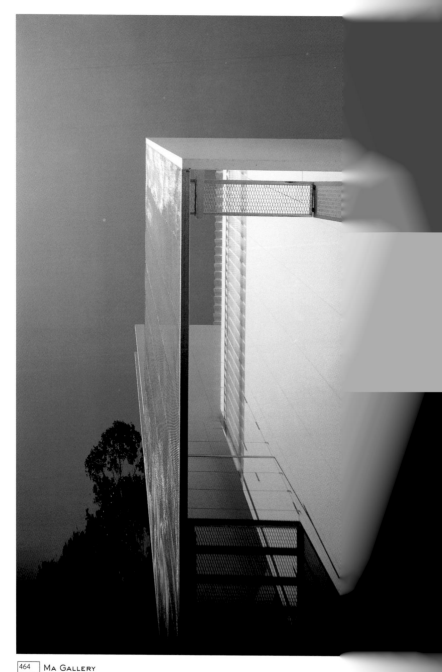

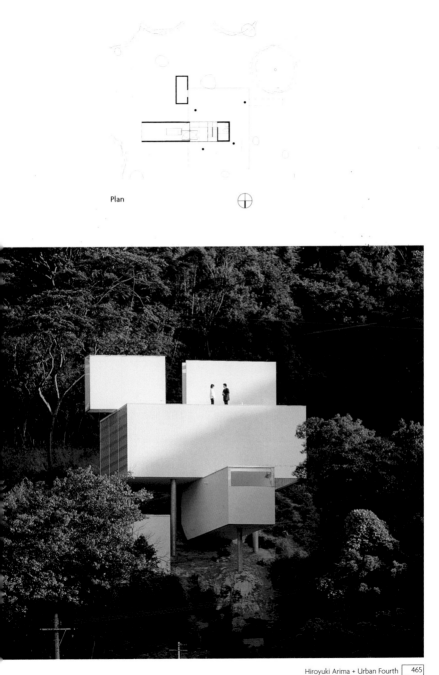

Plan

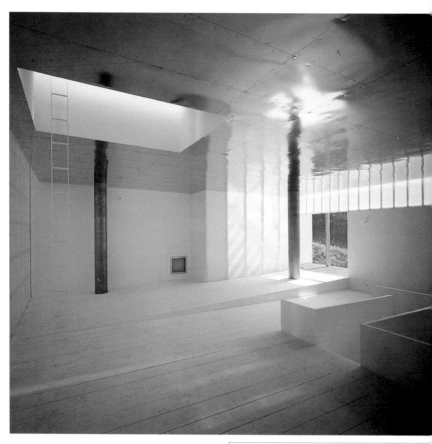

Common materials like concrete, cedar planks, sheet tin, corrugated polycarbonate, and wire mesh combined to generate flexible, flowing spaces.

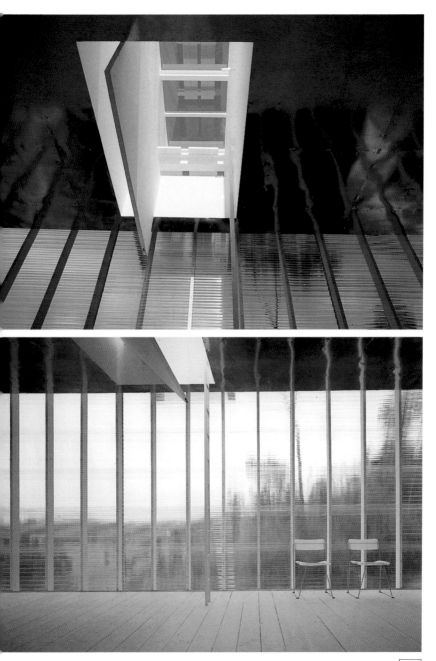

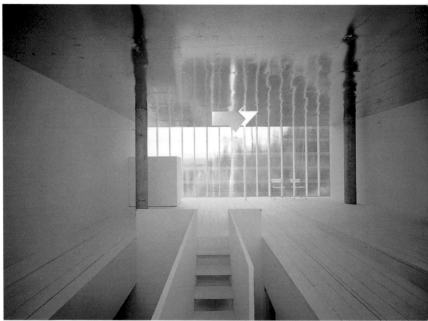

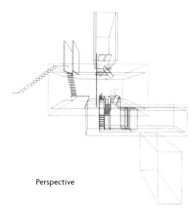

Perspective

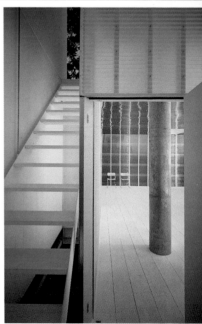

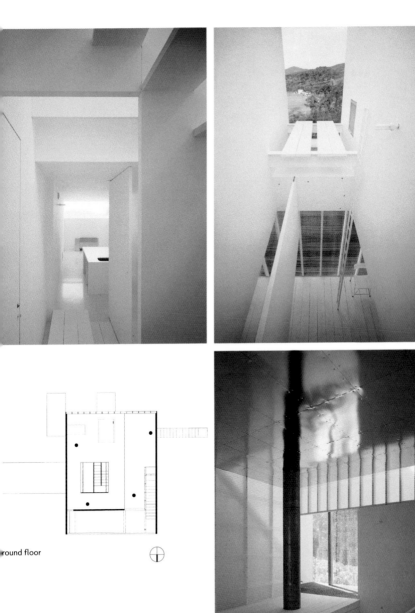

 round floor

JULIE SOHN BOUTIQUE

Conrado Carrasco and Carlos Tejada | © Eugeni Pons | Barcelona, Spain

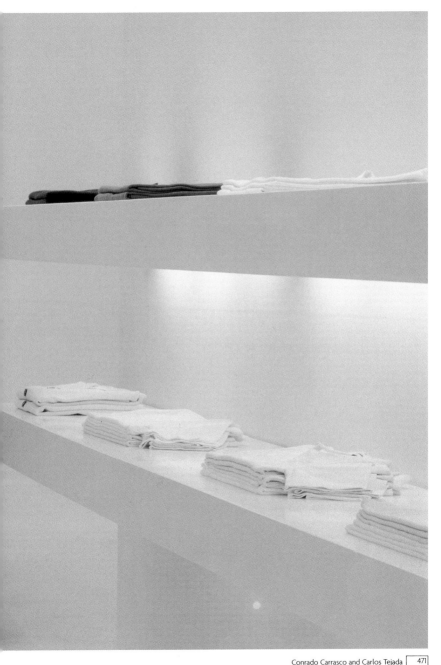

Section

Plan

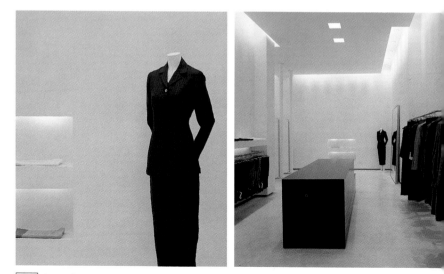

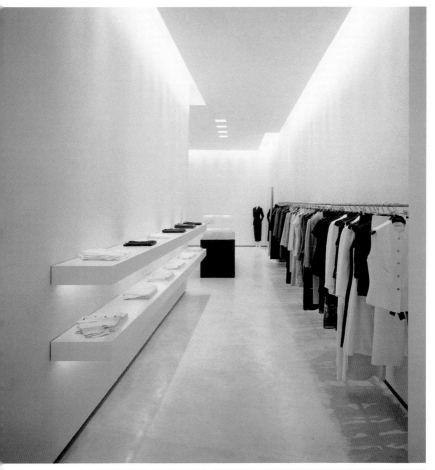

The organizing concept is open, neutral space. Clothes may thus be displayed like works of art, a design concept inspired by the art galleries on the same street.

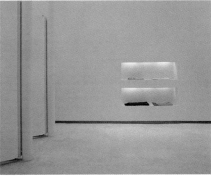

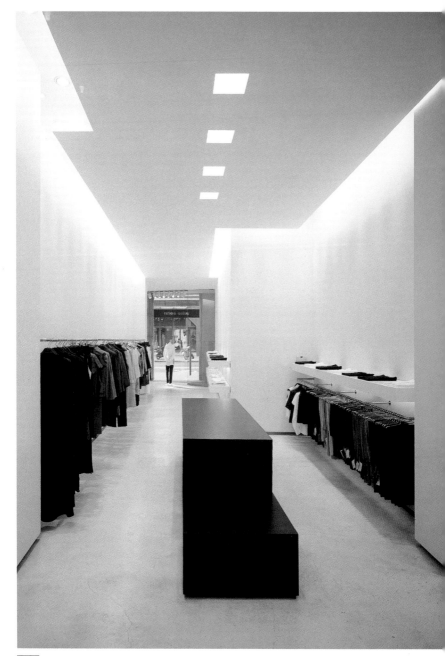

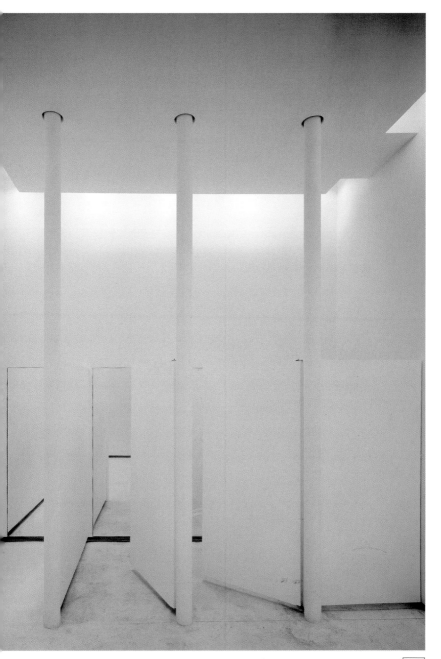

DOLCE & GABBANA BOUTIQUE

David Chipperfield Architects & P+ARCH | © Dennis Gilbert | Nishinomiya, Japan

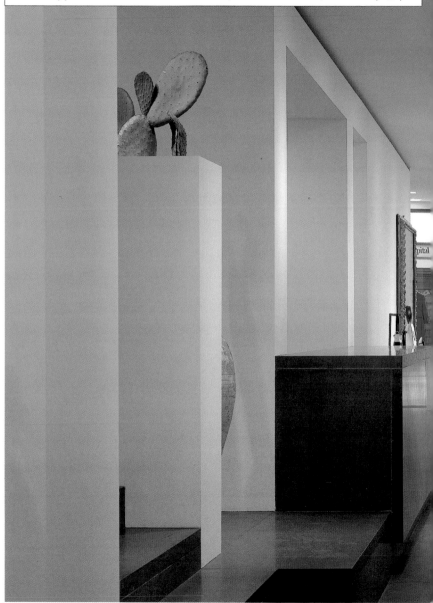

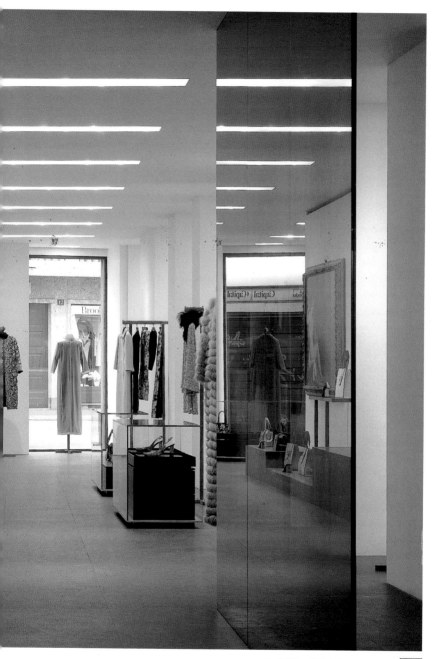

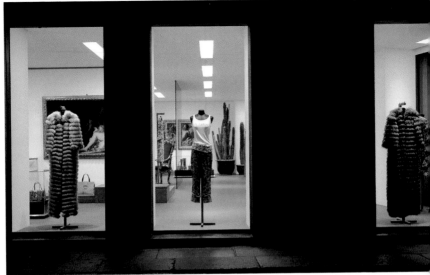

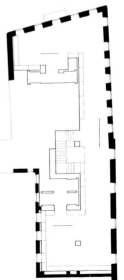

First floor

Second floor

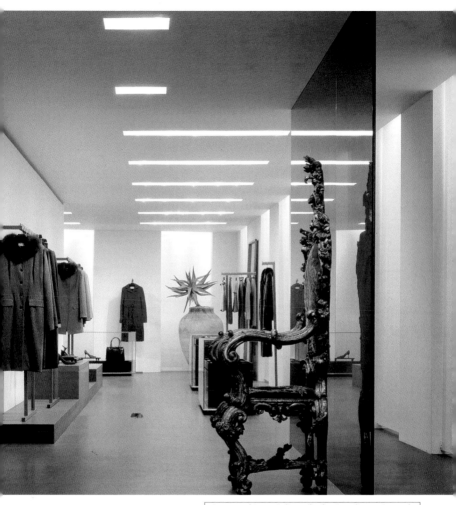

Austere architectonic lines take the viewer's attention to the merchandise. Dolce & Gabbana rounded off the boutique's appearance with a range of accessories to compensate for the minimalist aesthetics, including baroque chairs, pictures, sculptures, zebra skins, and plants.

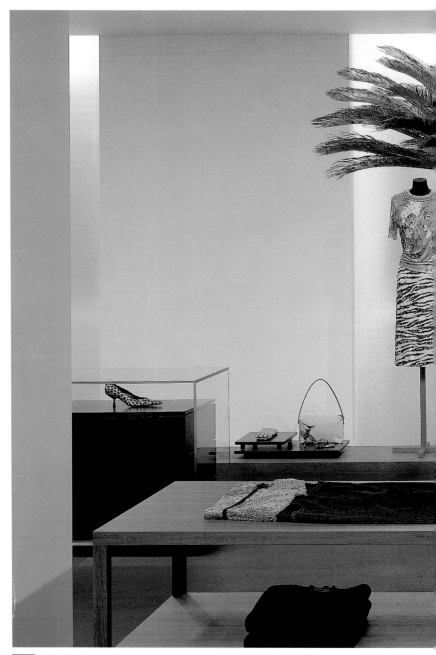

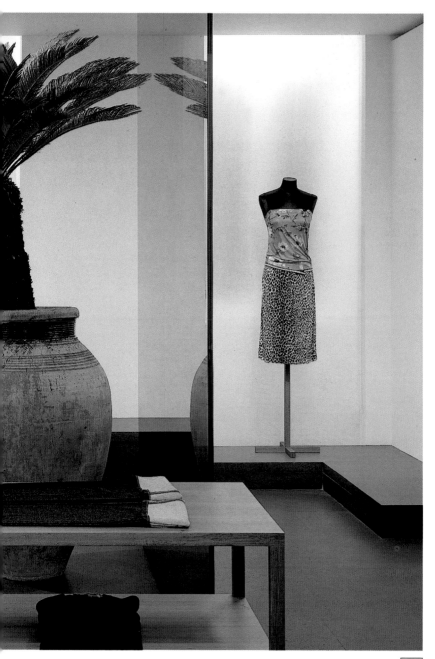

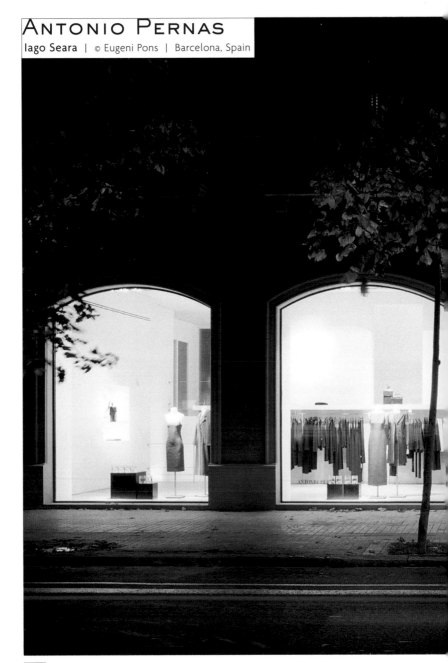

ANTONIO PERNAS

Iago Seara | © Eugeni Pons | Barcelona, Spain

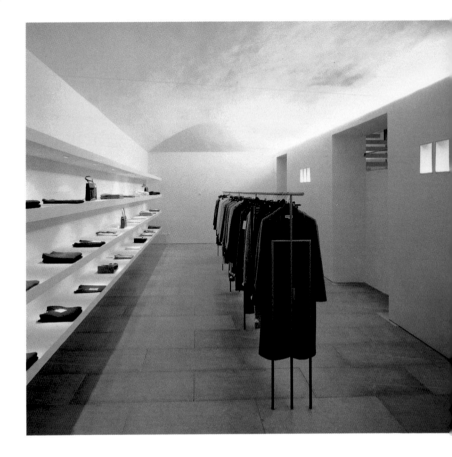

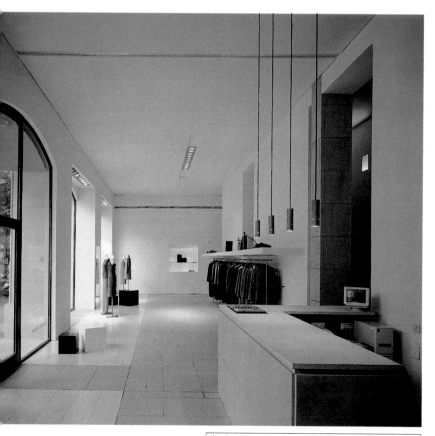

The shop represents the image of the commercial firm, identifying itself with the philosophy of the brand name and with the product targeting a specialized market. Thus, the space was renovated with natural materials like wood and stone.

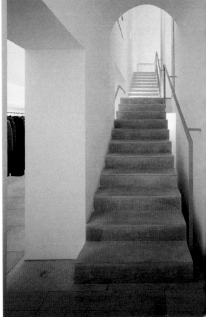

Lighting comprises one of the most important aspects: the light brings out the product on display and creates a context of tranquillity that stimulates purchases.

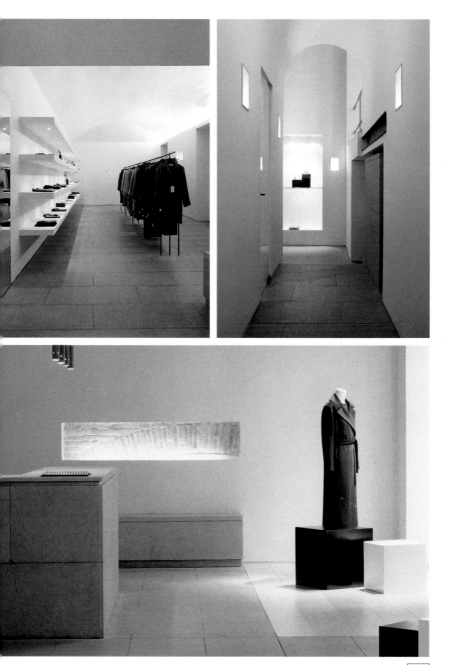

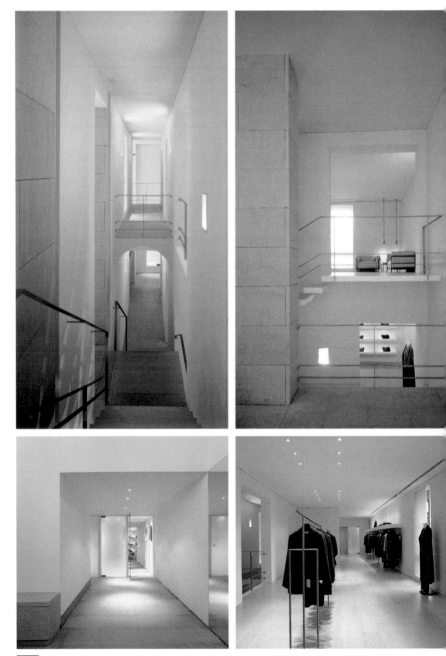

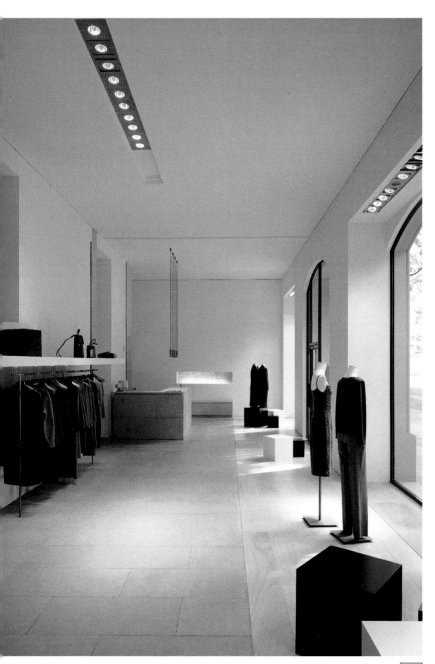

SHOP IN XIRIVELLA

Cristina Gómez García | © dual-AC | Xirivella, Spain

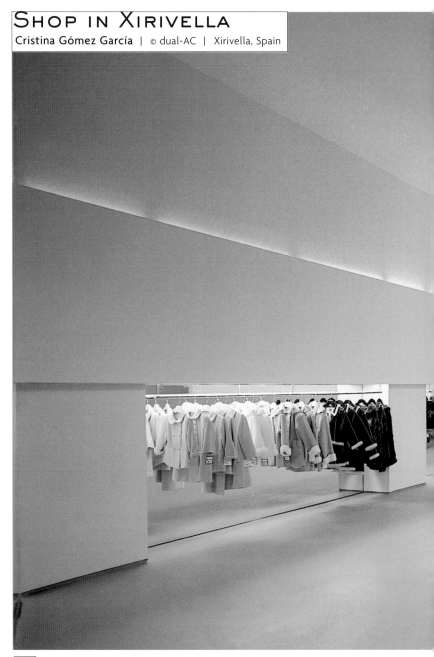

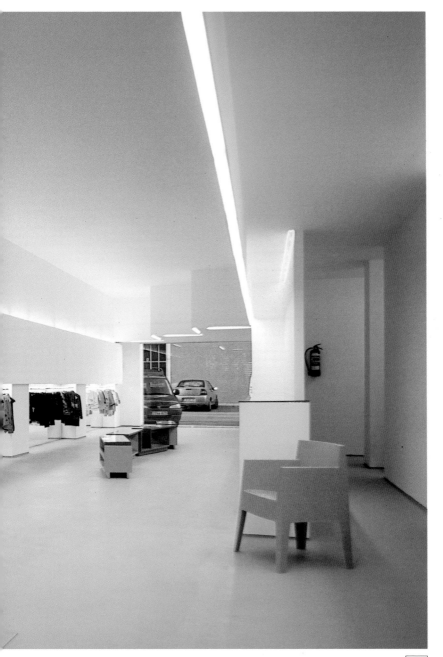

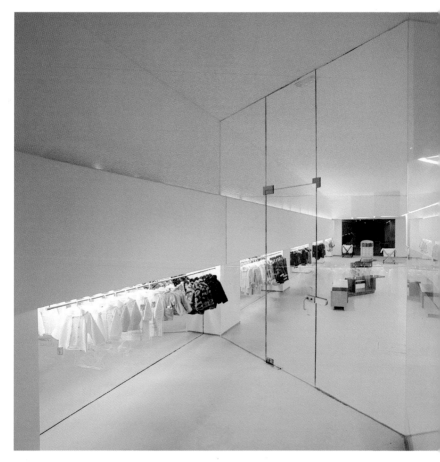

Plan

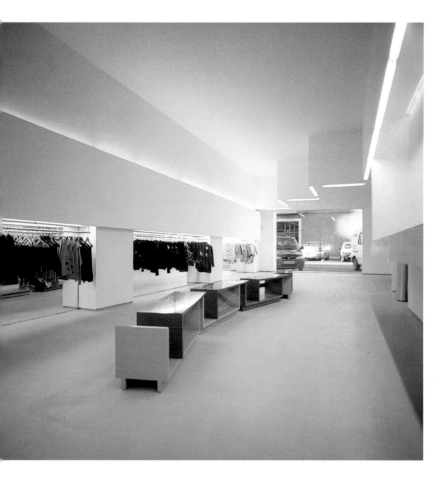

ctions

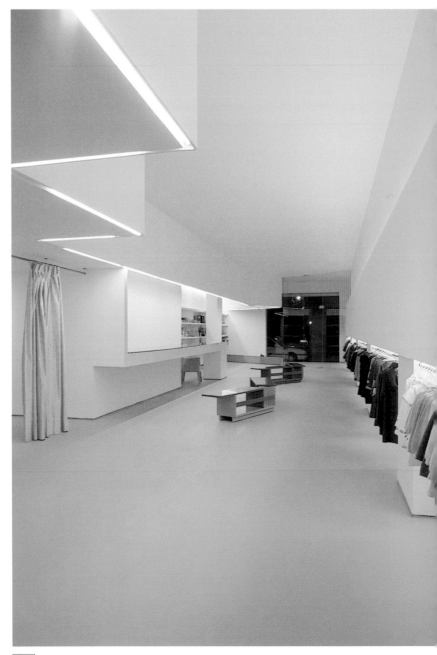

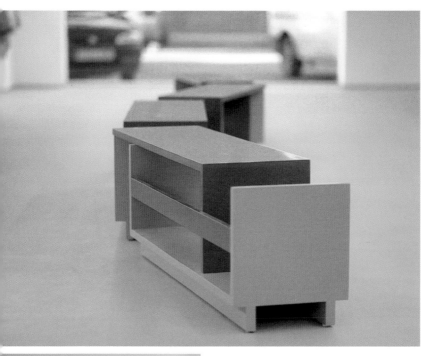

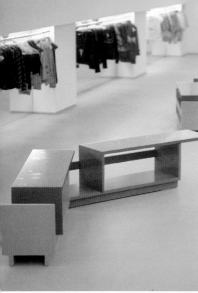

False ceilings create a differentiation of zones in a single unit of space. Geometry and illumination were the main protagonists in molding the space.

Cristina Gómez Garcia

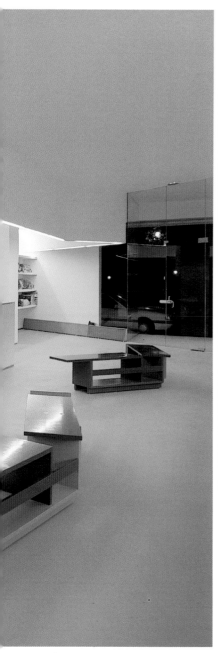

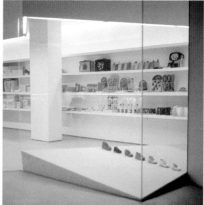

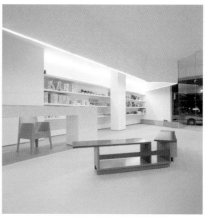

The table/counter forms part of the generating geometry. The floor has been given a layer of self-leveling gray-white mortar.

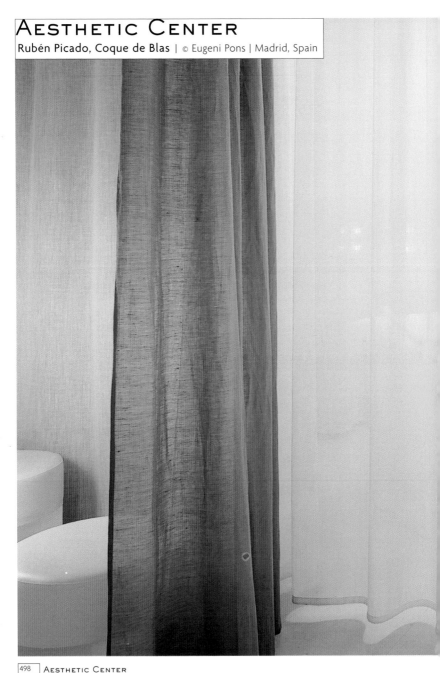

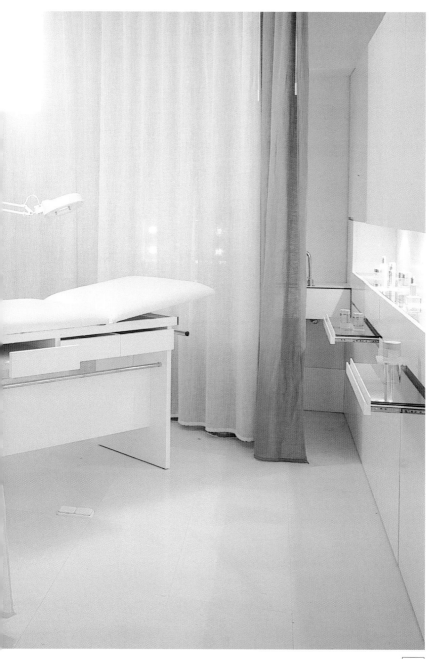

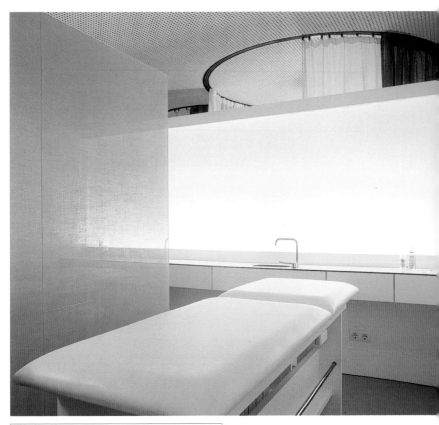

The internal divisions have been created by using cube-shaped modules with translucent panels and rail curtains. The uniform light is used to great effect.

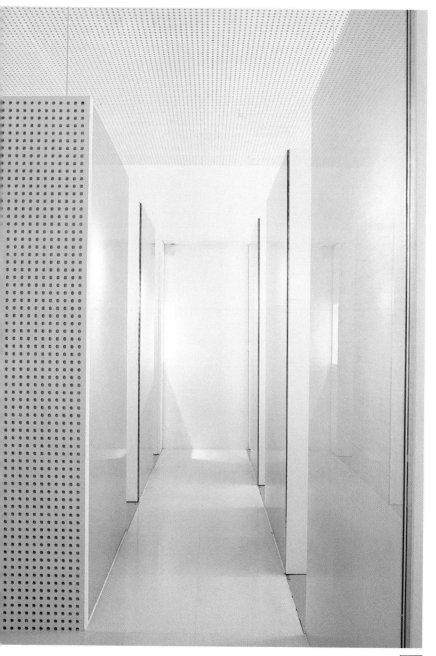

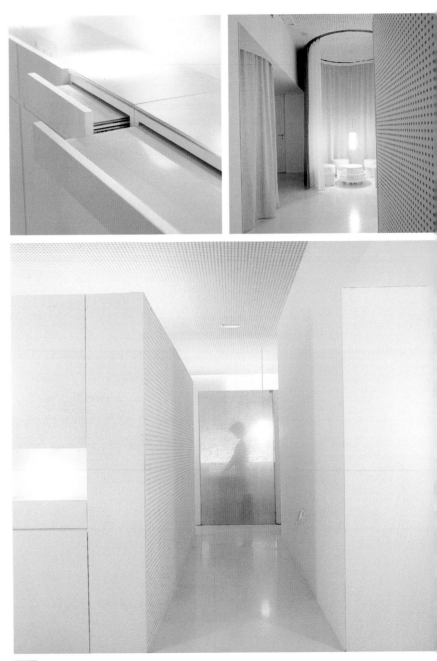

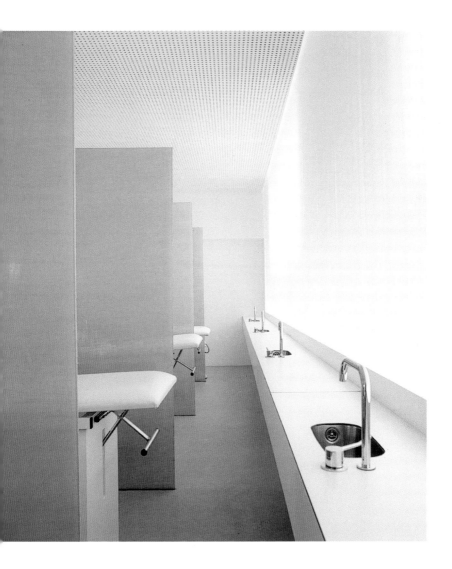

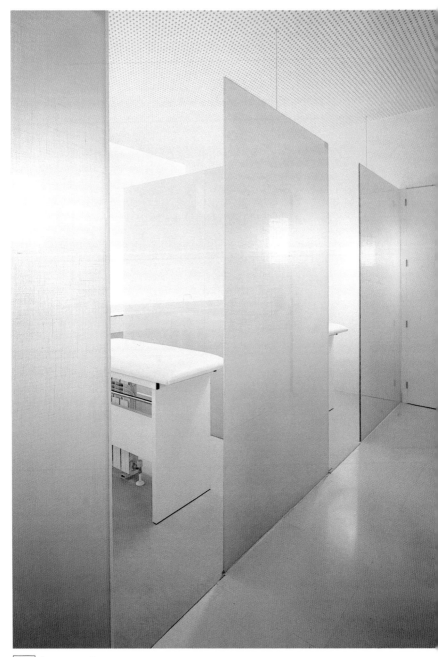

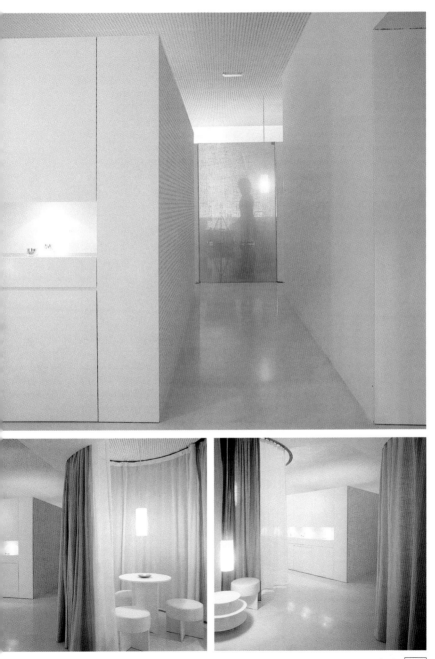

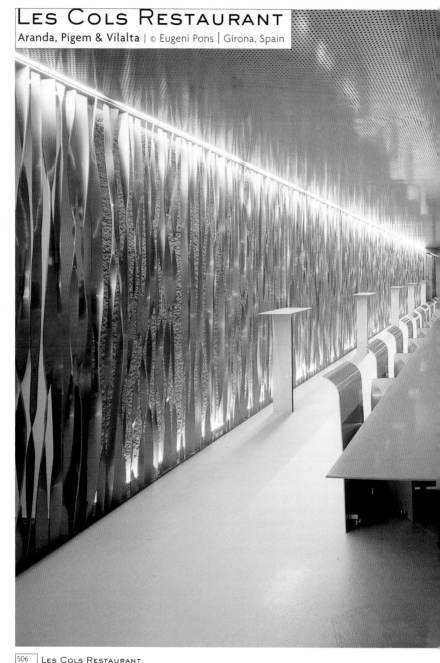

LES COLS RESTAURANT

Aranda, Pigem & Vilalta | © Eugeni Pons | Girona, Spain

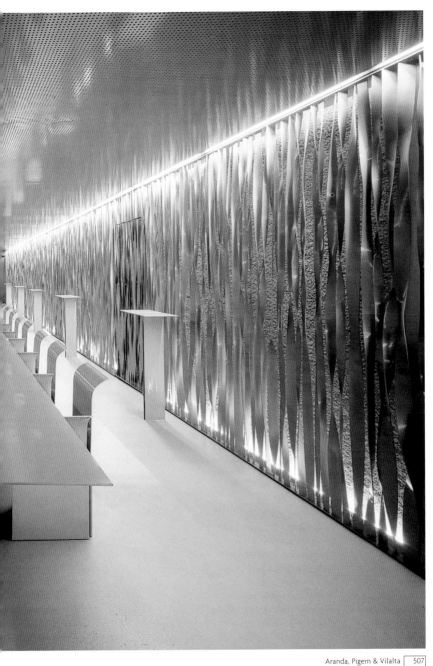

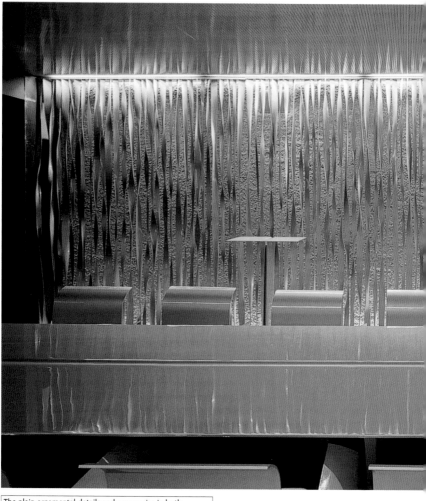

The plain ornamental details and accessories in both furnishings and architectural elements is counterbalanced by the metallic tones of the entire space.

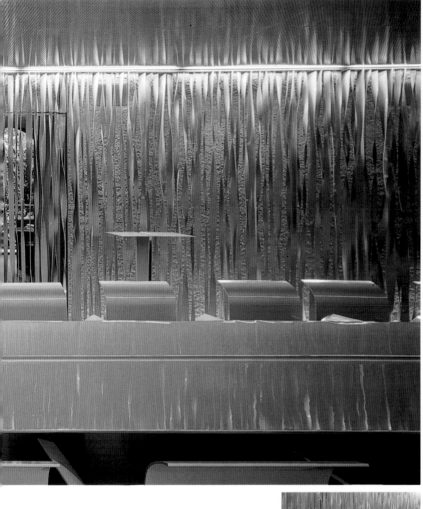

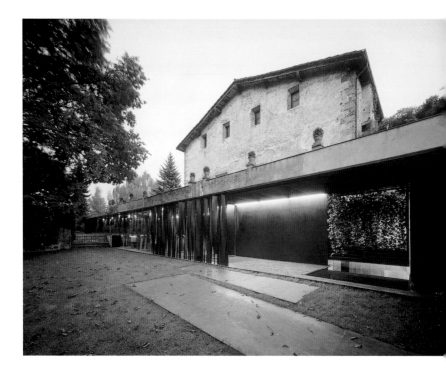

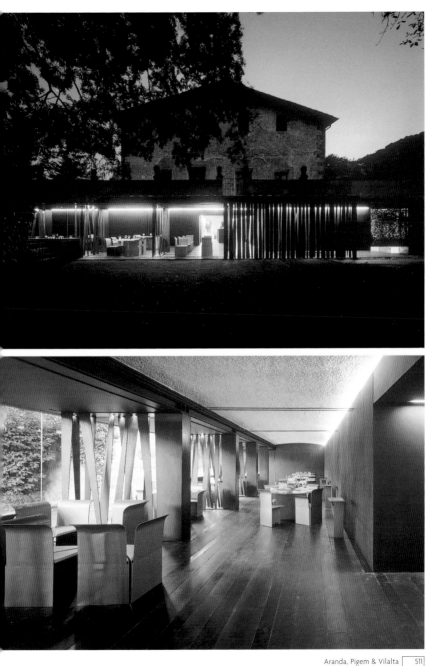

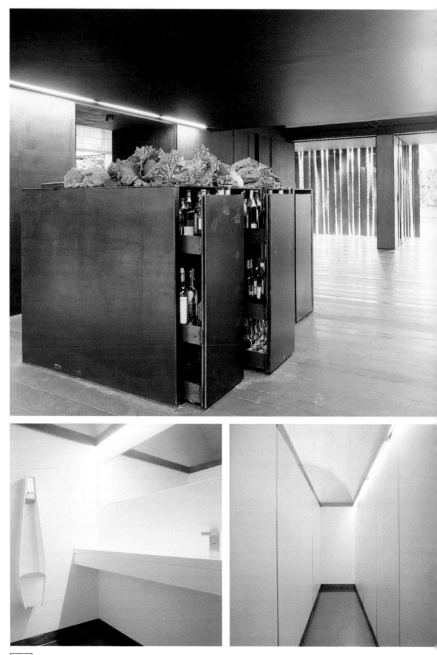

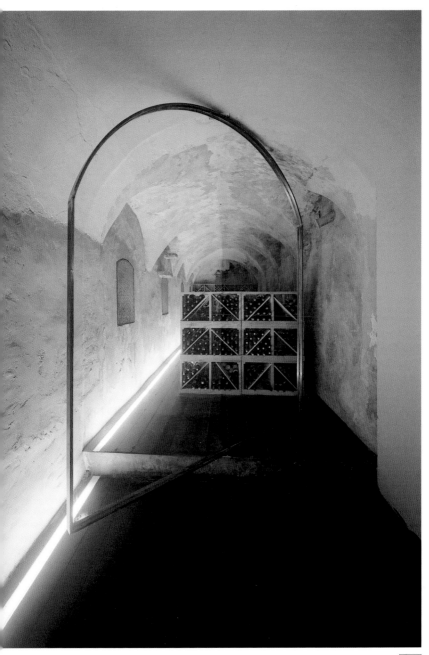

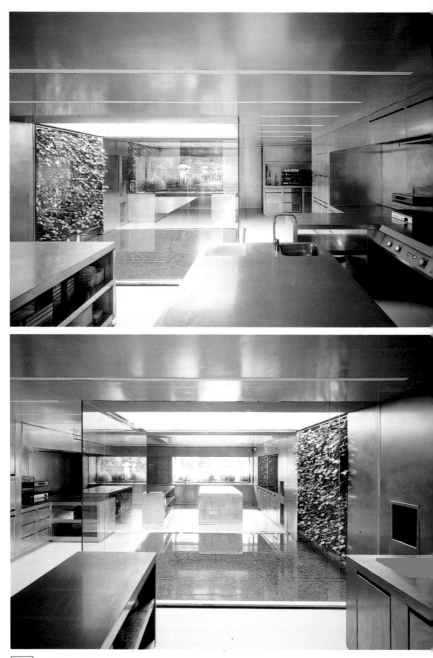

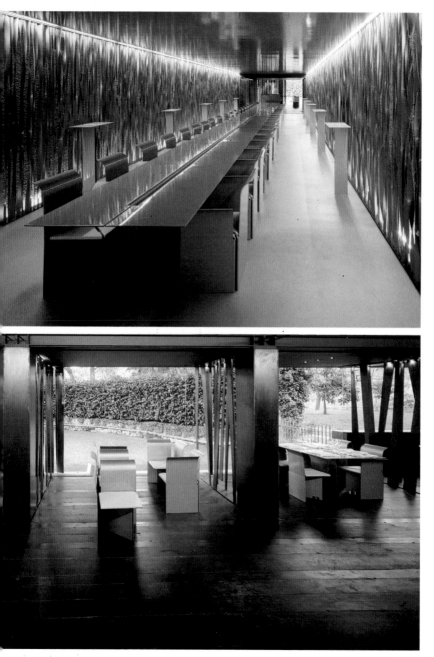

Wilhelm Greil Café

Dietrich|Untertrifaller Architekten | © Ignacio Martínez | Innsbruck, Austria

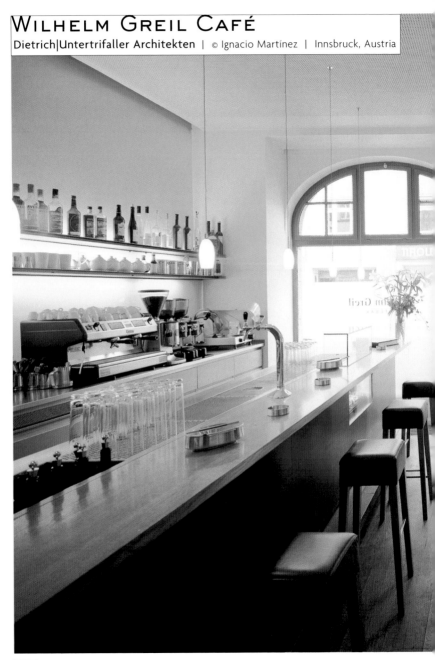

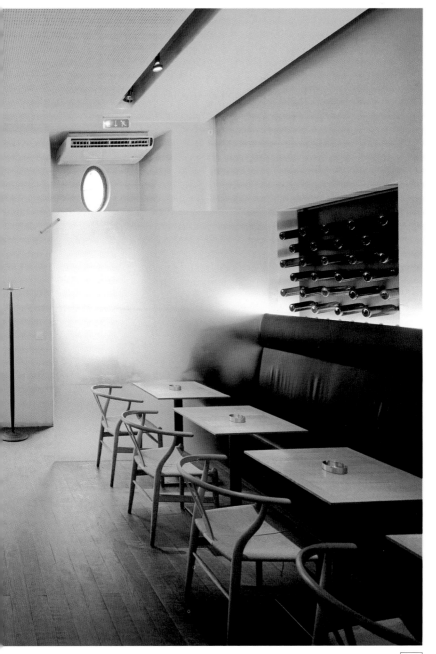

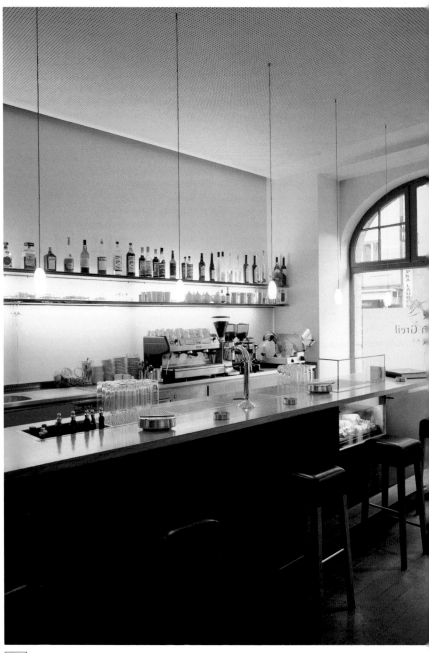

Order and symmetry reign supreme here. Both are clearly perceived in all sections of the Wilhelm Greil, and necessarily so. The close quarters of the real dimensions—only 431 square feet—would otherwise make the café appear to be even smaller.

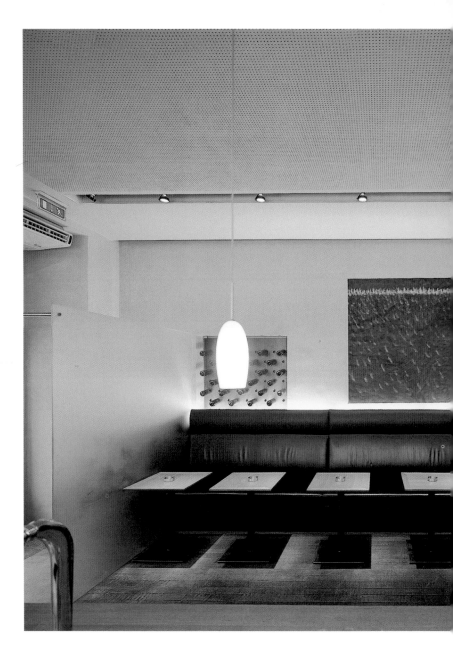

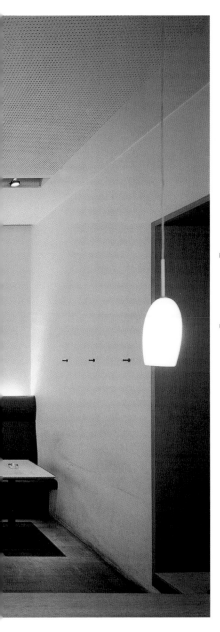

Section

Section

Plan

CAFÉ ZERO

Fletcher Priest Architects | © Chris Gascoigne/View | London, UK

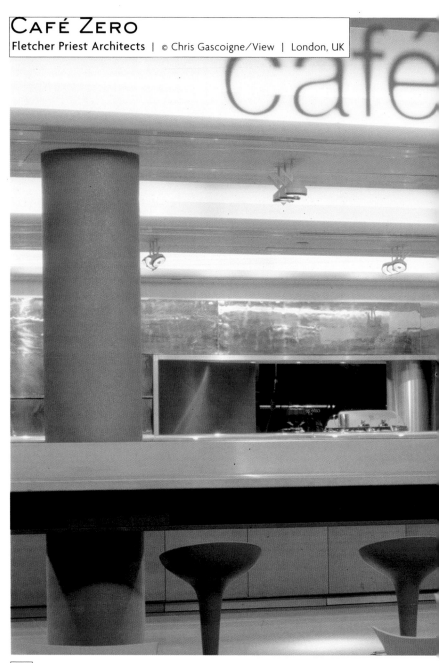

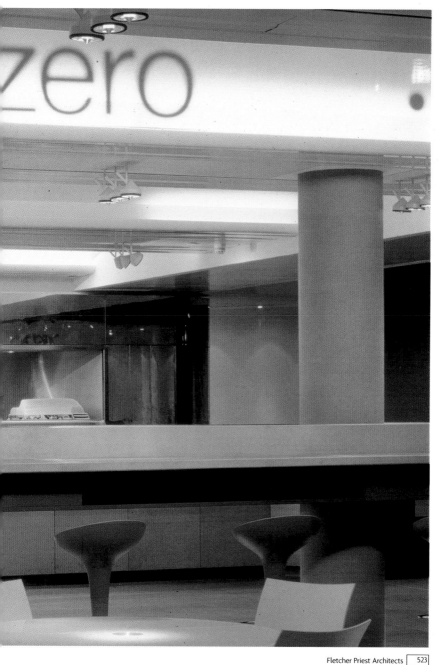

zero

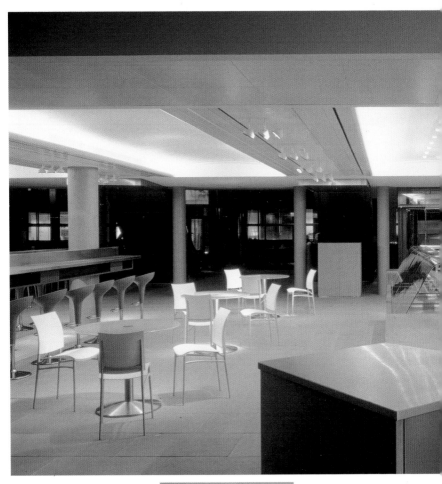

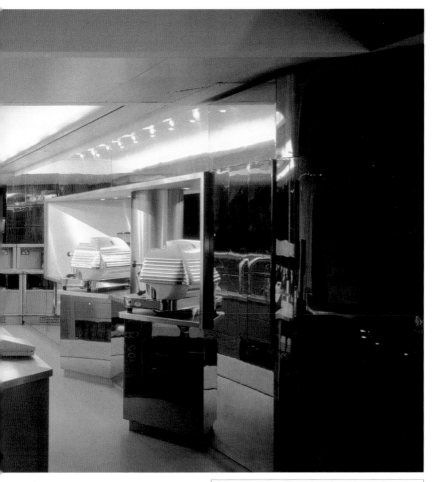

This space is truly public, with its design shaping the setting and simultaneously individualizing it by opening it out. A fluid link comes into being between inside and outside, thus providing the public with easier access to the elevators.

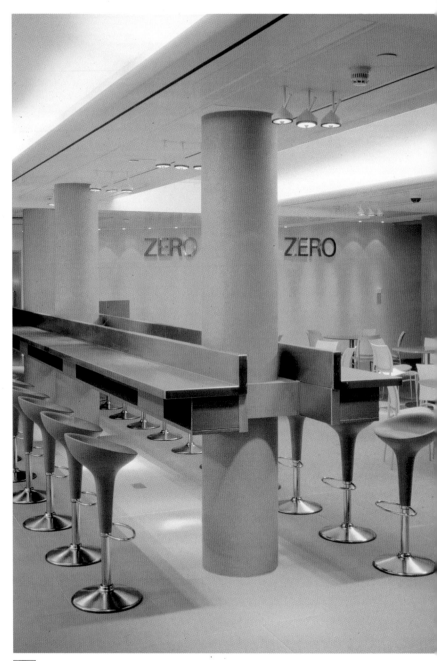

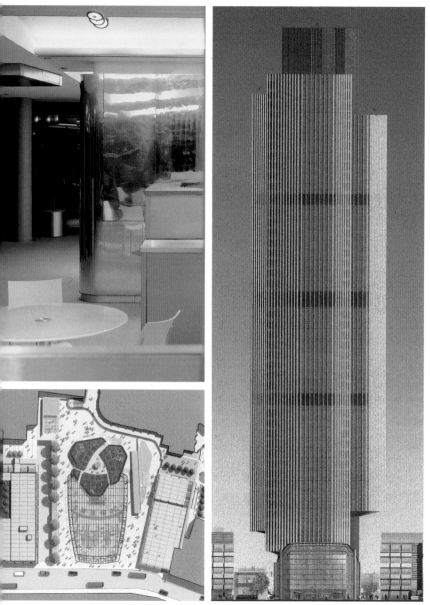

Plan

Elevation

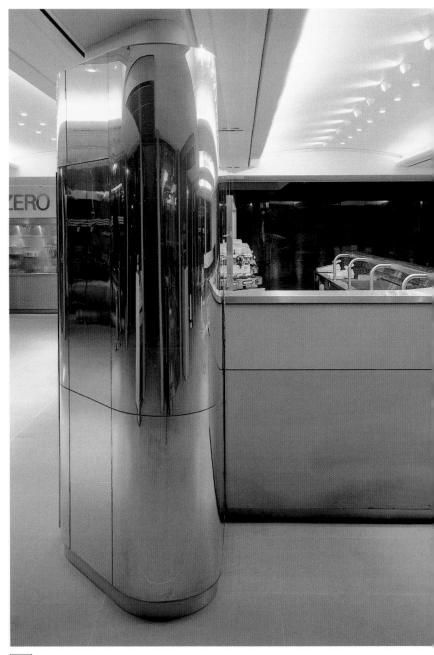

Ground floor

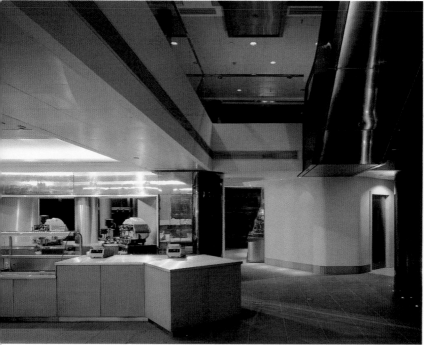

ONE HAPPY CLOUD RESTAURANT

Claesson Koivisto Rune Arkitektkontor | © Patrik Engquist | Stockholm, Sweden

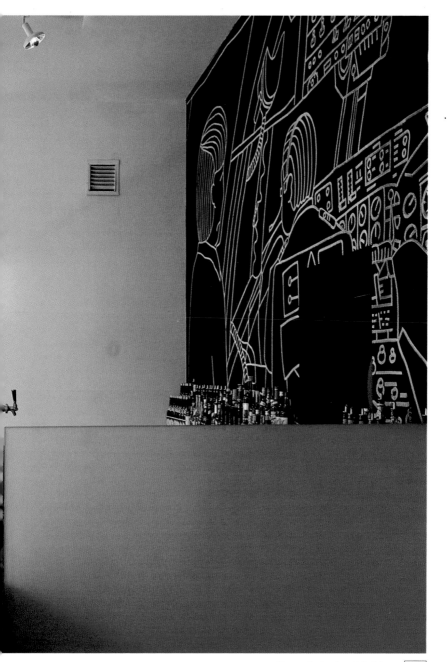

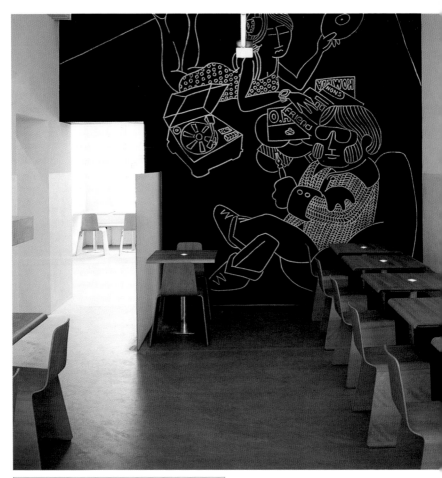

The creation of a pure merger between Japanese and Scandinavian traditions called for careful designing to handle both gastronomic and aesthetic elements.

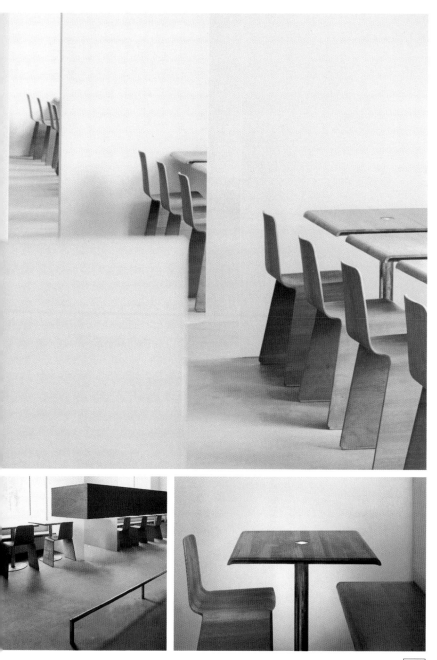

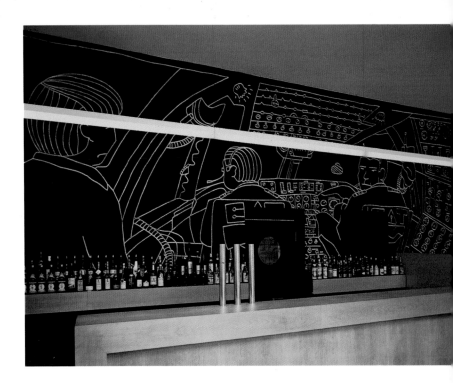

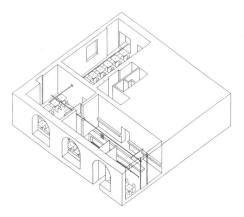

Perspective

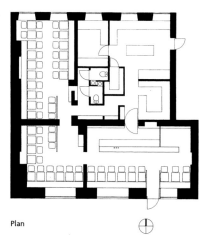

Plan

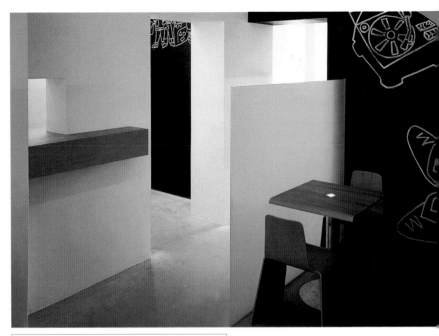

Ranged around the restaurant's perimeter, the tables offer ultramodern simplicity. The walls and large etched glass partitions divide the rooms into smaller areas. The wall forming a backdrop for the bar features designer Nille Svensson's chalk drawings on a black background.

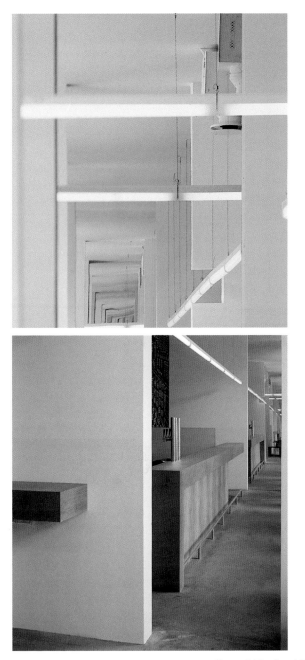

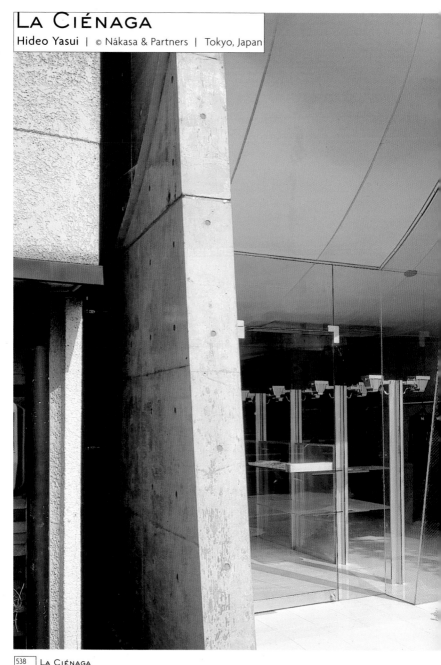

La Ciénaga

Hideo Yasui | © Nákasa & Partners | Tokyo, Japan

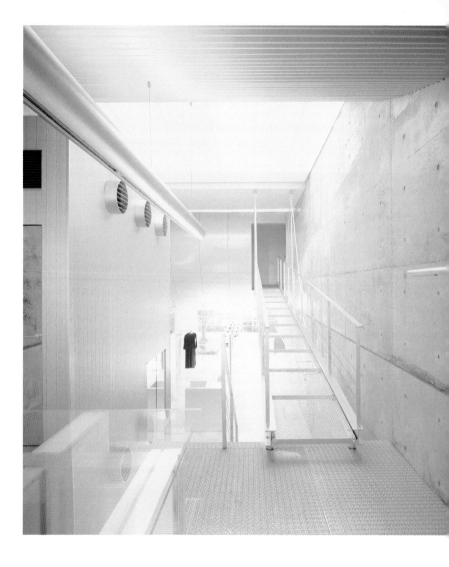

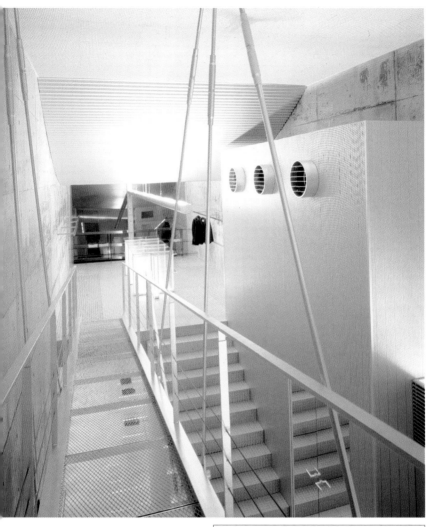

The shop was conceived as the minimalist expression of a typical Japanese architectural space: an empty rectangular area, deep and with the front surface cut off.

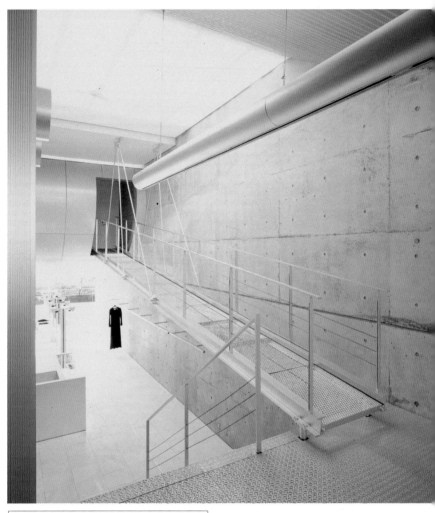

The divisions were created by using glass and metal. The metal is seen in the roof and the upper catwalk, making the space look like a single prefab cement unit.

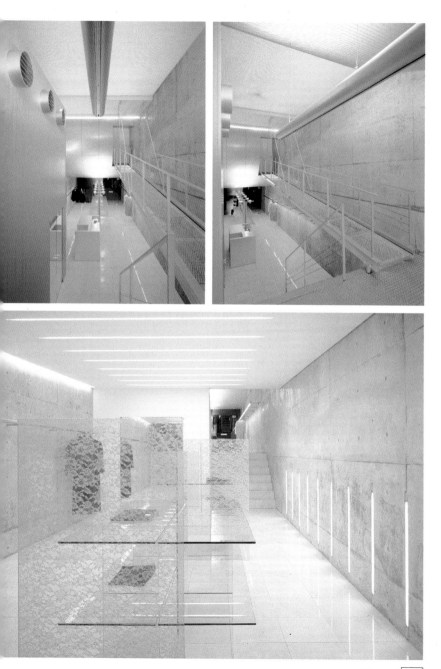

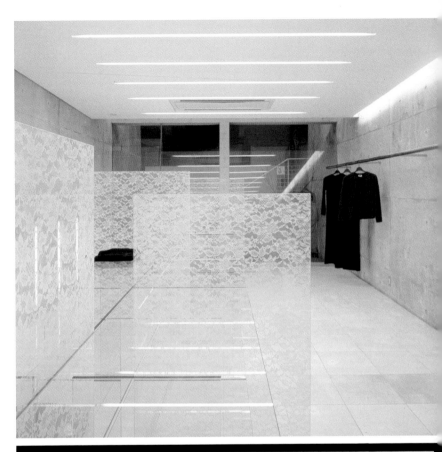

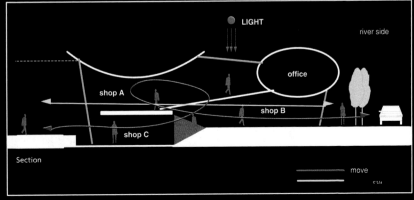

LIGHT

river side

office

shop A

shop B

shop C

Section

move

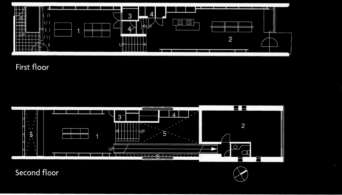

First floor

Second floor

EL JAPONÉS

Sandra Teruella & Isabel López | © Eugeni Pons | Barcelona, Spain

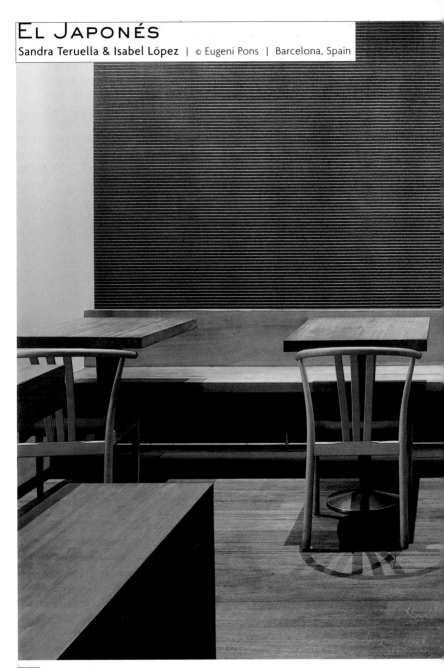

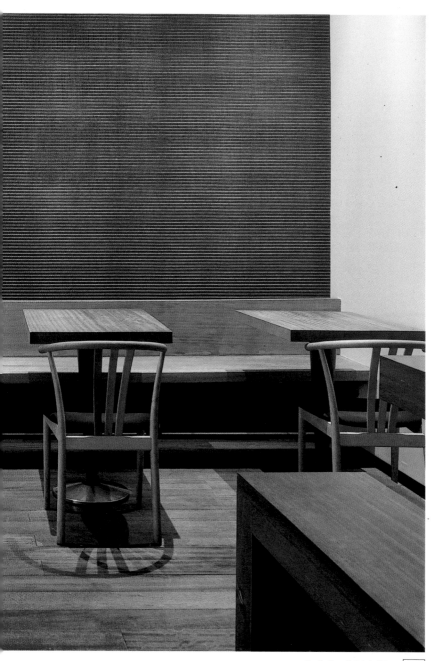

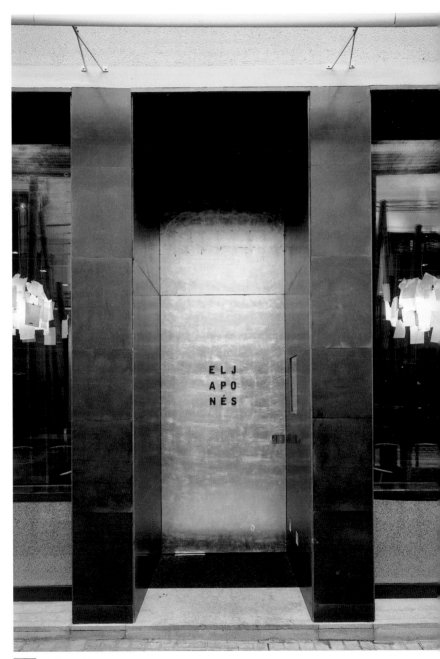

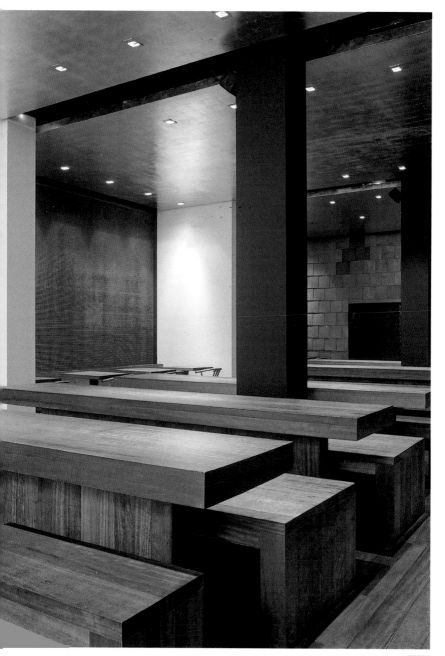

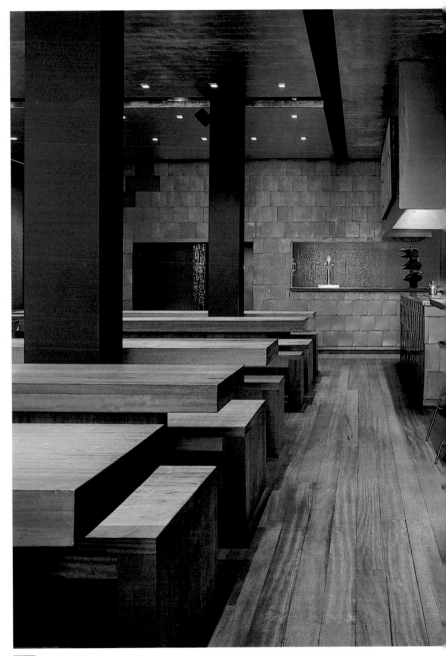

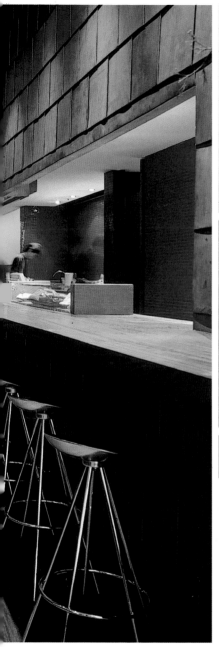

The use of striking, austere, straight lines; the combination of cold and warm materials; and the color and textural contrast all answer to theories of Japanese aesthetics.

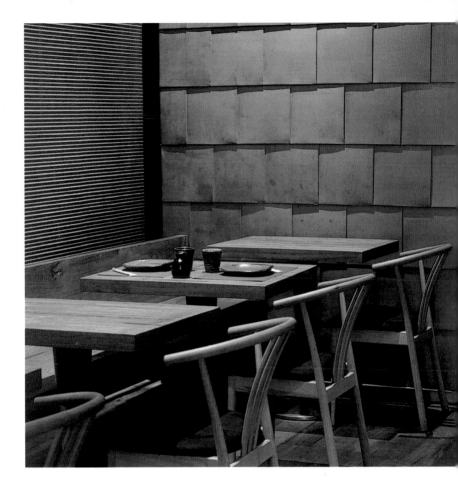

Elevation

The pieces of reddish ceramic mosaic in the service areas are reminiscent of Japanese lacquer work. They contrast with the zinc panel covering the outside of the bathrooms and the kitchen.

Sandra Teruella & Isabel López

No Picnic Offices

Claesson Koivisto Rune Arkitektkontor | © Patrik Engquist | Stockholm, Sweden

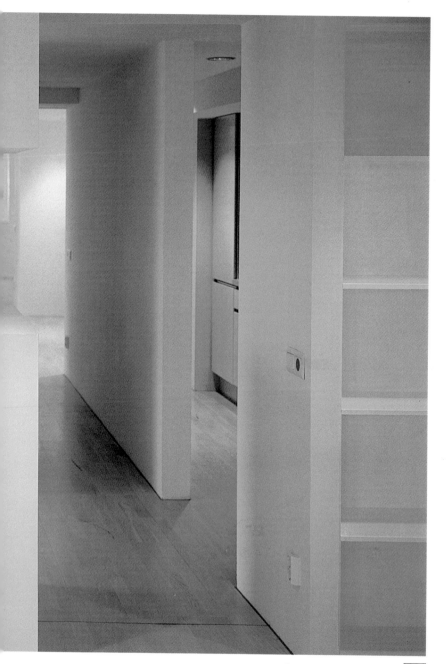

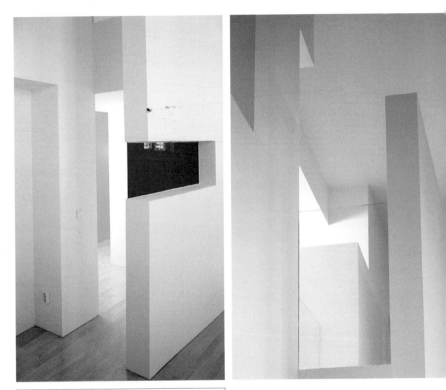

There are three levels here: the basement for the technical section, the first floor for shared areas, and the second floor where privacy is ensured.

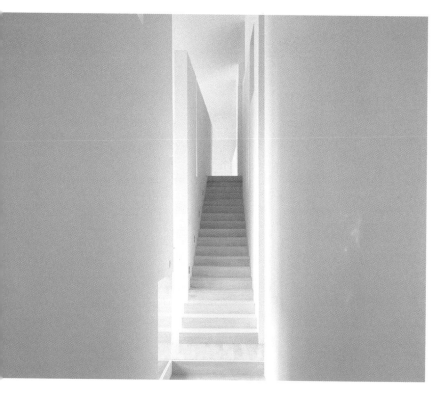

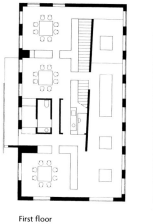

First floor

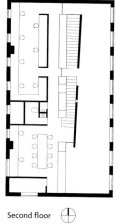

Second floor

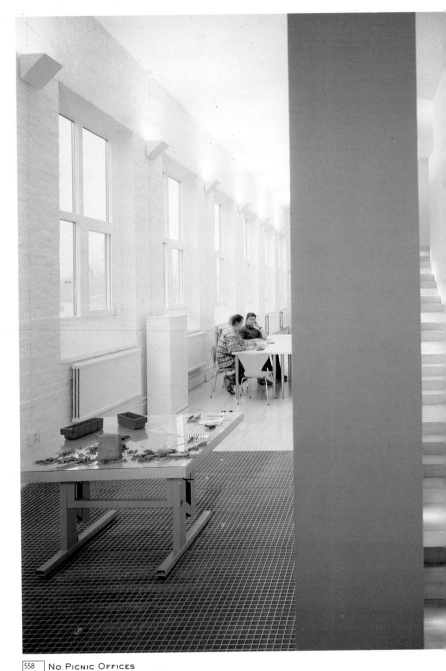

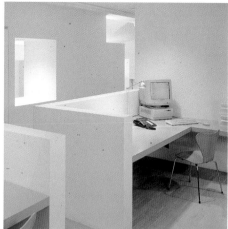

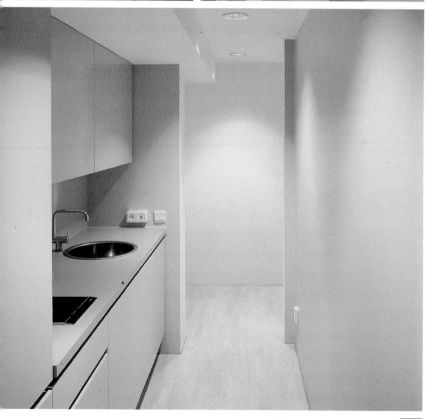

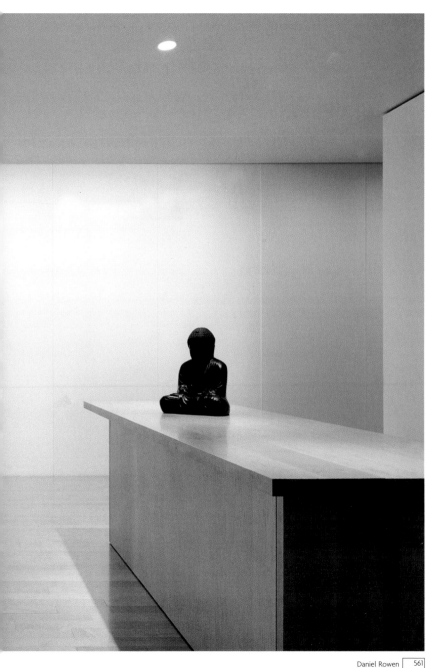

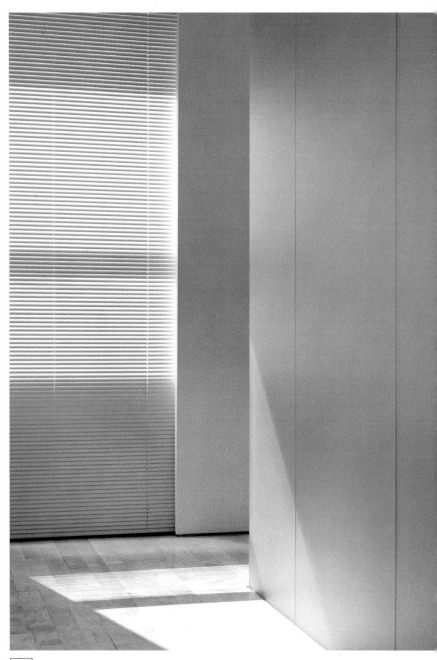

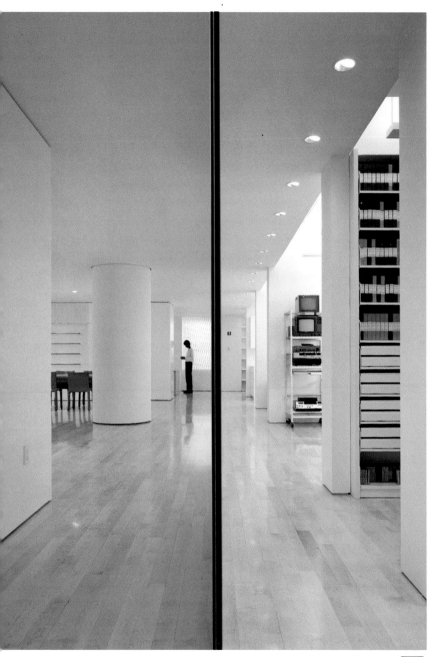

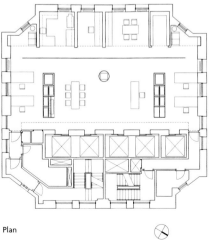

Plan

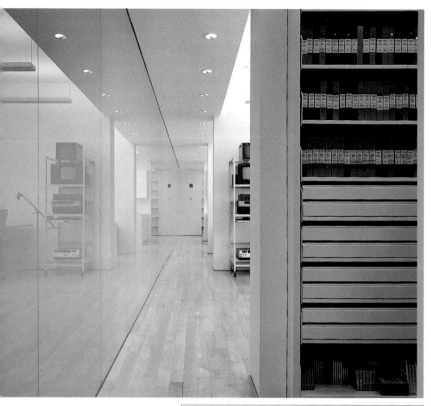

In this project for the headquarters of a publishing company specializing in Zen and meditation, the goal was to reflect the company's activities and the spirit of the individuals who work there.

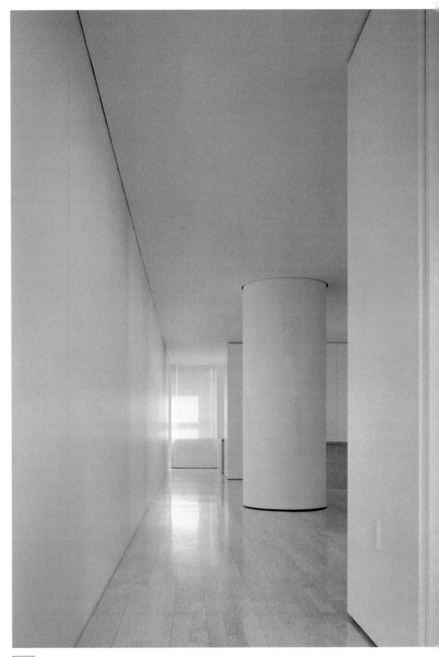

Perspective

The office design, which is anchored by the consolidation of the elevator lobby, reception desk, and conference area, flows through a single large space.

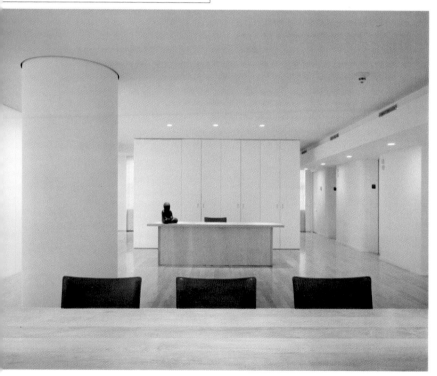

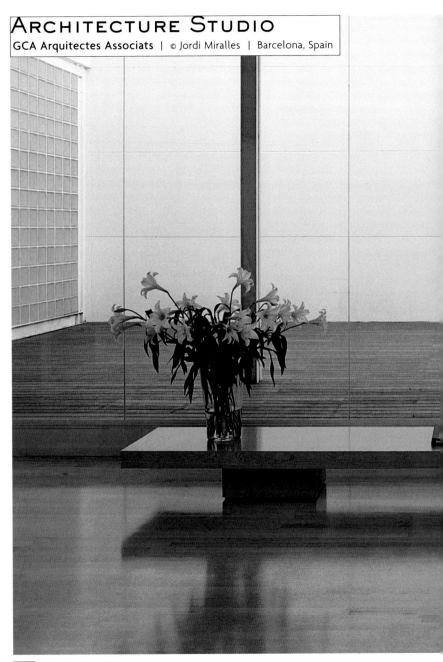

ARCHITECTURE STUDIO

GCA Arquitectes Associats | © Jordi Miralles | Barcelona, Spain

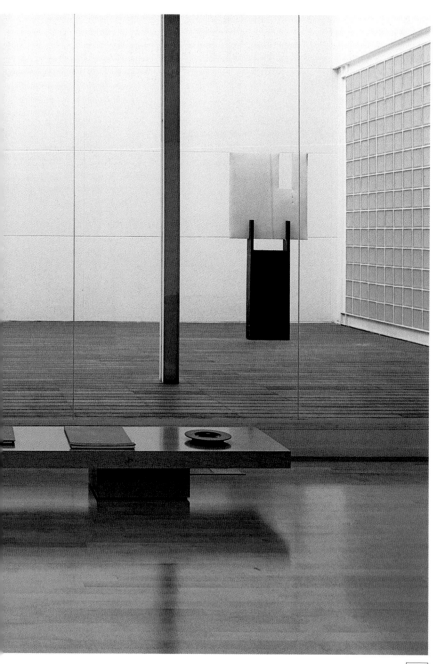

Cross section

Longitudinal section

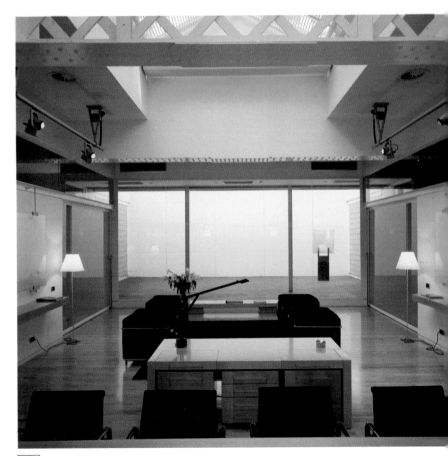

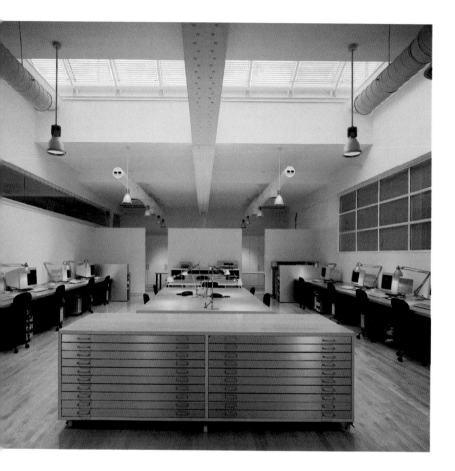

Plan

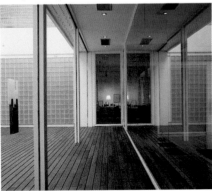

The dialogue here may involve strict opposites, but the working area—a large white box with overhead lighting via two oversize skylights—plays the most important part by far.

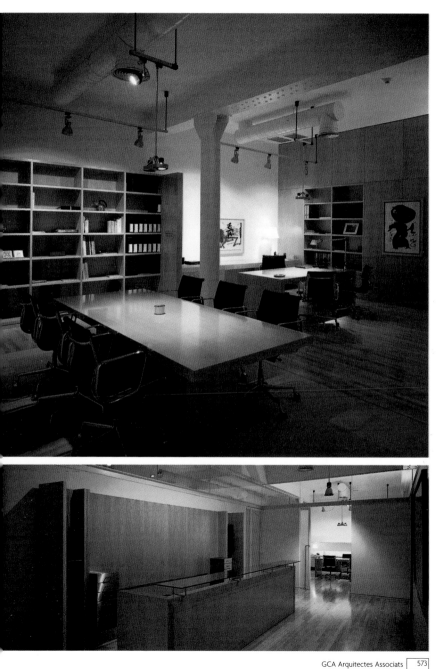

BANG AND OLUFSEN OFFICES

KHRAS | © Ib Sørensen, Ole Meyer | Struer, Denmark

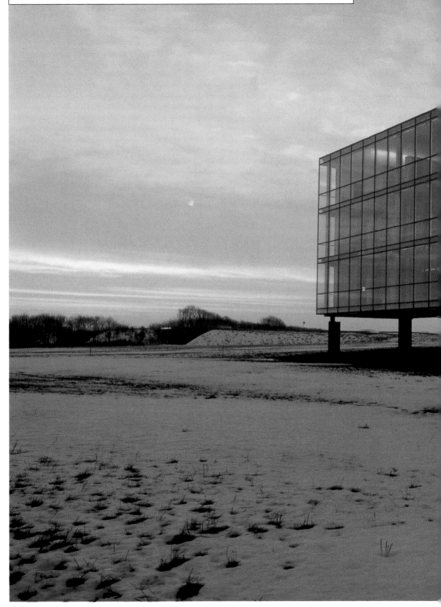

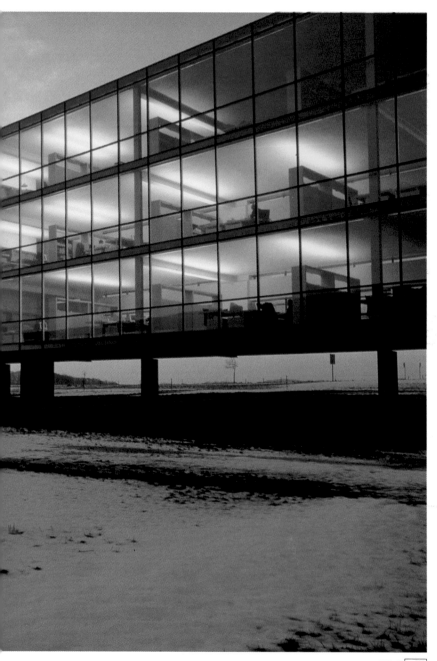

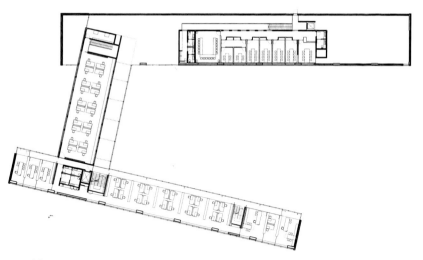

Second floor

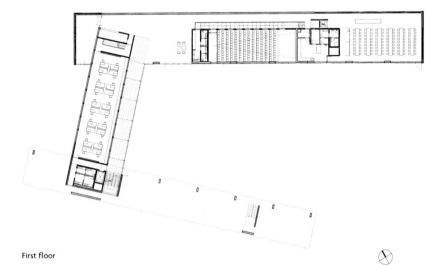

First floor

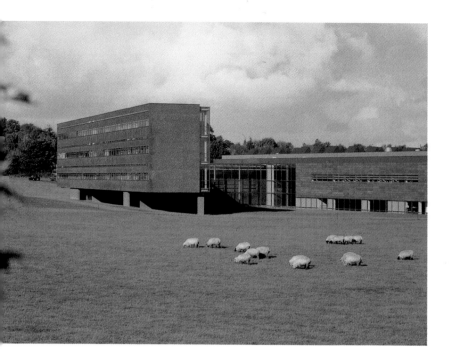

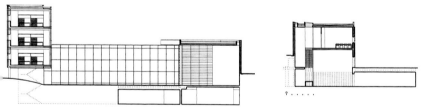

Cross sections

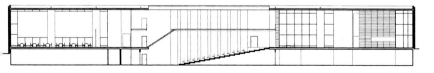

Longitudinal section

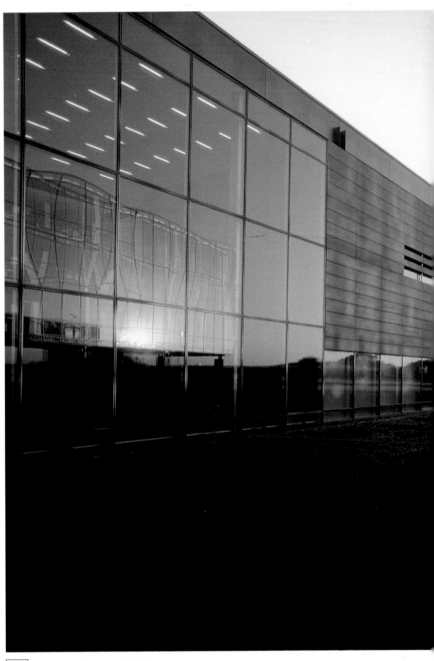

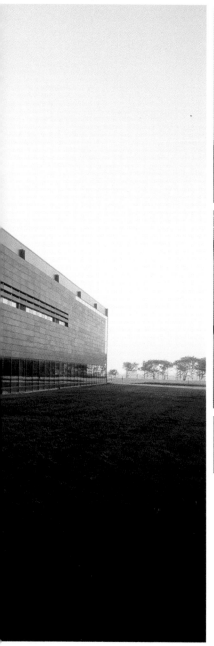

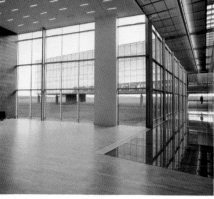

This building was inspired by the farms dotting the Danish countryside. These farmhouses traditionally include a patio that emphasizes visual contact throughout the parts of the building.

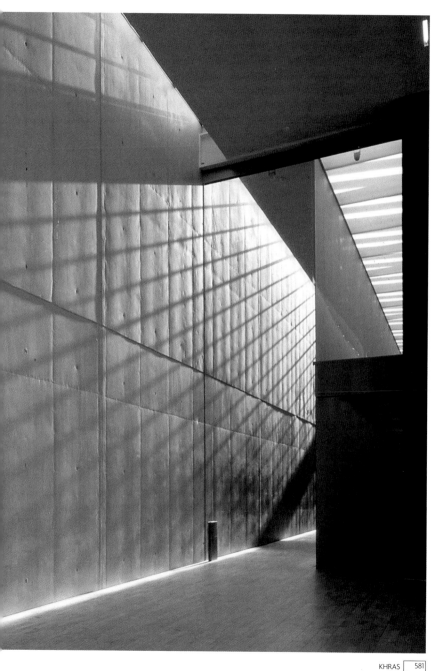

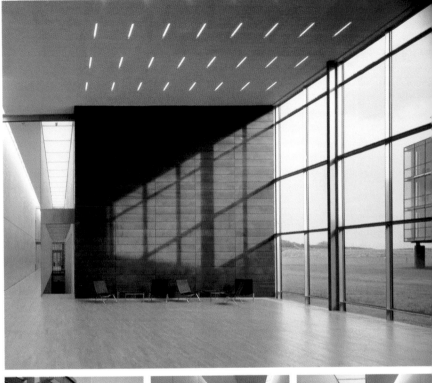

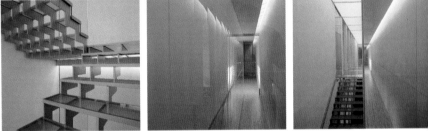

The headquarters' components are geometrically simple in their creation of intricate spatial variations within the landscape.

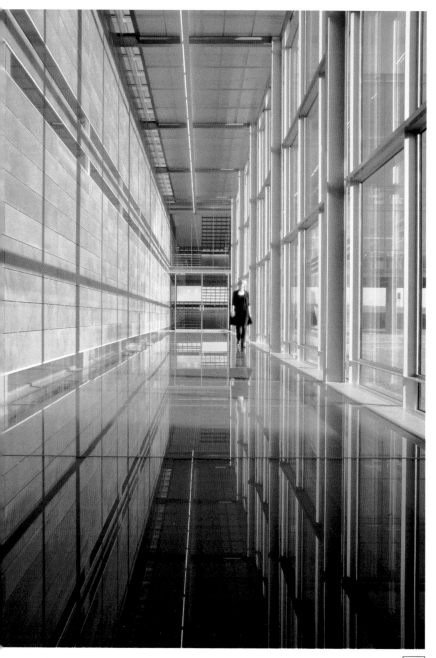

GARBERGS ADVERTISING

Claesson Koivisto Rune Arkitektkontor | © Patrik Engquist | Stockholm, Sweden

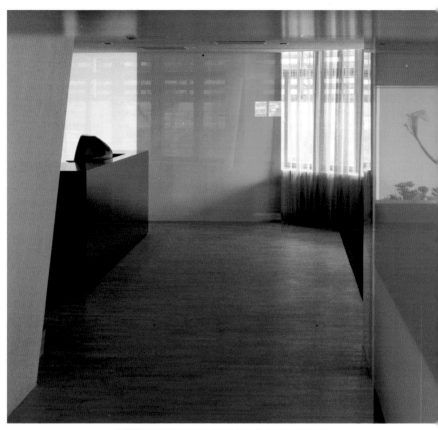

GARBERGS ADVERTISING

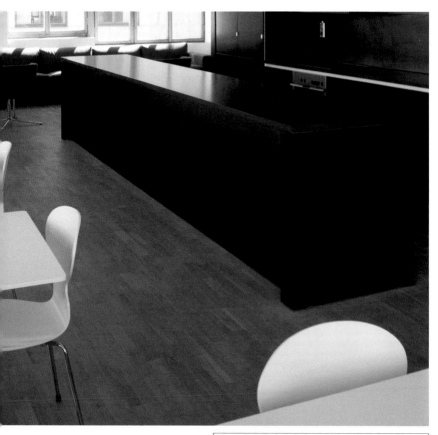

Partitions were carefully used to organize the different functional areas. Transparent panels alternate with translucent ones.

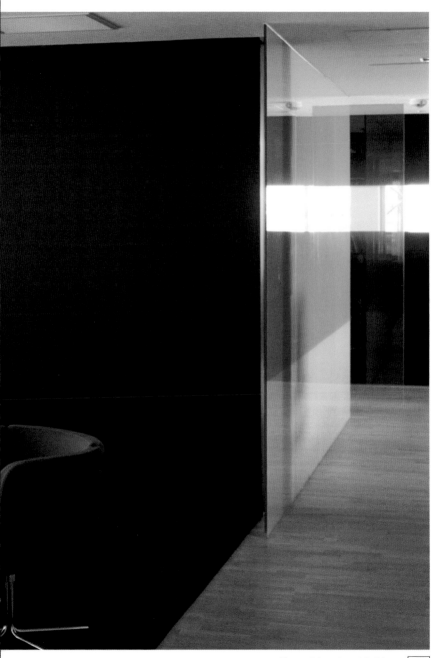

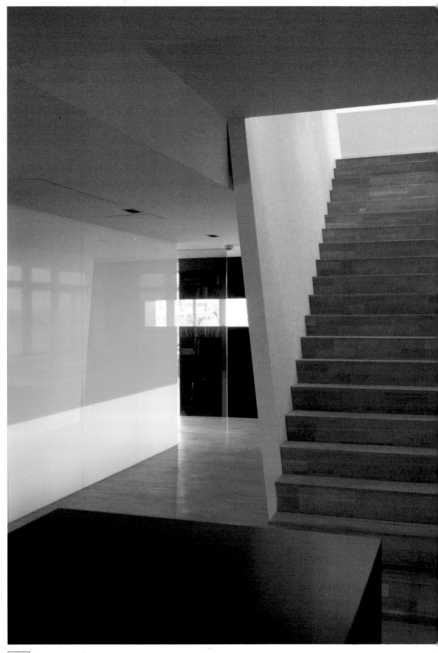

GARBERGS ADVERTISING

The interiors are puritanical and contemporary, free of superfluous elements. The highly functional design and the visual order are striking in their simplicity.

SONY MUSIC SWEDEN

Claesson Koivisto Rune Arkitektkontor | © Ake E:son Lindman | Stockholm, Sweden

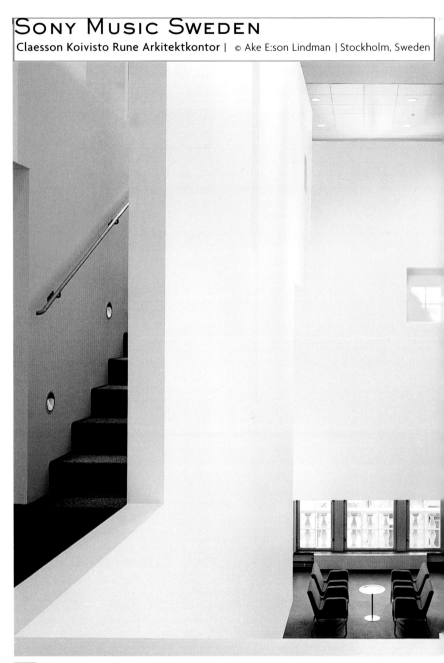

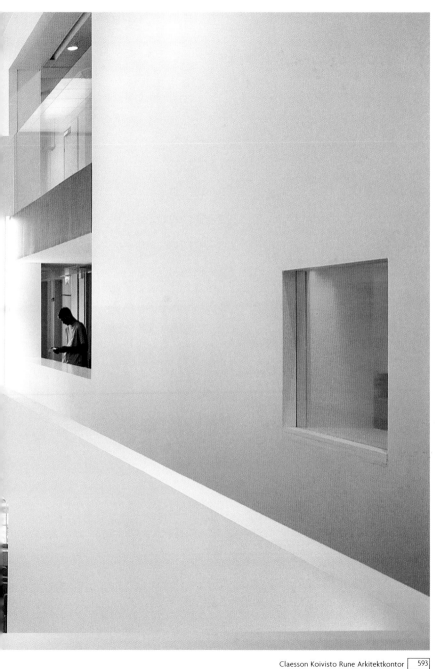

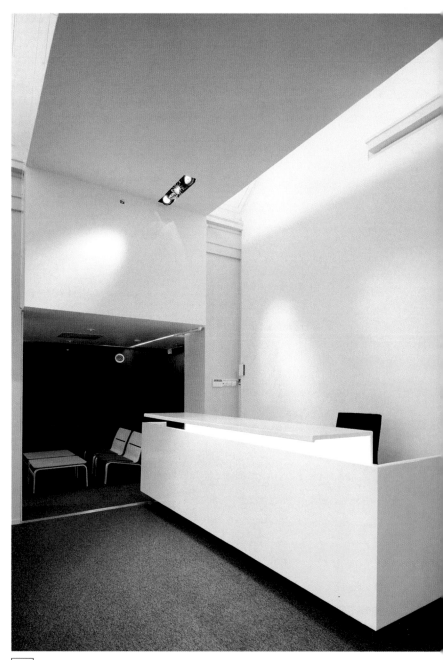

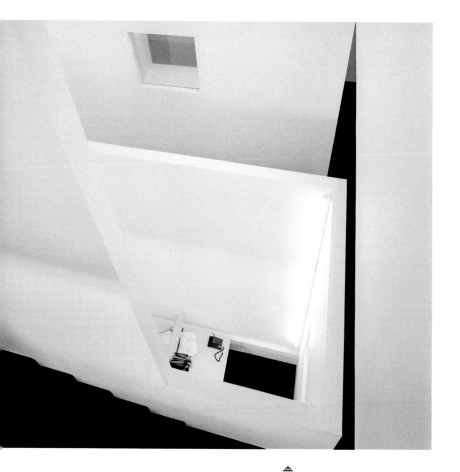

Perspective

Elevation

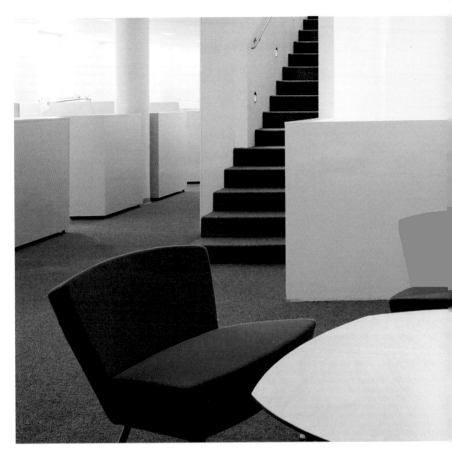

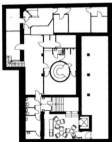

First floor

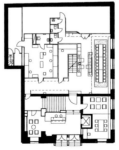

Second floor

Third floor

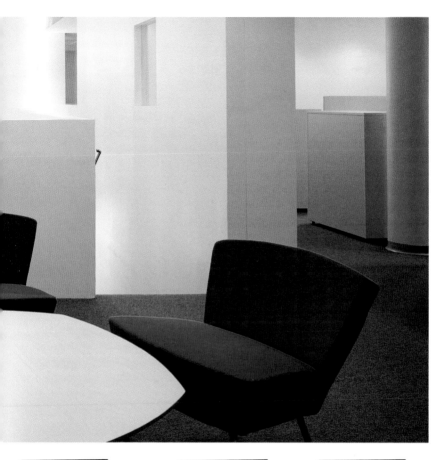

Fourth floor

Fifth floor

Sixth floor

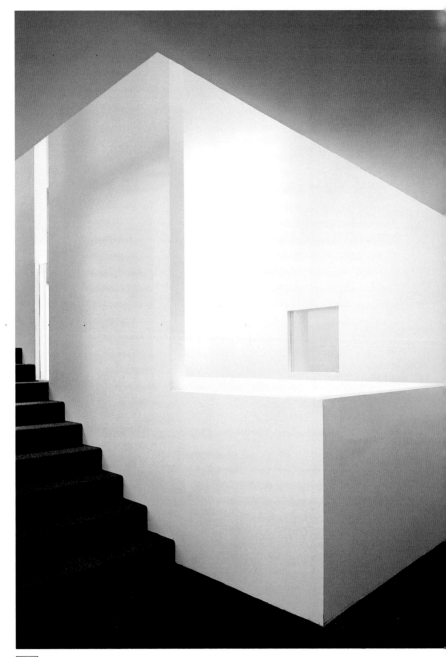

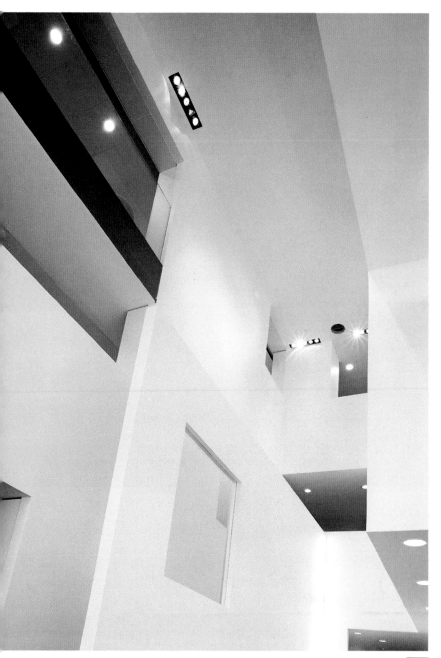

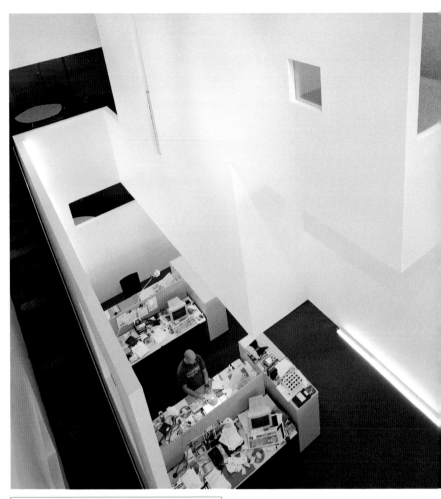

The interior is designed off of a staircase. The layout defines
the space, with partitions creating a hybrid of open and
closed office space.

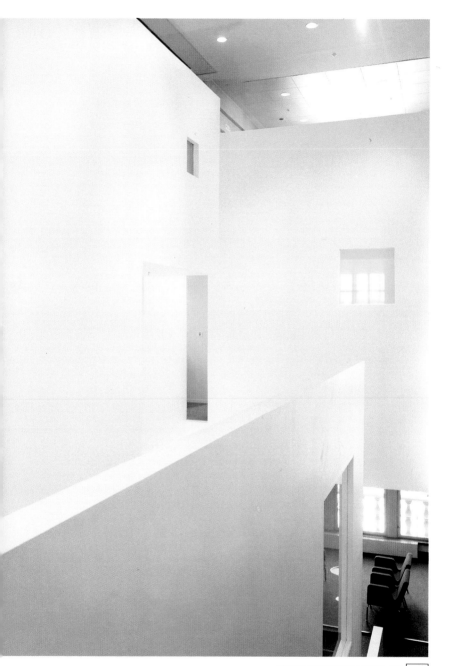

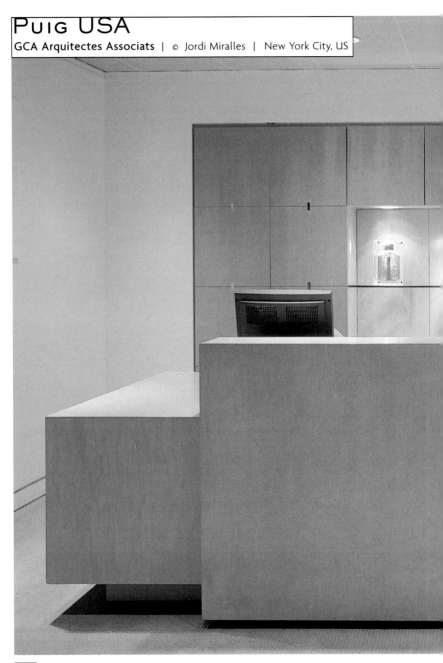

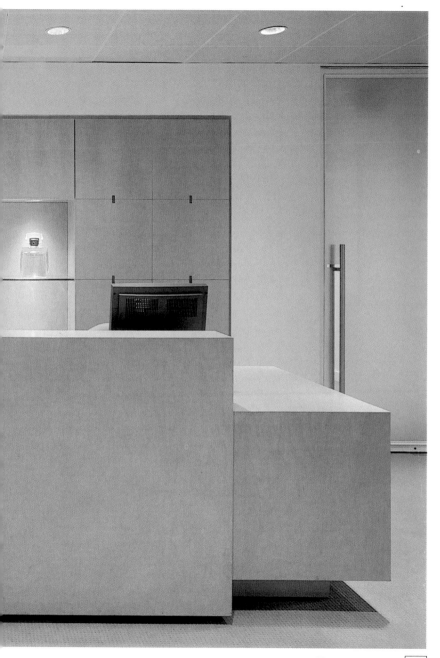

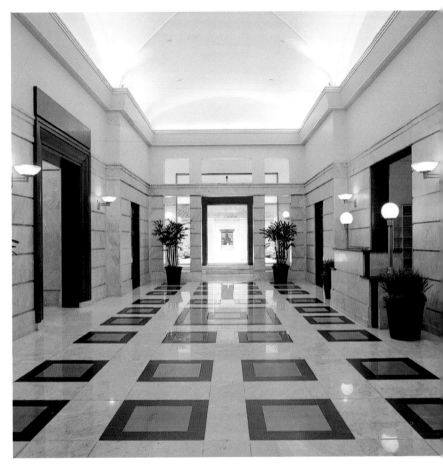

Plan

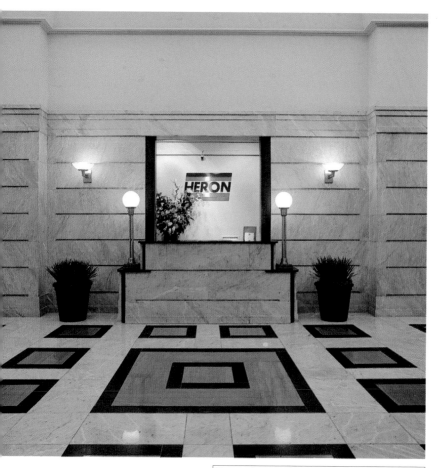

The reception area—the nerve center from which the space generates—is located in a 5,376-square-foot rectangle centered in the space to distribute the other zones.

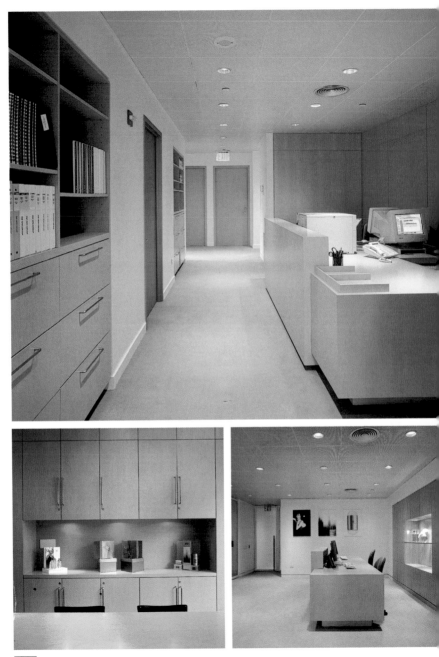

The sober range of finishes used—as well as materials, textures, colors, and lighting—recurs throughout the office space, endowing it with homogeneity.

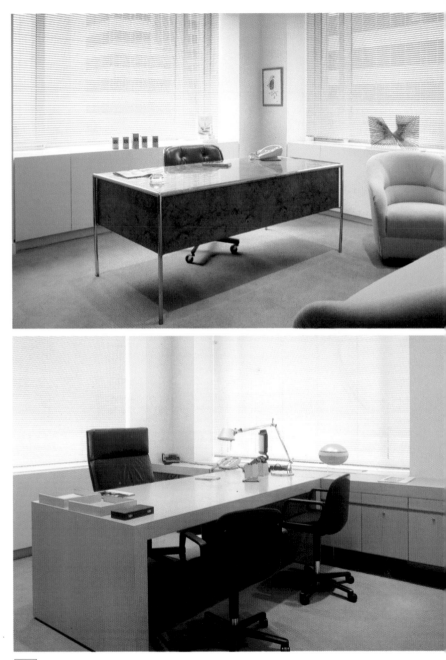

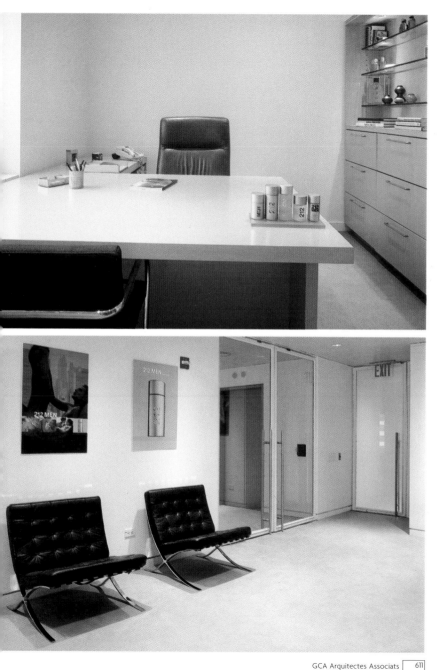

Sociedad General de Autores

Rafael Cáceres Zurita | © Jordi Miralles | Barcelona, Spain

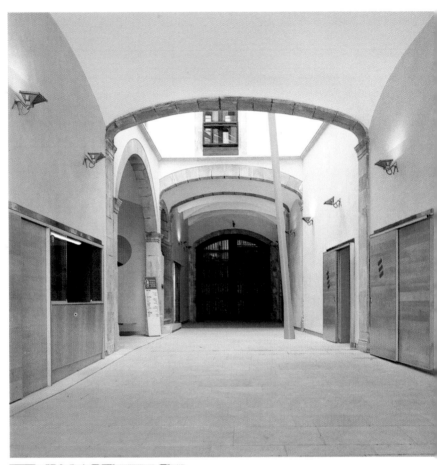

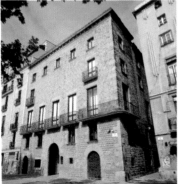

Cross section

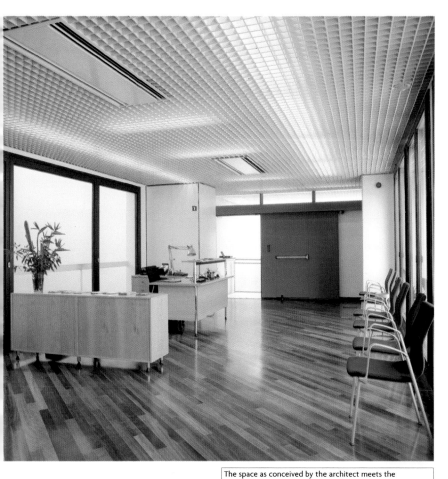

The space as conceived by the architect meets the functional requirements of the new company without destroying the previous architectural discourse.

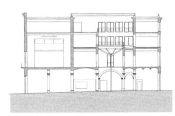

Longitudinal section

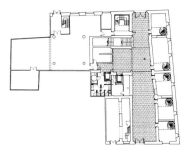

First floor

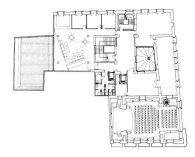

Second floor

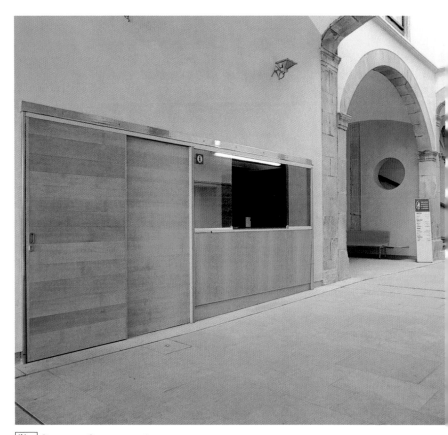

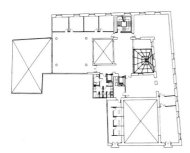

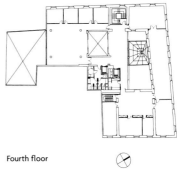

Third floor

Fourth floor

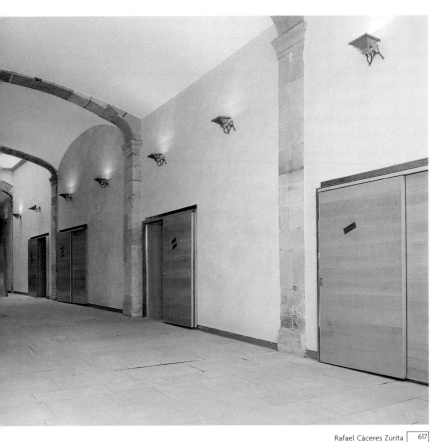

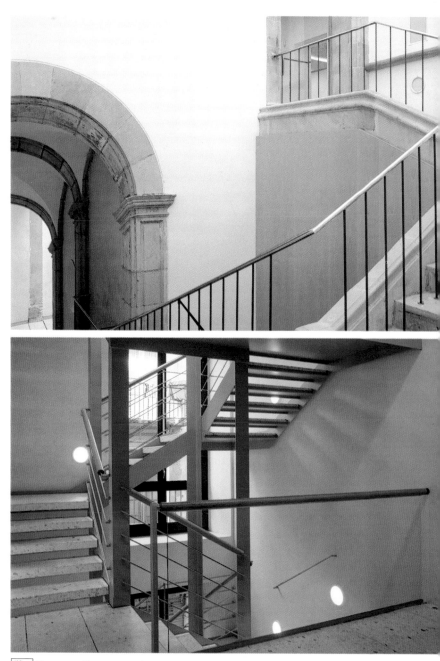

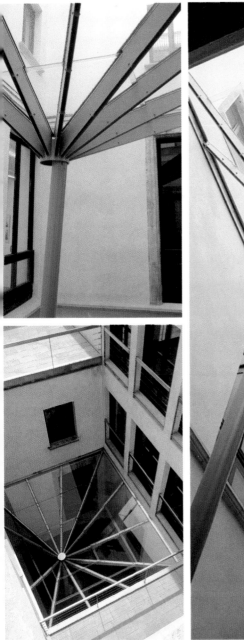
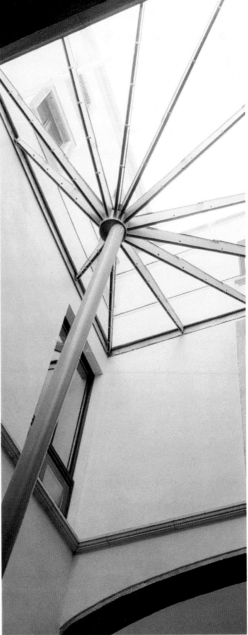

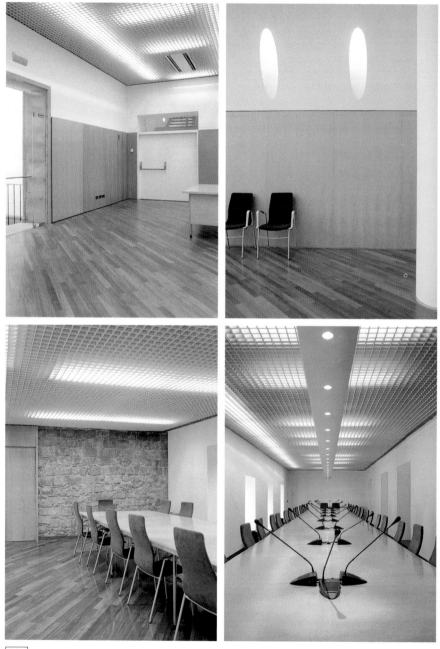

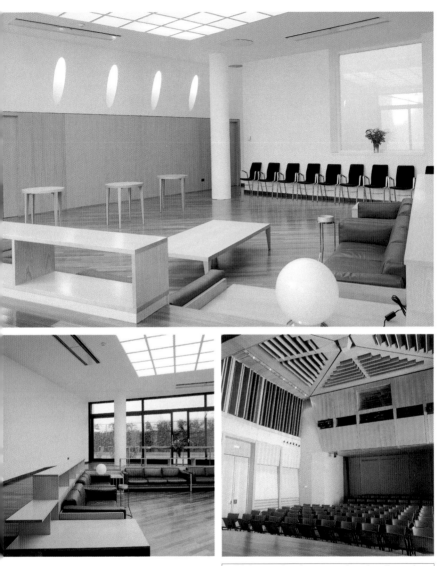

A global approach to design was eschewed to allow each floor to have its own ideal design. Here, the key concept is difference.

ISTAK

KHRAS | © Adam Moerk | Reykjavík, Iceland

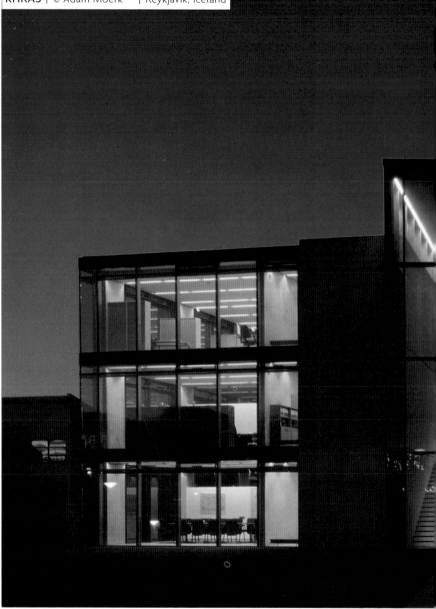

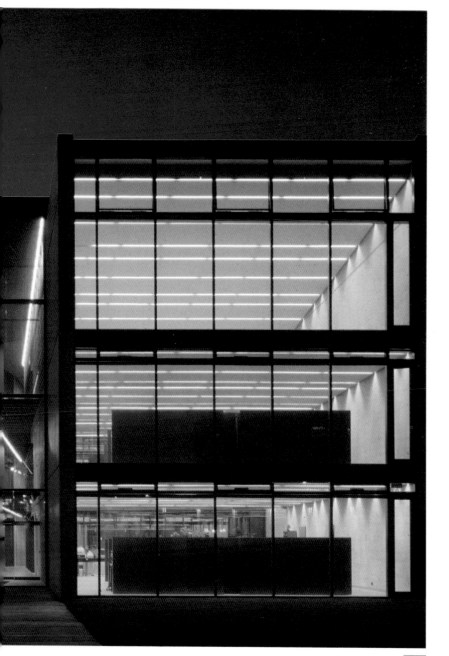

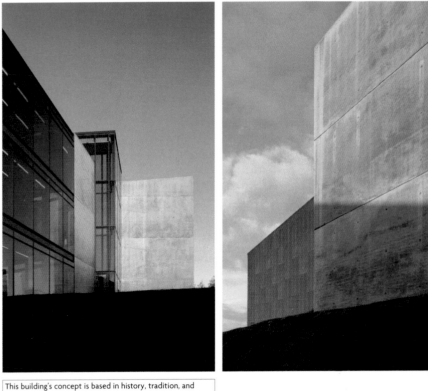

This building's concept is based in history, tradition, and blending into the landscape. However, the distribution empowers communication with the exterior.

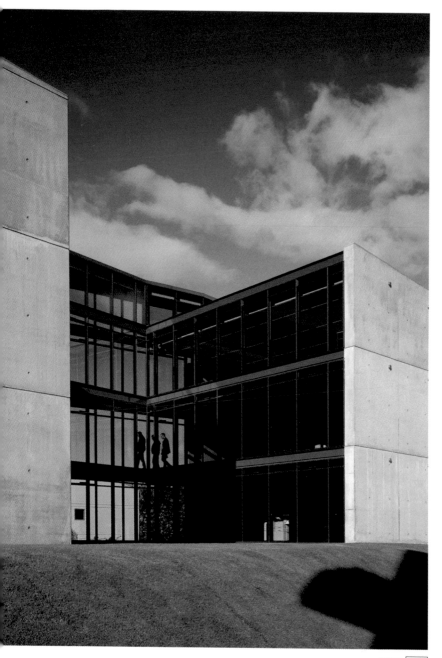

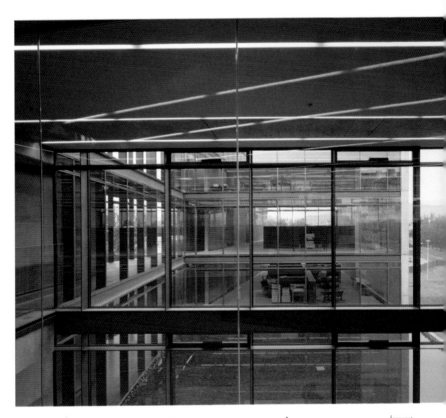

First floor Second floor Third floor Fourth floor

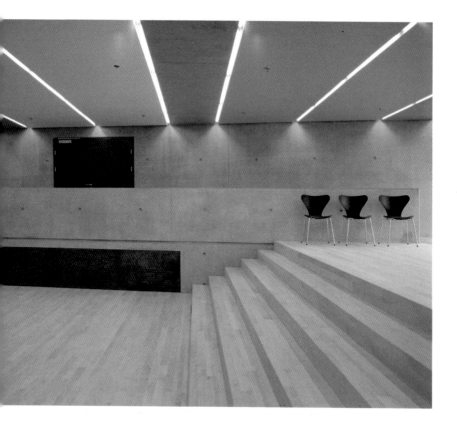

Cross section

Longitudinal section

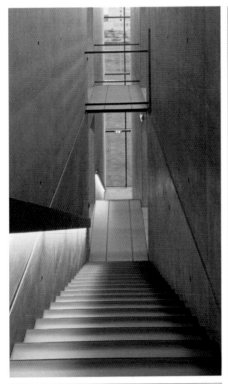

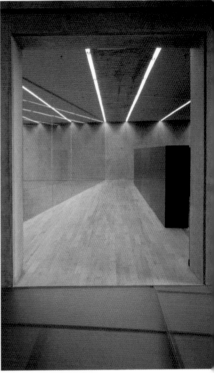

The surfaces and materials—steel, concrete, and glass—are scarce in relation to the colors of the landscape and give the construction a solid material weight.

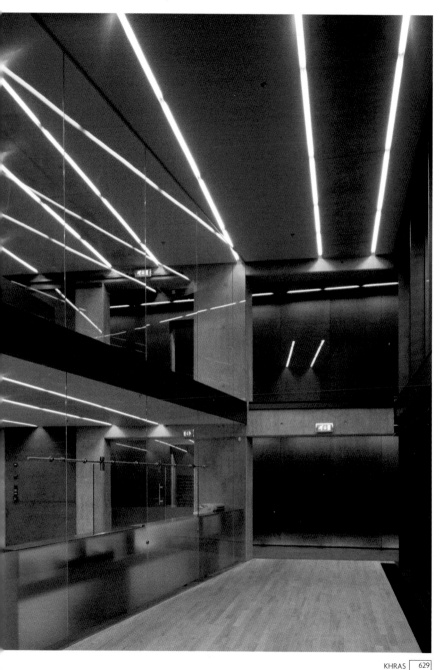

PRONOVIAS BARCELONA

GCA Arquitectes (Josep Riu de Martín) | © Jordi Miralles | Barcelona, Spain

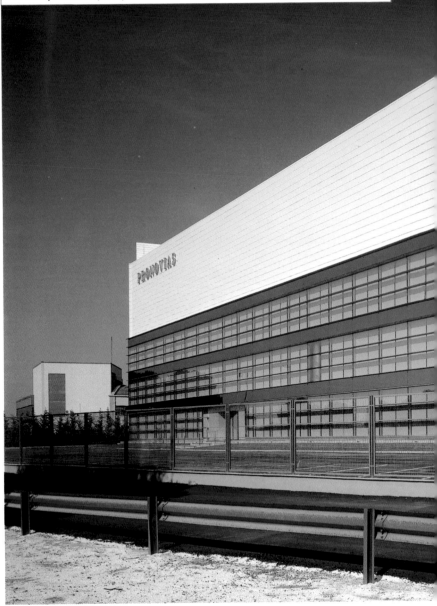

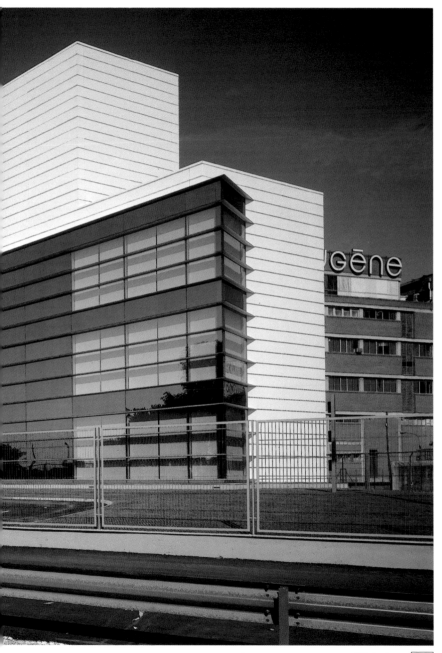

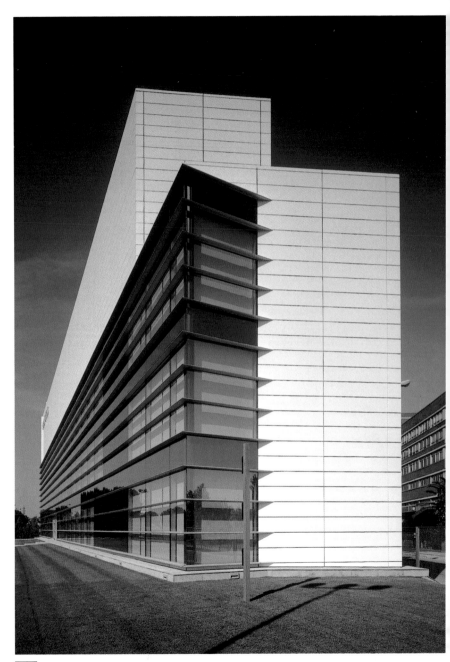

PRONOVIAS BARCELONA

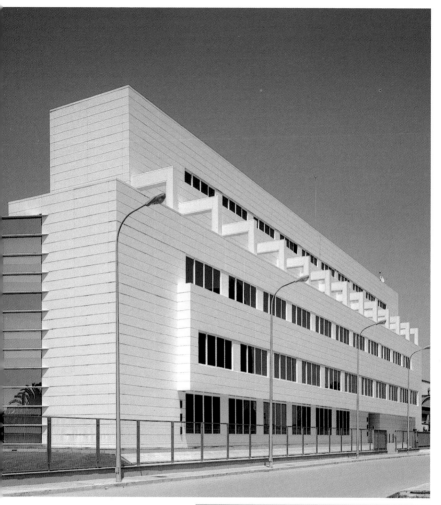

The design endows the construction with a homogeneous image. The building houses both offices and production facilities.

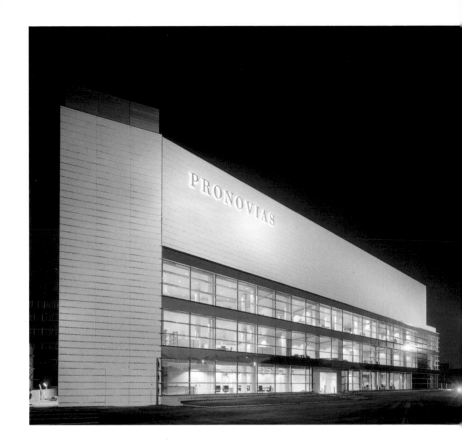

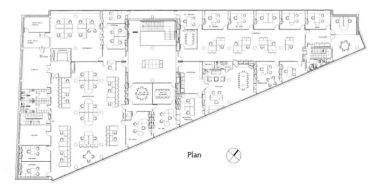

Plan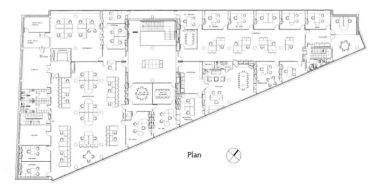

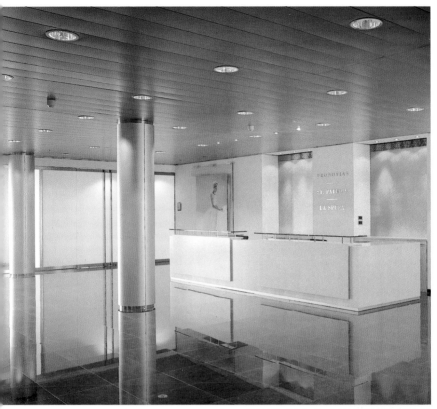

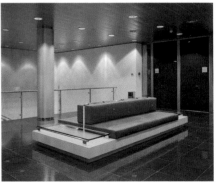

The work areas use partitions of aluminum and steel, and the walls are subdued. False ceilings house the lighting, and carpeting tones down floor reflections.

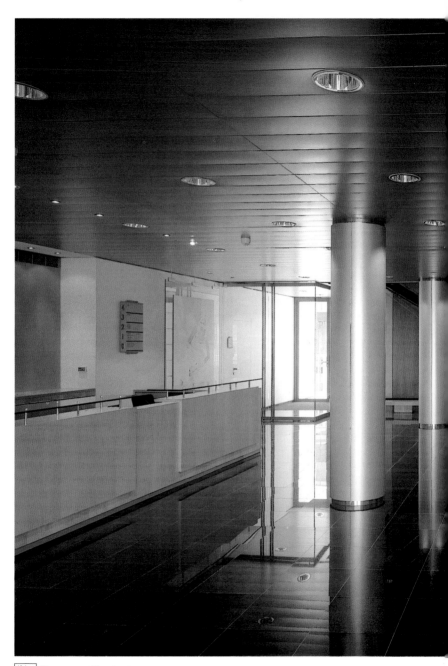

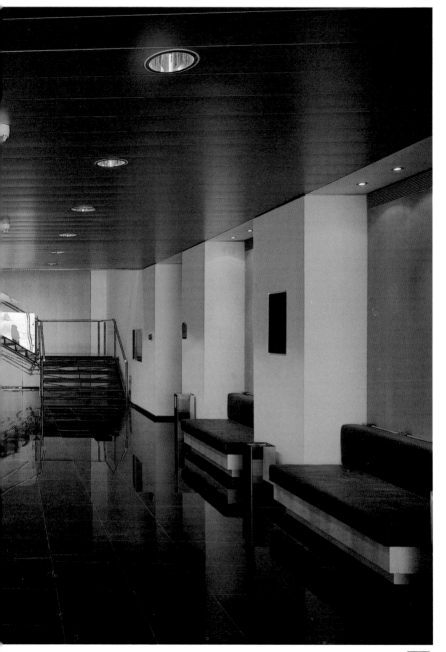

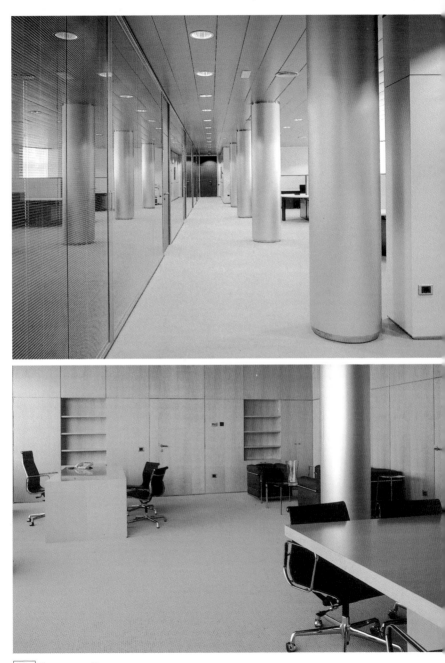

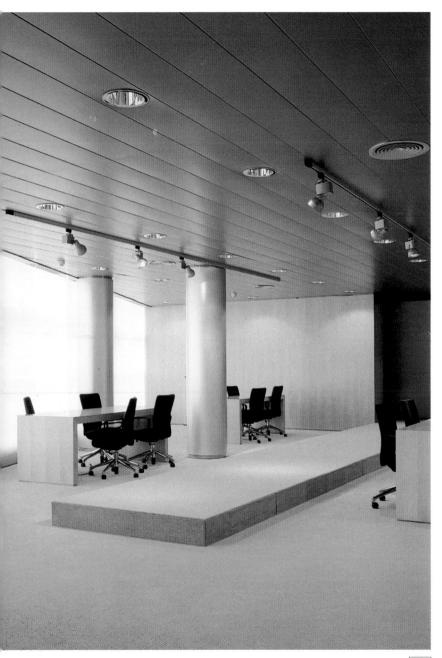